Talking with
the Turners

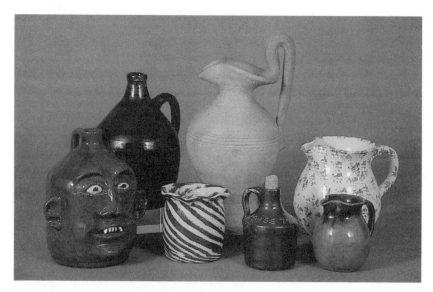

A sampling of wares and glazes. Front row from left: face jug by Cleater Meaders, swirlware vase by Boyd S. Hilton, souvenir jug by Bill Stewart, cream pitcher by Bill Gordy; rear row from left: jug by Eric Miller, Rebekah pitcher by Otto Brown, spongeware pitcher by Walter Lee Cornelison.

Talking with the Turners

Conversations with Southern Folk Potters

Thematic Excerpts Transcribed from Interviews Taped in the Field in 1981 and Preserved in the Folklife Resource Center of the McKissick Museum of the University of South Carolina with Introductory and Concluding Essays, Complementary Photography, and a CD Recording of the Potters' Voices

Charles R. Mack

FOREWORD BY WILLIAM R. FERRIS
INTRODUCTION BY LYNN ROBERTSON

UNIVERSITY OF SOUTH CAROLINA PRESS

Published in Cooperation with McKissick Museum

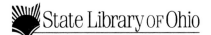

Published in Columbia, South Carolina,
by the University of South Carolina Press

Manufactured in the United States of America

10 09 08 07 06 5 4 3 2 1

Library of Congress Cataloging-in-Publication Data

Talking with the turners : conversations with southern folk potters / Charles R. Mack;
 foreword by William R. Ferris ; introduction by Lynn Robertson.
 p. cm.
"Thematic excerpts transcribed from interviews taped in the field in 1981 and preserved
in the folklife resource center of the McKissick Museum of the University of South
Carolina with introductory and concluding essays, complementary photography, and a
CD recording of the potters' voices."
 Includes bibliographical references and index.
ISBN 1-57003-600-4 (cloth : alk. paper)
 1. Pottery, American—Southern States. 2. Potters—Southern States—Interviews.
3. Folk artists—Southern States—Interviews. I. Mack, Charles R., 1940– II. McKissick
Museum.
NK4011.T35 2005
738'.092'275—dc22

 2005020427

Jacket photograph courtesy of the author

Dedicated to the Memory of George Terry (1950–2001),
Vice Provost and Dean of Libraries and Information Systems,
University of South Carolina.

George made good things happen.

What I hope will happen to the art of the potter will also happen to this labor of mine—seen by many and by many handled, it will arrive at its perfection.

—*Cipriano Piccolpasso,* Three Books of the Potter's Art, *ca. 1558*

CONTENTS

ILLUSTRATIONS

Prefatory Note

Most of the photographs accompanying this book were taken during the course of my field trips in 1981. I certainly wish I had been more skilled with a camera. As is the case with the interviews, I also wish I could redo many of the photographs and add to their number. But more than twenty-five years have passed, and that, unfortunately, is not possible. Most of the potters and family members interviewed are, however, pictured in these illustrations, so I am able to present a visual record to complement the verbal. I also have tried to present representative examples of the variety of workshops I visited in the hope that I can provide those who have not had a similar opportunity with some sense of their setting and of the vast disparity between them, ranging as they did from rustic to factory, from ramshackle to efficient, from Norman Smith's one-turner country pot shop to Billy Joe Craven's well-staffed manufacturing plant. Unless otherwise indicated, all the field photographs of the individuals or the potteries were made in 1981.

I not only interviewed and photographed on my travels but also collected. In some cases, I purchased, but in most instances the potters simply gave. So generous were they that my little Volkswagen Rabbit was heavily loaded as I drove back to Columbia, South Carolina, after my summertime foray into the lower South.[1] This representative cross-section of southern traditional

1. Although I recorded interviews in North Carolina only with Kenneth Outen, Boyd R. Hilton, and Boyd S. Hilton, between 1970 and 1983, I collected representative examples of pottery from all the traditional potteries in operation in the state, most of which is now part of the collection of southern ceramics at the University of South

ceramics produced at a time of transition is now a part of the collection of the University of South Carolina's McKissick Museum and has been used to further illustrate this volume. The museum's curator of collections, Karen Swager, organized the pottery for photographing, and the camera work was sensitively executed by Keith McGraw of the University of South Carolina's Division of Distance Education and Instructional Support.

Carolina's McKissick Museum. This includes pottery from western North Carolina (Pisgah Forest Pottery, Brown's Pottery, and Evan's Pottery), the Catawba Valley (Burlon Craig), and the Piedmont (Chrisco's Pottery, Cole Pottery in Sanford, G. F. Cole Pottery in Sanford, North State Pottery in Sanford, J. B. Cole Pottery in Seagrove, Hickory Hill Pottery, Jugtown Pottery, Joe Owen Pottery, Owens Pottery, Potluck Pottery, Seagrove Pottery, and Teague Pottery). These examples of primarily "transitional period" pottery form but a portion of the McKissick Museum's comprehensive collection of southern ceramics. Photography (turners and their shops) complementing this material is available for study at the museum.

Some of Those Interviewed

Appendix: Terms and Techniques

Tailpiece

FOREWORD

The clay pot marks the beginning of civilization as we know it. For thousands of years clay vessels contained the food and drink consumed at each meal. Today their shards guide archeologists as they reconstruct ancient civilizations whose pots are their most visible remains.

The American South is home to many of our nation's finest potters, representatives of a vital tradition that dates back to the region's first Indian, African, and European settlers. Museum curators and collectors proudly display southern pottery that has existed in our region for centuries and Indian examples that, in some cases, date back thousands of years.

Charles Mack offers us a detailed portrait of southern folk potters in his *Talking with the Turners.* Through photographs and oral histories that feature potters—or "turners" as many prefer to be called—Mack captures their worlds in fascinating detail. These artists explain what it means to be a potter. Theirs is a profession that passes from generation to generation within potting dynasties in which aspiring young artists apprentice with their elders. These young potters experiment and add new designs to traditional forms made within their families. Eric Miller says he thinks about this history as he molds a pot, "when the sweat is dripping off and I am about to burn up."

Successful potters must master both the artistry of their craft and the business skills needed to market their work. They must master both the clay pot and the pot shop. The business of potters ranges from the "one-turner shop" to the corporate garden center. Early potters hauled their wares to customers on mule-drawn wagons and sold fruit jars and churns to families during canning time. Today, some potters produce their work on a far grander scale. In Georgia, Billy Joe Craven's potters mold tons of clay each

day and produce fifteen thousand pieces of pottery weekly. Craven sells these pieces through garden centers located in the suburban South.

Each potter follows a timeworn process, shaping a piece from a mound of wet clay as it turns on a wheel. Through this process, the artist imposes his or her own design to create a cup, plate, pitcher, or churn. Each is magically created through the touch of the potter's hand. After witnessing this process, we understand why so many creation stories assert that God shaped man from clay.

Once the clay piece is molded, the potter decorates its form with a colorful glaze, ranging from traditional browns, whites, and blacks to brighter, more contemporary reds and yellows. The clay hardens and its glaze brightens through firing at high temperatures in a kiln. The length of firing and the source of heat vary from traditional wood-fired "groundhog" kilns to those heated with natural gas and electricity.

Southern potters create a broad range of earthenware, stoneware, and porcelain pottery pieces. They leave them unglazed or finish them with alkaline, salt, Albany slip, Bristol, or various other glazes. The final product is both beautiful and functional. Georgia potter Cleater Meaders argues that "when you drink tea that's been in a stoneware, it's got a taste that nothing else has . . . a taste that you can't get out of a glassware or a plastic."

Like a pilgrim on his journey, Charles Mark travels throughout the American South and speaks with potters about their work. He captures their worlds in their own voices and offers the reader a unique portrait of the southern potter and a world that is as ancient as the region's first settlers. Thankfully, their world endures today, as both a reminder of our ancestral roots and a window on our future.

WILLIAM R. FERRIS

PREFACE

The early morning mist still clung to the surface of the macadam as I drove my Volkswagen Rabbit across the Alabama line into Mississippi. Soon swallows swooped down to join me, darting in front of my car like dolphins before the prow of some Italian fishing boat. It seemed rather like a dream, and for a moment I almost could see the Mediterranean in my mind, a scene actually far more familiar to me than the cotton fields of Mississippi through which I now was driving. Italy, after all, the Italy of Renaissance art and architecture, was where my research most often took me. But here I was heading west through the South, embarked upon a folk pottery pilgrimage. This, certainly, was not the world of Alberti and Brunelleschi, of Masaccio and Botticelli, but that of Meaders and Smith, of Brown and Gordy, a world of pots and pug mills instead of palaces and churches, of alkaline glazes and Albany slip rather than frescoed walls and painted tabernacles.

My goal on this trip through the lower South was to document every traditional potter then at work in the region through taped interviews, photographs, and examples of their wares. Now, a week into the project, this excursion was proving a welcome change, accustomed as I had become to musty Italian archives, the cramped script of some extinct notary, and the mute testimony of palace facades and cloister yards. I was finding real pleasure in not having to supply the thoughts of long-dead architects and instead having my subjects talk for themselves. And these old-time potters certainly could talk. Most were replete with tales, told as they turned. With hours of interviews in Georgia and Alabama behind me, I knew that I would soon have to replenish my supply of tapes. This trip was turning into a novel, bountiful, and, even, joyful experience.

The year was 1981, and I was on a summer sabbatical from my usual research, inspired by a latent love for the potter's craft. There is just something about the transformation of a lump of clay into an object of beauty that has always captivated me. Ever since I had the childhood privilege of watching North Carolina's legendary master potter of Jugtown, Ben Owen, turn a coffee mug (I still have it) on his wheel, I have loved pots.[2] Much later, while in graduate school in Chapel Hill, North Carolina, my wife and I ate off plates turned by old A. R. Cole in nearby Sanford (they were more elegant and less expensive than store-bought crockery would have been).[3] I eventually became a historian of Renaissance architecture, but I retained my appreciation for ceramics; both buildings and pots are, after all, tectonic in nature. And pottery has one distinct advantage over most other art forms: shaped by hand, the human presence still lingers in the fired fabric of a pot, a fingerprint link between maker and user.

After years of ceramic flirtations, I finally had given in. The immediate inspiration for my career detour had been occasioned by excursions to Seagrove area potteries while a visiting professor at the University of North Carolina–Chapel Hill in the summer of 1977 and by the collecting interests of George Terry, then history curator (and later director) of the newly created McKissick Museum at my home institution, the University of South Carolina. One of the missions of the McKissick Museum was to document and collect the material culture of the South. In accomplishing this objective, special emphasis was placed upon the folk pottery of the region. Thus, a convergence of personal and institutional interests had caused this temporary change in my direction and was leading me down a road I always have been glad I took.[4]

Only a few days into this trip, with stops in middle Georgia and Alabama behind me, my southernness was beginning to show. I could even detect a slight drawl creeping into my speech as I chatted with potters along the way. I recalled that, several years earlier, one of my students had accused me of speaking with a "Yankee accent" that she claimed was difficult to understand. That charge had come as rather a shock to someone raised in Virginia,

2. On Ben Owen and the Jugtown Pottery, see note 30, p. 18.

3. On A. R. Cole, see especially Dorothy Cole Auman and Charles G. Zug III, "Nine Generations of Potters: The Cole Family," *Southern Exposure* 5 (1977): 166–74.

4. Now once again, as I write this, more than two decades later, I find myself traveling the same roadway into the continuing cultural folk heritage of the American South. As I do, the images of the places and the sounds of the voices seem as fresh as ever.

schooled in North Carolina, and presently teaching in South Carolina. But, in any case, here I was in the Deep South, driving through its rural countryside, happily aware of my southern connections and eagerly anticipating my next conversation with an authentic symbol of the region's pottery heritage.

By the end of my summer's research, I had managed to tape interviews with some forty individuals, contained on fifteen ninety-minute cassettes. To visually document my conversations, I had taken quantities of color slides and black-and-white photographs, made as the potters talked and turned. In deference to the work already done by others on the potters of North Carolina, I had concentrated my attention upon those in the other southern states, but I did visit with some of the turners working in the Catawba Valley section of the North State.[5] I also made an expedition into Kentucky to visit the oldest functioning pot shop in America. Included on the tapes I brought back to South Carolina were lengthy interviews with such prominent turners of the day as Bill Gordy, Lanier Meaders, Norman Smith, and Walter Lee Cornelison. The recordings also contained the reminiscences of potters less well known at the time but nonetheless clearly significant: Boyd S. Hilton, Cleater Meaders, D. X. Gordy, Ed Meaders, Marie Rogers, Gerald Stewart, Grace Hewell, Howard Connor, Wayne Wilson, Jack Hewell, Eric Miller, Harold Hewell, Kenneth Outen, Ralph Miller, Oscar Smith, and Horatio Boggs. Also of interest are the informative comments of family members, such as Arie Meaders, Hattie Mae Stewart Brown, Verna Suggs Duncan, Horace V. Brown Jr., and Annette Brown Stephens. In several instances, these field recordings have turned out to be the only opportunity through which those interviewed were able to have a lasting say in the history of southern traditional pottery.

My original intention in making these recordings was to gather material for a book that would present the history of southern pottery with a special emphasis upon the traditional potters then at work throughout the South— the only area in the United States in which folk pottery was maintaining a

5. Among those then at work documenting the history of North Carolina pottery were Daisy Wade Bridges and Stuart Schwartz at the Mint Museum of Art in Charlotte, Charles G. "Terry" Zug III of the University of North Carolina–Chapel Hill, and Seagrove potters Dorothy Cole Auman and her husband, Walter. The landmark exhibition "The Traditional Pottery of North Carolina," organized by Terry Zug, had been held at the Ackland Art Museum in Chapel Hill at the beginning of 1981: the previous year, Daisy Wade Bridges had put together an extraordinary show for the Mint Museum of History titled "Potters of the Catawba Valley."

continuum. But after organizing what I believe was a visually handsome and informative exhibition and publishing two related articles, I decided to return to my primary Renaissance pursuits.[6] Before doing so, I presented a complete set of my tape recordings, together with a selection of my field photographs documenting the potters and their shops, to the Folklife and Resource Center of the McKissick Museum. Two hundred and forty pieces of pottery complementing these materials, most of which had been collected on my 1981 travels, joined the McKissick collection in 1992–93. The aggregate created an important resource for the study of southern material culture at a most critical moment in its history, when the survival of the potter's craft was very much in question throughout much of the region. As it turned out, it was also a time when what some might term "unsophisticated authenticity" in many of the locales was about to be replaced by market-driven self-consciousness and enhanced by the appreciative intervention of folklore specialists and interviewers such as myself.[7] Actually, 1981 proved to have been a very good year to have undertaken my documentary mission.

6. "Turned to Tradition: The Folk Pottery of Today's South" was held from September 4 to October 23, 1988, at the Columbia Museum of Art. It was the first show designed to present both the historical and contemporary ceramic traditions from the entire region. Its breadth of coverage was reflected in my "Traditional Pottery: A Southern Survival," *Southeastern College Art Conference Review* 10, no. 4 (1984): 176–83, and "Turned to Tradition: The Folk Pottery of Today's South," *Collections: The Journal of the Columbia Museum of Art* 1, no. 1 (1988): 8–14. More recently, I organized a show comparing southern ceramics with pottery in the Bunzlauer style from Germany titled "Two Traditions in Transition: Folk Potters of Eastern Germany and the American South," held at the McKissick Museum, May 24 to December 13, 1998, to demonstrate how similar pressures often lead to like solutions. I discussed this exhibition in "Two Traditions in Tradition," an essay published in the brochure *1998 Fall Folklife Festival* (Columbia: McKissick Museum, University of South Carolina, 1998), 7–8. Information on the German pottery may be most easily found in Charles and Ilona Mack, "Bunzlauer Geschirr: A German Pottery Tradition," *Southeastern College Art Conference Review* 13, no. 2 (1997): 121–31.

7. Just how "unsophisticated" the southern potter was might be debated. The term certainly does not apply to those working in North Carolina, nor to most then at work in Georgia, although it might be applicable to some located off the tourist routes in Alabama and Mississippi, such as Norman Smith or Gerald Stewart. In a sense, the intrusion of outside influences can be said to have begun in the early 1920s, when Jacques and Juliana Busbee intervened in the Seagrove area of North Carolina and established their Jugtown Pottery. Commercial interests continued to condition changes throughout the 1930s, especially in North Carolina. On this, see the passage from a 1926 article quoted

My choice of a repository for the recordings and supplementary materials was a sound one. The holdings of the University of South Carolina's McKissick Museum in the field of folklife are considerable and span many aspects of southern material culture, from pottery to quilts, from bluegrass music to seagrass baskets, from foodways to folk carvings. Unfortunately,

in note 11, p. 7. Another stage in "the loss of innocence" took place, beginning in 1967, when the Smithsonian Institution "discovered" and filmed the Cheever Meaders Pottery in northern Georgia. Fourteen years later, Cheever's son, Lanier, was honored at a Meaders Pottery Day at the Library of Congress. Just before I visited him in 1981, the Smithsonian had invited Catawba Valley, North Carolina, potter Burlon Craig to take part in their Washington Mall Folklife Festival. Researchers such as John Burrison in Georgia, Charles G. "Terry" Zug III in North Carolina, and Henry Willett in Alabama were already hard at work documenting the traditions of their states. While there was nothing "naïve" or untutored about such potters as Burlon Craig or Lanier Meaders, much less the Hiltons, Coles, or Gordys, there still remained a certain "pristine" quality in the attitudes of other less prominent potters throughout the region.

On the issues of authenticity and recognition, see especially the essay by Douglas DeNatale in Douglas DeNatale, Jane Przybysz, and Jill R. Severn, eds., *New Ways for Old Jugs: Tradition and Innovation at the Jugtown Pottery,* exhibition catalog (Columbia: McKissick Museum, University of South Carolina, 1994), 1–15; Ralph Rinzler and Robert Sayers, *The Meaders Family: North Georgia Potters* (Washington, D.C.: Smithsonian Institution Press, 1980), 42–43; and Allen Huffman and Barry Huffman, *Innovations in Clay: Catawba Valley Pottery* (Hickory, N.C.: Hickory Museum of Art, 1987), 7. All along, there have been efforts to illuminate the story of the southern folk potter. Numerous regional, state-based, and more localized exhibitions have been instrumental in drawing attention to southern-produced pottery, both historical and contemporary / traditional. For a listing of some of the earlier of these, see Mack, "Traditional Pottery," 182n5.

Public attention has been a two-edged sword, helping to preserve by providing needed financial support but, at the same time, destroying the very purity that had demanded preservation in the first place. A case in point is the addition of the face jug to the potter's repertoire, the growing popularity of the item with collectors, and its current mutation into grotesquely featured and gaudily painted perversions of the playful whimsy it once was. On face jugs, see the following exhibition catalogs: Regenia A. Perry, *Spirit or Satire: African-American Face Vessels of the 19th Century* (Charleston, S.C.: Gibbes Art Gallery, 1985) and Jill Beute Koverman, *Making Faces: Southern Face Vessels from 1840–1990* (Columbia: McKissick Museum, University of South Carolina, 2000). A number of authorities see a link between an African American tradition and the making of the face jug. While this may be true in respect to examples from the old Edgefield potteries, where slaves were employed, I believe this source to have been overstated. I would much prefer to see it as an end-of-the-day innovation suggested by the natural anthropomorphic shape of a jug and arrived at independently at different times and places.

these collections (as is so often the case with university-based resources) have been underpublicized and thus remain underutilized by both scholars and the general public. It is my hope that this volume of transcript excerpts, augmented by photographs of the potters, their pot shops, and their wares, along with the opportunity, on the included CD, to actually listen to the voices of many of those interviewed, will not only provide access to significant information concerning the southern pottery tradition but also draw attention to the many-faceted folklife resources at the McKissick Museum.

In organizing the format through which the potters and their families would be heard, I rejected the obvious state-by-state or turner-by-turner approach in favor of a thematic presentation. This, I felt, would be the more interesting arrangement and the one by which the potters could best be introduced in a more conversational fashion. The interview core of this book is prefaced by an essay that describes the nature of folk pottery in America and the qualities that distinguish its southern tradition; the essay surveys previous research on the topic, and discusses the role played in 1981 by traditional pottery in the southern states. The interview excerpts themselves are introduced by a biographical listing of those recorded in 1981 and whose comments I have selected for inclusion in this volume. An epilogue summarizes the way in which the Fates have treated the survival of southern pottery in the intervening years. Finally, to facilitate an understanding of the context of their conversations, I have included an appendix listing some of the terms and practices used by potters.

Talking with the Turners offers only highlights drawn from some twenty hours of interviews; the selections are purely personal. For a better insight into the full character of the interviews and an opportunity to encounter a wider range of personalities, the reader is referred to the complete set of

Outside inspiration also may have played a role in the phenomenon; see Lanier Meaders's explanation for his face jugs as given in John Burrison's *Brothers in Clay: The Story of Georgia Folk Pottery* (Athens: University of Georgia Press, 1983), 270, concerning the suggestion of a folk-art dealer from Virginia, or the story of the dentist and Horace Brown recounted in the text.

On the conflicts between genuineness and recognition, see Robert Sayers, "Potters in a Changing South," in *The Not So Solid South: Anthropological Studies in a Regional Subculture,* ed. J. Kenneth Morland, *Proceedings of the Southern Anthropological Society* 4 (1971): 93–107, and Shalom Staub, "Folklore and Authenticity: A Myopic Marriage in Public Sector Programs," in *The Conservation of Culture: Folklorists and the Public Sector,* ed. Burt Feintuch (Lexington: University Press of Kentucky, 1988), 166–79.

audiotapes (now converted to digitized format to better preserve their content and to enhance the sound quality) and related materials on deposit in the Folklife Resource Center at the McKissick Museum. Furthermore, as I have noted, the museum also houses examples of the pottery produced by all of the turners whose voices appear on the tapes, some of which illustrate this volume, as well as an extensive sampling of wares produced during the same period by the potters of the western and central (Seagrove) portions of the North Carolina. In addition, the museum possesses an extensive collection of historic pottery from the region, especially its alkaline glazing tradition, which originated in South Carolina. All of this material is available at the McKissick Museum to those interested in researching the ceramic history of the American South.

As I have replayed these old tapes and made the transcriptions, I have thought of so many more questions to ask, of other directions I could have pursued in our conversations and of other times when I just should have kept silent and have let the turners talk. But these second thoughts come too late, as that part of the pottery story of the South has now faded into history along with most of those who told it to me a quarter of a century ago.

> *For who would wish for the sake of an earthen jug, . . .*
> *To raise such racket and to cause such trouble?*

> —*Heinrich von Kleist,* The Broken Jug

ACKNOWLEDGMENTS

Back in 1980, when I first proposed my taping expedition to the late George Terry, then director of the McKissick Museum and later vice provost and dean of libraries and information systems of the University of South Carolina, he was immediately supportive; his love of the enduring pottery traditions of the South was at least as strong as my own. My travels through the South in the summer of 1981 were supported by a Research and Productive Scholarship Grant from the University of South Carolina. Before, during, and after the undertaking, I benefitted from the generous advice and assistance of such experts in southern folk culture and pottery traditions as the late Charles Counts (whose seminal book, *Common Clay,* was inspirational to me and served as my initial guide) and the late "dean" of folk pottery researchers, Georgeanna Greer. For assistance with the traditions of Georgia, I am indebted to John Burrison, for that of Alabama to Hank Willett and Joey Brackner, and for North Carolina to Charles "Terry" Zug III and Stuart Schwartz. Of course, I owe my greatest debt to each and every turner and family member with whom I came into contact. They could not have been more open, cooperative, and hospitable.

In 1981, while traveling about the South in the summer's heat, I enjoyed the encouragement and support of my wife, Ilona, as I do once again in finally bringing this long-term project to an appropriate conclusion. Both she and our daughter, Katrina, accompanied me on several portions of my pottery excursions, and I thank them both for their patience and their valuable contributions to the project over the years.

After some two decades of hiatus, my proposal to put excerpts from these tape recordings into book form was greeted with enthusiasm by the McKissick's current director, Lynn Robertson. Lynn provided resources and

support for my project and kindly has contributed the introduction for this publication. While assembling the various materials into manuscript form, I was given assistance, whenever needed, by the McKissick's curatorial staff, especially Karen Swager, curator of collections, and, before his departure for military duty in Iraq, Saddler Taylor, the museum's curator of folklife and research, whose expertise with CD recordings proved most encouraging. The actual CD was masterfully prepared by his assistant, Chris Scott. At the University of South Carolina Press, acquisitions editor Alex Moore immediately recognized not only the rich resource this book would provide but also the opportunity it offered to demonstrate the press's commitment to the history and culture of the South as well as to promote the research activities of the university.

During the second stage of this interrupted journey, I have benefitted from the advice of numerous colleagues, some of whom I have already noted. Most especially, I have enjoyed the encouragement and council of my Art Department colleague, ceramics professor Virginia Scotchie and her husband Peter Lenzo, himself a master potter and well known for his creative face jugs.

In creating this book of excerpts, I was aided by the partial transcriptions of several of the tapes made intermittently during the 1980s by students working on projects under my direction. These former students were Patricia Rojas, Thomas McPherson (now director of the Mobile Museum of Art in Mobile, Alabama), and David Houston (now curator of the Ogden Museum of American Art in New Orleans). Although their labors have assisted greatly in providing me with an entry point for constructing the present volume, I have listened to each recorded interview again and have examined their transcriptions word by word, making necessary changes. I take full responsibility for any inaccuracy in the presentation offered here. The majority of the excerpts have come from transcriptions I made specifically for the present project.

The verbal testimony of the turners is a valuable memorial to the grand ceramic history of the American South. That tradition, however, is better understood when expressed not just in words but also through sight and sound. That the text that follows is complemented by numerous illustrations, including new photographs of the pottery I collected in 1981, and a compact disk of the potters' voices, was made possible by an award from the College of Liberal Arts (now merged into the College of Arts and Sciences) of the University of South Carolina.

Finally, I wish to express my special gratitude to William Ferris, former chairman of the National Endowment of the Humanities and now Joel R. Williamson, Eminent Professor and senior associate director of the Center for the Study of the American South at the University of North Carolina–Chapel Hill, who kindly agreed to write the foreword to this volume. When I first met Bill, he was director of the Center for Southern Culture at the University of Mississippi, an innovative research facility that served as the academic model for numerous study centers throughout the region. At a critical juncture, his efforts did much to preserve the traditions of southern folk culture.

INTRODUCTION

Sometime in the 1930s, the University of South Carolina was presented with a collection of utilitarian pottery. It included a large glazed storage jar by the fabled African American potter then known only as Dave. These were not the first ceramics to come into the university collections, but they would emerge several decades later as important in establishing a successful program of research and collecting at McKissick Museum. The museum was established in 1976 to bring together these and many other important university holdings that had been dispersed across the campus. Years later, George Terry, the first curator, recalled, "As the boxes were opened during those early months, it was obvious to those of us who were entrusted with constructing the first comprehensive catalog, that the strongest potential lay in those objects that reflected the life of the South, and, in particular, the rich heritage of South Carolina traditional crafts." The museum staff quickly earned a reputation for the research, collection, and exhibition of South Carolina traditional ceramics. In the mid-1980s, a project to document the alkaline-glaze tradition broadened the museum's scope to include most of the southern states. But the major growth to the collections came in 1992, when Charles and Ilona Mack contributed over two hundred pieces from their private collection of work by the region's traditional potters. This acquisition came with oral history interviews undertaken by Professor Mack in the summer of 1981. Although the pottery was frequently exhibited, the tapes remained safely tucked away in the museum's folklife archives until now. They are the subject of this book.

There is that old adage about "being in the right place at the right time." Add to that equation the "right person," and you have the reason why the interviews in this book are so significant. Charles R. Mack was the right

person to set off that hot summer in search of the remaining traditional potters of the Deep South, a place that still supported doing things the "old way." He undertook his adventure just in time, as many of the individuals in this book were retiring from the hard labor of working with clay or modifying their wares to satisfy an increasingly urban taste. They still, however, had clear memories of earlier days as well as insights into the more distant histories of their families' involvement with the craft.

Those memories, and the other personal reflections, make this book an outstanding contribution to the history of traditional southern pottery. In the conversations between Mack and his many subjects, the reader can sense the personal connection each potter had with his or her work. Those connections differ from potter to potter. Some talk about the long tradition of craftsmanship in their families. Others speak earnestly of their own personal quest for quality and improving the craft. But each contributes a personal perspective not available in most published histories and museum exhibitions.

Now, after twenty-five years, the oral histories Mack carefully collected have come to a wider audience. Through careful editing and topical organization, they offer us new information on not only southern pottery but also the daily life of rural craft workers. Not marked by gallery exhibitions, auctions, or eBay sales, it was a world of hard work, marginal profits, unexpected ups and downs, and, frequently, family pride. Walter Lee Cornelison talks about his family origins and recounts that "one of the boys received a land grant in North Carolina for his services in the Revolutionary War. He . . . came . . . into Kentucky. Now, whether he came here knowing the clay—you know, it would make a nice story for you to say that that's the way it happened, but, frankly, I don't know. They kept so few records about the potteries or anything that they didn't have to back then, and they didn't. They spent their time making pottery." His interview speaks to generations of work at a craft that was little recorded until now. Oral histories seldom come up with that "nice story" of which Cornelison speaks; the one that ties up all of the loose ends. But even if the potters in this book are not able to definitively explain the long-ago origins of regional styles and glazes, Mack was still able to fill in much information missing from those "few records about the potteries."

This book reads almost like the script for a "road movie" or a novel of self-discovery. A young man takes off over untraveled back roads in his Volkswagen in search of a deeper understanding of something he reveres. He stops on his journey and learns from the locals. Through that experience,

he gains not only knowledge but also a new respect for his subject and a sense of perspective about our country and its traditions. Traditional crafts are ordinary stuff but far from trivial. Their histories reflect where we have come from, who we have become, and how we choose to live our lives. As Simon and Garfunkle said in their poetic song of travel and discovery, "We've all come to look for America." In these pages, we find some of the answers to our search.

<div align="right">Lynn Robertson</div>

COMMENTARY ON THE
TURNING TRADITION

*Only a few old men continued to make dishes
and pickle jars for neighboring households. Along
the backwoods roads they peddled surplus wares.*[8]

1981 Impressions

At one of my very first stops in the summer of 1981, at Byron, Georgia, just
south of Macon, Cleater Meaders reminded me that potters don't really
"throw" pots, they "turn" them.[9] Watching Mr. Meaders slam a ball of clay
down onto his wheel and then turn it into a pitcher of beauty convinced me
of the rightness of his remark. Whatever a studio ceramicist might do, a
southern traditional potter proudly "turns" his pot. And he, consequently,
thinks of himself far more often as a "turner" than as a "potter," and never
as a "ceramicist." He also usually will "burn" his ware rather than fire it in
his "kill" (as the word "kiln" generally is pronounced in the South). In fact,
the nomenclature used around the pot shops throughout the region actually
reveals a lot about what sets the southern traditional potter apart from other

8. Quoted from a Jugtown Pottery leaflet distributed at its village store outlet at 37
East 60th Street, New York, N.Y. (McKissick Museum), ca. 1930.

9. Actually, the words "turn" and "throw" are closely related in their linguistic ori-
gins. "Throw" derives from the Middle English *throwen,* meaning "to cause to turn or
twist."

practitioners of the craft. I have found the distinctions and shades of meaning well worth remembering.

Two decades ago, when I taped the conversations excerpted in this book, the South, like the rest of the nation, already was crisscrossed by ribbons of interstate highways. The topography of the landscape, then as now, was denoted not so much by rivers, creeks, forests, and hills as by highway numbers and freeway exits. Cities such as Atlanta, Birmingham, Charlotte, and Nashville had mushroomed and exploded out into what, until recently, had been tranquil countryside. High-rise office buildings rather incongruously had come to dominate city skylines. In many ways, these urban centers of the New South seemed as cosmopolitan as their more senior counterparts in the Northeast: Atlanta, after all, had become home to the busiest airport in the world and was fast on its way to leading the nation in smog production.

Yet if you took one of the interstate turnoffs, you frequently could motor into a memory of the past as you followed narrow blacktop roadways through communities where little seemed to have changed in years. In spite of its miles of interstates, metropolitan sophistication, and airport hubs, much of the South still remained a last refuge for the vanishing folklife culture of our American heritage. Nowhere was this more visibly evident a generation ago than in the continuing tradition of the southern country potter.

In those days, as you drove along the rural highway that links Tuscaloosa, Alabama, with Louisville, Mississippi (as I did on June 11, 1981), the impression was of a countryside in which time almost seemed to be standing still. Here, despite the bustling reality of an increasingly urbane South, you could easily resurrect images of Faulkner's South, King Cotton, Tobacco Road, sharecropping, and—for those who were mindful of material culture —stoneware jugs, churns, milk crocks, and batter bowls. Here, and along other byways throughout the region, people in 1981 still pickled, salted meat, and put up kraut in locally produced heavy clay jars covered with drippy green alkaline glazes or in rich brown Albany or Michigan slips. Two decades earlier, the potteries of North Carolina's Seagrove area had begun to boom thanks to urban visitors intent on recapturing the traditions of the past; many of the pot shops of the deeper South, however, remained largely traditional in a purer sense of the word.

The Character of Southern Folk Pottery

Generally speaking, traditional, or folk, pottery is produced by individual potters working independently in small shops and not in factory production lines; it usually is made by hand and turned on the wheel. Often designated

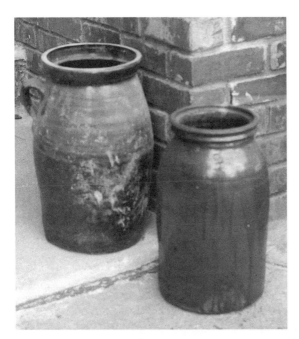

Churn and jar by Horace V. Brown Sr. at the home of Horace V. Brown Jr., Acworth, Ga.

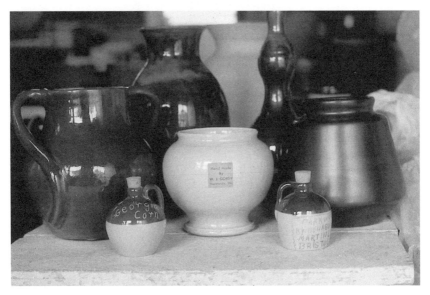

A selection of items from the 1930s to 1950s in Bill Gordy's shop, showing some of his glazes, Cartersville, Ga.

A pre-1940 churn by Maryland Hewell with cobalt banding under glass glaze at the home of Ada Hewell, Gillsville, Ga.

Exhibit of pottery decorated by Arie Meaders, White County Library, Cleveland, Ga., 1981.

Collection of Boggs family pottery from the nineteenth century, Boggs Pottery, Prattville, Ala.

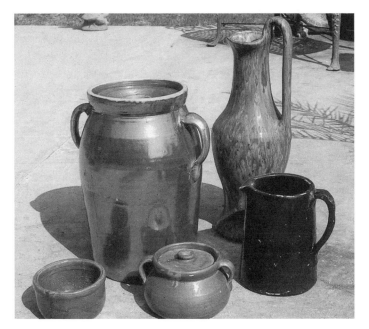

Examples of ware formerly turned at the Connor Pottery, Ashland, Miss.

a folk craft, American traditional pottery is distinct from the consciously sophisticated "art," "studio," or "craft" pottery executed in the more self-conscious and internationally connected ceramic styles. Although primarily functional in intent, it also is distinct from commercially produced table crockery and other forms of "store-bought" chinaware.

Folk pottery in America (the pottery of our native inhabitants is another impressive story) has evolved over the past three hundred years out of British and German prototypes with some limited admixture of other stylistic influences, including Asian and (especially in the South) African. Whatever changes that occurred in form, fabric, and decoration generally resulted more from the natural outgrowth of altered functional and economic requirements and less from new artistic urges or a compulsion for innovation and change.

In general, traditional pottery is made by master craftsmen (or women) trained at the wheels of their parents, relatives, or neighbors rather than in the more artificial environments of an art school, university art department, or studio. Many of today's practitioners in the South, and almost all of those interviewed, for example, were born into potting dynasties generations old. In determining just who might be classified a "southern folk potter," this family connection plays the major role. It is precisely this heritage that gives to this category of ceramics its sense of "place" and basic "rightness" and endows it with much of its aesthetic value and art historical significance. Traditional, or folk, pottery is one of the fundamental American art forms and, because its historical thread is unbroken in the South, one of that region's most important cultural contributions .

Background to the Southern Survival

Ever since the first pottery kilns were built at the Spanish colony of Santa Elena on Parris Island, South Carolina, in the late 1580s and at the English settlement at Jamestown, Virginia, sometime between 1625 and 1640, this utilitarian folk craft has played an essential role in American life.[10] The U.S. census of 1870 listed more than five thousand professional potters then at work in the nation. Hundreds of potteries, often seasonal, one-man, or

10. On the Santa Elena pottery, see Chester DePratter and Stanley South, "Return to the Kiln: Excavations at Santa Elena in the Fall of 1997," *Legacy* 3, no. 1 (1997): 6; on the Jamestown pottery, see J. Paul Hudson and C. Malcolm Watkins, "The Earliest Known English Colonial Pottery in America," *Magazine Antiques* 71, no. 1 (January 1957): 51–54.

family affairs, flourished throughout the United States into the early years of the twentieth century. In the days when life was simpler and existence was not store dependent, the country potter occupied a significant position within the social and economic structure of the American family. Crocks, churns, jugs, batter bowls, milk pitchers, and storage jars were necessities, and wherever the clays were suitable, local farmers learned to mine and prepare them and to master the art of turning and burning. Much of their time was also spent in marketing their wares, first by wagon and later by pickup. Old-time potter Norman Smith of western Alabama recalled traveling with his father all the way to Atlanta to sell a kiln load of churns and crocks. For their effort, back in the 1920s, the Smiths got ten cents a gallon. Pot making, like farming, often proved a marginal occupation.

By the beginning of the twentieth century, many of the potteries across the nation were forced to cease operation as they yielded to the overwhelming competition of mass-produced, store-bought crockery and the appeal of substitute materials such as glass and graniteware. Changing economic patterns, living habits, and altered demographics also accelerated the decline of pottery's utilitarian popularity. Some of the old shops sought survival in the production of unglazed garden ware; others (particularly in the South) began exploring new directions in favor of wares that might have "eye appeal" for a different sort of consumer. A few other potters, such as various members of the Meaders family in the hills of North Georgia, the Stewarts in Mississippi, and the Smiths in northwestern Alabama, worked in communities sufficiently isolated from the pace of radical progress to preserve a demand for utilitarian jugs, churns, crocks, and preserving jars. As others have noted, the continued existence of the southern potteries can be seen as a byproduct of the region's rural nature and the generally slow pace of development in the decades following the Civil War.

Thus, many southern potters were still at their wheels when Americans began their love affair with their cultural past. The rural potter's survival in the South remained tenuous throughout much of the twentieth century, but gradually it became more certain as the clientele changed from erstwhile country consumer to craft-conscious collector.[11] The period from about 1920

11. Recognition of this transition is found in Ivan Stowe Clark, "An Isolated Industry: Pottery of North Carolina," *Journal of Geography* 25 (1926): 227–28, which notes:

In the earlier days of the industry practically all of the ware was marketed locally. Some of it was loaded into the covered wagons and carried to the village stores or it

to 1970 was, however, a delicate time for traditional pottery, even in the South, where societal conditions best encouraged its preservation. In fact, it was not really until the era of bicentennial rediscovery that the general category of southern traditional pottery could be removed from the "endangered" list. By that time, it was much too late for the utilitarian potteries in the rest of the nation. As the twentieth century entered its final quarter, the southern country potter had the distinction of being the last representative of a distinguished American craft tradition. In 1981, that heritage was restricted to the thirty-odd pot shops then still in operation in North Carolina, Georgia, Alabama, Mississippi, and Kentucky.

Scholarship and Southern Pottery

The ceramic commonplaces of the eighteenth, nineteenth, and early twentieth centuries have attracted collectors of Americana for decades. Yet the historical and aesthetic recognition of southern traditional pottery came about rather slowly. Since most of the initial researchers into the history of American ceramics were northerners writing for the benefit of northern collectors, they concentrated their attention upon the pottery with which they had the greatest familiarity and which held the primary interest for their readers —the pottery of New England, the mid-Atlantic states, and the Midwest.[12]

was sold from house to house by the potter himself. There were few middlemen in the business; in most cases the articles were sold direct from the producer to the consumer. The country store keeper was about the only middleman in the business. The smaller articles were sold at a certain set price each, while the larger articles such as churns, jugs, etc., were sold at so much per gallon (of their capacity). In recent years the potter has found the tourist to be a good buyer of the fanciful and decorative pottery and has therefore learned the value of advertising. He now builds his shop near the road where he can display his wares to better advantage and to larger numbers of people. He also carries his products to the cities and larger towns of the state and sells them in wholesale lots.

Since the industry has begun to grow, due to modern methods, those who have the ability to do the work, are finding it very profitable. The modern business methods, good roads, and automobiles are bringing these people more and more into contact with the outside world. They are gradually picking up the artificiality of our modern civilization: but slowly, very slowly; for they are a simple people with frugal tastes.

12. These studies included Edwin Atlee Barber, *The Pottery and Porcelain of the United States: A Historical Account of American Ceramic Art from the Earliest Times to the Present Day* (1893; repr., Watkins Glen, N.Y.: Century House Americana, 1971); John

The physical appearance of southern pottery, actually, is markedly different from that of the North and Midwest. Just as the essence of southern literature lies in the "telling," the beauty of southern pottery is formed in the "turning." The aesthetic of southern pottery depends upon subtle factors of form, texture, and color and the fortuitous conjunction of clay fabrics and firing methods. Its distinction is to be found in its nuances, in the "phrasings" of its slow, formal rhythms and in the gentle ranges of tonal color variations.

Only rarely in the South does one find the slip-trailed redwares common to eastern Pennsylvania or parts of New England, or the cobalt blue, decorated stoneware of the Northeast and Midwest (the pottery of the Shenandoah Valley of Virginia and of the Moravian settlers of North Carolina were notable exceptions). The southern turner seldom resorted to decorative additions or deliberate embellishment. Cobalt, for example, was generally too expensive for the farmer-potters of the southern states. In the South, form truly follows function.

The aesthetic attraction of traditional southern pottery results from its harmonious form, subtle glazing, and unpretentious nature rather than from any surface elaboration or decoration. Just as important to its appeal is the maker's personal involvement in all stages of the production, from digging the clay to selling the pot. And since the production methods are not regularized by factory efficiency, the element of accident in just what happens in the kiln when the pot is fired is often a factor in producing results that can be pure serendipity.

The subtle virtues of southern folk ceramics achieved outside appreciation slowly. One of the first signs of "outsider" attention came from Jacques and Julianna Busbee, who were so delighted with the simplicity of a common North Carolina "dirt dish" that they founded the Jugtown Pottery in 1921.[13] This and other efforts to keep the old potteries viable were successful,

Spargo, *Early American Pottery and China* (Rutland, Vt.: Charles E. Tuttle, 1974); John Ramsay, *American Potters and Pottery* (1939; repr., Ann Arbor, Mich.: Ars Ceramica, 1976); William C. Ketchum Jr., *The Pottery and Porcelain Collector's Handbook: A Guide to Early American Ceramics from Maine to California* (New York: Funk & Wagnalls, 1971); and Harold F. Guilland, *Early American Folk Pottery* (Philadelphia: Chilton Books, 1971).

13. One must exercise caution in accepting the Busbees' version of the resurgence of the potteries of central North Carolina. As astute business people, this couple cultivated a mystique surrounding their Jugtown Pottery, turning out for the public not only exceedingly handsome vessels but also charming stories to enhance the folkloric value of

but little primary research was done on the actual history of the potters and potteries of the South.

In 1939, ceramic historian John Ramsay complained that "in light of our present knowledge, it is possible to write the history of the [ceramic] industry of the South only in very general terms." He added that "historical details are difficult to obtain and are then not too reliable." Ramsay saw several reasons for this unfortunate state of affairs:

> Since industries of the South played a negligible part in its development, Southern historians have confined their attentions to past glories, political, military, and social, and few of those studies of local industries so valuable to a compilation . . . have been made. Further, in the aristocratic, almost

their wares. According to Julianna Busbee in "Jugtown Pottery: New Ways for Old Jugs," *Bulletin of the American Ceramic Society* 16, no. 10 (1937): 415:

> About 1915 Jacques Busbee of Raleigh came upon a bright orange pie plate. The color was so arresting—the form so crude and peasant like—that he was tremendously thrilled. It was that empty pie plate that we set sail in on an adventurous journey. And it has taken us for a long ride, bumpy sometimes, but always interesting. . . . For Jacques Busbee believed that an injection of art into the country potter would bring a new and interesting industry to the State, make our future highways colorful, and would develop a new angle from the age-old one.

Such a romantic tale is reminiscent of an earlier account of the origins of the craft industries of the southern highlands. This story also involved the intervention of a discerning outsider, in this case northerner Frances Goodrich, who came down to Appalachia in 1890 "to nurture the poor." See Jan Davidson, *Coverlets: New Threads in Old Patterns,* exhibition brochure, Smithsonian Institution Traveling Exhibition Service and the Mountain Heritage Center, Western Carolina University (Washington, D.C.: Smithsonian Institution, 1988), 1. In this forerunner of the Jugtown legend,

> Goodrich believed that the women especially needed a group project, to help shore up the community. Then one day in 1895, an inspiration appeared. Mrs. Davis, a neighbor, gave Goodrich a gift: a brown and cream-colored coverlet, a relic of the pioneer days in the North Carolina mountains. It was a momentous occasion. . . . "Here," she said to herself, "was a fine old craft dying out and desirable to revive."

In both the Busbee and the Goodrich tales, an exaggerated emphasis is placed upon the perceptive vision of a "foreign" benefactor. Yet despite the romantic coloring of the truth, there is something to these stories; the public was able to buy not only pots and quilts but also delightful legends, and that was good for business and helped revive fading southern folk crafts at just the right moment.

feudal, civilization of the South, the potters were individuals of slight importance, so that local historians give them scant attention.[14]

Little had been done to clarify this situation when, three decades later, a historical guide to American stoneware still was claiming that in "the Southeast no great number of stoneware makers ever operated."[15] At the time that line was written, its author had little accessible evidence to the contrary. Southern traditional pottery continued to remain, to all but a few within the region, a largely unknown aspect of American folk culture.[16]

The general paucity of research into the story of southern pottery is attested to by the fact that of the 158 pages of articles on American pottery that were featured in the prominent national periodical *Magazine Antiques* between 1922 and 1974 and selected for publication in monograph form in 1977, only 10 are devoted to the southern states.[17] Fortunately, by the beginning of the 1970s, efforts were underway to rectify this sin of omission and to document the history of the hundreds of country potters who had operated shops in the region. Throughout the South, a number of historians, anthropologists, folklorists, and pottery enthusiasts became active in researching and writing the story of southern pottery.[18] The results of these investigations have been reported in a variety of published studies and have been

14. Ramsay, *American Potters and Pottery,* 81–82.

15. Donald Webster, *Decorated Stoneware Pottery of North America* (Rutland, Vt.: Charles E. Tuttle, 1971), 22.

16. This despite the success of Jugtown, the pottery items brought home by northern tourists, and the quantities of clay products from the South being distributed, from the 1930s on, in such northern outlets as Macy's.

17. Diana Stradling and J. Garrison, eds., *The Art of the Potter: Redware and Stoneware* (New York: Main Street / Universe Books, 1977).

18. This was accomplished through such books as Georgeanna H. Greer, *American Stonewares: The Art and Craft of Utilitarian Potters* (Exton, Pa.: Schiffer Books, 1981). For some additional works treating the ceramic traditions of the southern region, see note 20, p. 13.

The late Georgeanna Greer possessed an encyclopedic knowledge of southern ceramics. Most of the major pottery-producing states in the region have had their individual historians who have been active in researching and publicizing their state's potting history. Charles G. "Terry" Zug III, John Bivens, Stuart Schwartz, Leonidas Betts, and Daisy Wade Bridges led the way in North Carolina; Carlee McClendon, Stephen and Terry Ferrell, Fred Holcombe, and George Terry in South Carolina; John Burrison and Ralph Rinzler in Georgia; John Willett and Joey Brackner in Alabama; and Samuel D. Smith and Stephen T. Rogers in Tennessee.

given ever more frequent public display in museum exhibitions throughout the region.

The bulk of this regionally focused research was directed, initially, at clarifying the development of pottery making in the South during the nineteenth and early twentieth centuries, its golden era. But the study of traditional pottery making in the South had no need of being limited to historical research, as it had to be elsewhere in the country. Back in 1939, John Ramsay, while lamenting the dearth of information available to him about southern potters, had pointed out that

> the Southern potters have been isolated for generations from the current of improvements of modern manufacture and technique. One result of this is that the production of handmade utilitarian is still a living industry in the South, with scores of small plants operating, where at most three or four northern potters of the old school survive.[19]

Since Ramsay's day, the remaining old-time potteries in the North and Midwest had disappeared, and by the early 1980s, the active southern potteries were also in a numerical decline. Considering the competition and societal pressures, the amazing thing, however, was that several of the southern pot shops were still open and that some of them were even thriving. The existence of some of these potteries was no longer threatened, as it once had been, by a lack of customers. Beginning in the 1970s, a surge of interest in this all-but-vanished folk art assured many of the potters—those who had been willing to compromise somewhat with the traditional ways of doing things—of a ready market among a rapidly expanding group of collectors who had replaced the kraut-preserving, butter-churning farmwives of an earlier era.

Those potters, who now were turning out smaller and more colorful items or who produced ware reminiscent of the historical tradition but suited to new decorator functions, were beginning to find a ready market with the urban consumer who savored pottery-collecting expeditions into the countryside as a way of returning to the roots of the American experience. Certainly, the country's bicentennial had an impact. Already, by 1981, crowd control was becoming a consideration when kilns were being opened at potteries in North Carolina, Georgia, and Kentucky.

However, since these potteries were primarily one-person or family operations with histories going back, in some cases, eight to ten generations, their

19. Ramsay, *American Potters and Pottery,* 81.

authenticity and continued survival was dependent upon some new member of the family accepting the hard life of the potter and assuming his or her place at the wheel. By the end of the 1970s, although some of the better-situated and more customer-conscious potteries were beginning to prosper, the fate of a number of other southern potteries was in doubt (particularly those in the Deep South), making their immediate study, documentation, and recognition by the public all the more urgent.

It should be noted that, by the early 1980s, many of the functioning potteries that remained in the South did not easily correspond to what some folklorists or pottery purists might wish to classify as authentically "folk." This is because the potters had adapted to changing conditions and a very different clientele from the one their fathers and grandfathers had served; yet they still were, in my opinion, very much a part of a cultural continuum —but an evolving, and even mutating, one. These turners had taken their places among the last true survivors of a very rich pottery heritage.

I had art on my mind as well as the pottery.

—D. X. Gordy, June 8, 1981

The State of the States in 1981

The following state-by-state survey of several of the potteries active in 1981 is illustrative of the way in which traditionally produced ware continued to be turned out in the approximately forty pot shops then in operation in the South and by the some seventy turners working in them.[20] These recollections are based upon the research I carried out at the time and are intended to serve as a partial introduction to the character, variety, and vitality of the old-time potter's craft in the context of a modern South as well as to provide a setting in which the excerpts from the recordings might be better appreciated.

20. Most of the research on the contemporary as well as the historical potteries of the South has been done on a state-by-state or area-by-area basis. For a more general overview, see Charles Counts, *Common Clay* (1971; rev. ed., Indiana, Pa.: A. G. Halldin, 1977); Mack, "Traditional Pottery," 176–83; Nancy Sweezy, *Raised in Clay: The Southern Pottery Tradition* (Washington, D.C.: Smithsonian Institution Press, 1984); and John Burrison et al., "Southern Folk Pottery," in *Foxfire 8,* ed. Eliot Wigginton and Margie Bennett (Garden City, N.Y.: Anchor Press / Doubleday, 1984), 71–384.

South Carolina

In the summer of 1981, the state from which I had set out served as a worst-case example for active potteries. The last traditional potter who had worked in South Carolina had died fourteen months earlier; his shop had quickly fallen into ruin and his kiln already was nearing collapse (within five years, all physical trace of its existence would have vanished). Fifth-generation potter Otto Brown had come to South Carolina from Georgia via North Carolina, where other members of his family continued to operate two potteries south of Asheville.[21] Made aware of the good local potting clays, he opened a shop just north of Bethune, South Carolina, in 1962. He died there in 1980, at age seventy-nine; his son Jimmy, a potter and a preacher who had worked with him at Bethune, had died four years earlier. Jimmy Brown's daughter Annette and her husband, Leroy Stephens, who were operating a retail garden ceramic shop and sold the Lynches River clay once turned by Annette's father and grandfather, talked about setting up a wheel and kiln in Bethune, but the continuation of traditional pottery making in South Carolina was in doubt.

The apparent demise of traditional pottery in South Carolina certainly was not only unfortunate but also rather ironic, for the state once was home to several bustling potting communities, and it was in South Carolina that a whole new type of glaze had been developed. Sometime early in the second decade of the nineteenth century, alkaline glazes made their first documented American appearance in the Edgefield district of southwestern South Carolina.[22] From Edgefield, the technique of using wood ash, lime,

21. On Otto and Jimmy Brown, see Courtney Carson, "Seven Generations of Pottery," *Sandlapper* 1, no. 8 (1968): 18–20, and Arthur Porter McLaurin and Harvey Stuart Teal, *"Just Mud": Kershaw County, South Carolina, Pottery to 1980* (Camden, S.C.: Kershaw County Historical Society, 2002), 59–63.

22. The alkaline-glazed pottery of Edgefield received its first extensive review in Georgeanna Greer, "Preliminary Information on the Use of Alkaline Glaze for Stoneware in the South, 1800–1970," *Conference on Historic Site Archaeology Papers* 5, no. 2 (1971): 154–70, and Stephen T. Ferrell and T. M. Ferrell, *Early Decorated Stoneware of the Edgefield District, South Carolina,* exhibition catalog (Greenville, S.C.: Greenville County Museum of Art, 1976). These studies have been joined by Georgeanna Greer, "Alkaline Glazes and Groundhog Kilns: Southern Pottery Traditions," *Magazine Antiques* 149, no. 4 (1977): 768–73; Joe Holcombe and Fred Holcombe, "South Carolina Potters and Their Wares: The Landrums of Pottersville," *South Carolina Antiquities* 18, nos. 1 and 2 (1986): 47–62; Cinda K. Baldwin, *Great and Noble Jar: Traditional Stoneware of South Carolina* (Athens: University of Georgia Press, 1993); and Jill Beute Koverman,

cinder, and glass glazes on stoneware spread across the South to eventually dominate much of the pottery production from southwestern Virginia to Texas during the pre–Civil War years.[23]

North Carolina

Alkaline glazing was particularly well received in the Catawba Valley of North Carolina, northwest of Charlotte and just south of Hickory.[24] In this potting enclave, the alkaline process was used almost exclusively. Here, dozens of little pottery operations once turned out basic utilitarian items to satisfy local needs. By 1981, their number had been reduced to two. Burlon B. Craig and Boyd S. Hilton were the only two potters then turning traditional ware in the Catawba Valley.

ed., *"I Made This Jar": The Life and Works of the Enslaved African-American Potter, Dave,* exhibition catalog (Columbia: McKissick Museum, University of South Carolina, 1998).

It is generally assumed that the use of alkaline glazes is restricted to the American South and to Asia, where it is represented in the celadon glazes of China and Korea. Scholarly opinion is united in seeing a connection between the two traditions. That connection is, supposedly, to be found in the published letters of an early-eighteenth-century French traveler who described the Chinese technique. The East-West connection is reviewed in Daisy Wade Bridges, "Ash Glaze Traditions in Ancient China and the American South," *Journal of Studies of the Ceramic Circle of Charlotte and the Southern Folk Pottery Collectors Society* 6 (1997). It is theorized that these reports may have come to the attention of the erudite Abner Landrum of Edgefield, who put into practice at his pottery what he had been reading. I am somewhat skeptical of this lineage and prefer to see the use of alkaline glazes in the South as an independent innovation born of necessity. In the South, where salt was often too expensive a commodity to toss into a kiln, it would have been only natural for farmer-potters to have looked about for a substitute and to have begun experimenting with ingredients at hand—wood ashes, lime, cinders, and the like. It should be pointed out that alkaline glazing is not so geographically restricted as reported. In eastern Germany during the nineteenth century, wood-ash glazing was in some limited use. On this, see Rudolf Weinhold, *Töpferwerk in der Oberlausitz: Beiträge zur Geschichte des Oberlausitzer Töpferhandwerks* (Berlin: Akademie-Verlag, 1958), 110.

23. See Catherine Wilson Horne, ed., *Crossroads of Clay: The Southern Alkaline-Glazed Stoneware Tradition,* exhibition catalog (Columbia: McKissick Museum, University of South Carolina, 1990), and Bridges, "Ash Glaze Traditions."

24. On the Catawba Valley tradition, see Daisy Wade Bridges, ed., *Potters of the Catawba Valley, North Carolina,* exhibition catalog, *Journal of Studies of the Ceramic Circle of Charlotte* 4 (Charlotte, N.C.: Mint Museum of History, 1980), to which can now be added Huffman and Huffman, *Innovations in Clay,* and the exhibition catalog *Two Centuries of Potters: A Catawba Valley Tradition* (Lincoln, N.C.: Lincoln County Historical Association and Lincoln County Museum of History, 1999).

Burlon Craig's shop was one of the most traditional in the South.[25] Burl was descended from Scottish ancestors who, together with German immigrants, settled the region in the eighteenth century. He began his potting career as a child in the 1920s by chopping wood to fuel a local potter's kiln. Burl learned to turn at the wheel and later went on to work for several other neighborhood potters. Shortly after World War II, he took over an old kiln and set up a pottery of his own. In the early 1980s, he still was digging his own clay, pulverizing it in his pug mill, mixing his special combinations of ash and glass slip glazes, turning his pots and specialty items on a foot-powered treadle wheel, and burning his ware in an old-fashioned wood-fired, cross-draft groundhog kiln.

Up until a few years earlier, Craig had turned out straight utilitarian items, but following the advice of interested collectors, he had added a line of popular novelty items: face jugs, snake jugs, and the two-bodied swirl-ware that was a distinctive genre of the Catawba Valley potters in the 1920s and 1930s. Craig had trained Boyd S. Hilton, the other traditional potter at work in the area in 1981. Hilton was part of a celebrated potting dynasty at work in the first half of the twentieth century, but he had spent most of his life in other pursuits before retiring to his family's farm and rediscovering the Hilton family's traditional occupation. With Craig as his mentor, Hilton quickly became a meticulous turner, devoted to experimentation and perfection. The pottery he turned out (including superlative two-bodied swirl-ware) in his backyard pot shop was a worthy continuation of the Hilton family tradition. In actuality, Boyd S. was a sophisticated "hobby" potter, turning a limited production for his own satisfaction and in recognition of his heritage. He had no commercial interest in mind. But he hoped his son, Boyd R. Hilton, who was living near Winston-Salem and had begun to do some turning, would keep the family practice alive.

Over the years, an estimated six hundred potters have been at work in North Carolina; in 1981, fewer than twenty traditional potteries were still in operation.[26] In the western part of the state, in addition to the two shops in

25. Burlon Craig was given a specific focus in Leonidas Betts and Charles G. Zug III, *Burlon Craig: An Open Window into the Past,* exhibition catalog (Raleigh: Visual Arts Center, North Carolina State University, 1994). An interview with Burlon Craig and his wife, Irene, appears in Wigginton and Bennett, *Foxfire 8,* 209–55.

26. Those publications that treat the pottery traditions of North Carolina in their entirety include Meredith Riggs Spangler, "In Prayse of Pots," *Journal of Studies of the*

the Catawba Valley and a recently closed shop run by Kenneth Outen in the town of Matthews, southeast of Charlotte, there were three potteries situated in the Appalachian foothills near Asheville. Two of these businesses were run by members of the Brown family of Georgia—a shop at Arden established in 1923 by Otto Brown's brothers, Davis and Javan, and operated by Davis's grandsons, Charles and Robert Brown, and one at nearby Skyland owned by Evan Brown, with whom his father Javan (Otto Brown's brother) had worked until his death in 1980.[27] The other Asheville-area establishment was founded in the early 1920s by the art-craft potter Walter B. Stephen.[28] Stephen had come to North Carolina in 1913 from Iowa and Nebraska by way of Tennessee. His Pisgah Forest Pottery, since Stephen's death in 1961, was in the capable hands of his step-grandson, Tom Case, and his former assistant, Grady Ledbetter.

The most famous and active pottery-producing area of North Carolina lies in the eastern Piedmont region of Moore, Randolph, and Lee Counties, generally known as the Seagrove district after the largest town in the area.[29]

Ceramic Circle of Charlotte 2 (1973): 5–26; Ed Gilreath and Bob Conway, *Traditional Pottery in North Carolina: A Pictorial Publication* (Waynesville, N.C.: Mountaineer, 1974); Charles G. Zug III, *The Traditional Pottery of North Carolina,* exhibition catalog (Chapel Hill, N.C.: Ackland Art Museum, 1981); Charles G. Zug III, *Turners and Burners: The Folk Potters of North Carolina* (Chapel Hill: University of North Carolina Press, 1986); and Charlotte Vestal Brown and Leonidas J. Betts, *Vernacular Pottery of North Carolina: 1982–1986, from the Collection of Leonidas J. Betts,* exhibition catalog (Raleigh: University Center Gallery, North Carolina State University, 1987). For a guide to contemporary potters working in North Carolina, including some of those more "studio" inclined, see Johnna M. Ritchie and T. Dale Ritchie, *Guide to North Carolina Potters* (Concord, N.C.: Watermark Publications, 1996).

27. See Rodney Leftwich, Tom Patterson, and John Perreault, *From Mountain Clay: The Folk Pottery Traditions of Buncombe County, NC,* exhibition catalog (Cullowhee: Belk Art Gallery, Western Carolina University, 1989). An interview with Louis and Charlie Brown appears in Wigginton and Bennett, *Foxfire 8,* 345–84.

28. Daisy Wade Bridges and Kathryn Preyer, eds., *The Pottery of Walter Stephen,* exhibition catalog, *Journal of Studies of the Ceramic Circle of Charlotte* 3 (Charlotte, N.C.: Mint Museum of History, 1978).

29. On the potteries of the Piedmont, including those of the Seagrove area, see Nancy Sweezy, "Tradition in Clay: Piedmont Pottery," *Historic Preservation,* October/November 1975, 20–23; Stuart C. Schwartz, "Traditional Pottery Making in the Piedmont," *Tarheel Junior Historian* 17, no. 2 (1978): 22–29; and a series of brochures produced annually since 1982 in conjunction with the Seagrove Pottery Festival and containing essays on the various historic and contemporary potters of the area.

Although the well-researched potteries of this part of central North Carolina were deliberately omitted from the interviews I recorded in 1981, a brief word about them is necessary to complete the North Carolina ceramic picture. Here, centered around the Seagrove community, happily situated not too distant from major population and tourist centers, eight potteries were making a go of it in the early 1980s. Two additional potteries of Seagrove-area origin also were producing ware in the town of Sanford, some thirty-five miles to the east. Originally, the potters of this locale, of English and Welsh ancestry, had turned out lead-glazed earthenware, locally called "dirt dishes." Early in the nineteenth century, when the inherent dangers of low-fired lead glazing were made known, this type of pottery went out of favor and largely was replaced by undecorated salt-glazed stoneware. The potters, who also spent much of their time behind their plows, did well, and there were a lot of them turning out crocks, jugs, jars, churns, pitchers, and other functional items needed by their neighbors. In the days following the Civil War, there was little money for the fancier store-bought, factory-produced items that were beginning to put the country potter out of business elsewhere in the nation.

By the 1920s, however, the demand for the basic stock and trade pottery of the Seagrove-area potters had begun to wain, so much so that most of the old family shops were forced to close. Those who managed to hold on tried to attract a new clientele by reintroducing earthenware pottery, which they produced using the brightly colored, safer commercial glazes then becoming available.

Instrumental in the effort to preserve the potting traditions of central North Carolina were two couples who moved into the area, attracted by its rural character and history. With the help of several local potters (chief among them, the legendary Ben Owen), the celebrated Jugtown Pottery was founded in 1921 by Jacques and Juliana Busbee, whose contribution to recognizing the worth of the southern tradition has been noted earlier.[30] Their effort, together with that of Henry and Rebecca Cooper at North State Pottery outside of nearby Sanford, brought Piedmont pottery to the attention

30. On Jugtown, see Jean Crawford, *Jugtown Pottery: History and Design* (Winston-Salem, N.C.: John F. Blair, 1964); Gay Mahaffy Hertzman, *Jugtown Pottery: The Busbee Vision,* exhibition catalog (Raleigh: North Carolina Museum of Art, 1984); and Douglas DeNatale, Jane Przybysz, and Jill R. Severn, eds., *New Ways for Old Jugs: Tradition and Innovation at the Jugtown Pottery,* exhibition catalog (Columbia: McKissick Museum, University of South Carolina, 1994).

of northern buyers in the late 1920s and 1930s and probably helped to assure the existence and resurgence of the remaining local potteries.[31]

Jugtown still flourished sixty years after its founding, its management in the hands of local potter Vernon Owens and transplanted northerner Nancy Sweezy, but the pottery life of the area was dominated in the early 1980s by such regional names, connected for generations with the pottery trade, as Craven, Owen, Teague, Auman, Chrisco, Owens, Albright, and Cole. Four of the shops in existence in the early 1980s were run by various branches of the Cole family, which had arrived in the area in the eighteenth century from the Staffordshire pottery district of England.[32]

Kentucky

Brightness of color and a bit less variety in form also typified the stoneware of Kentucky's last potting family, the Cornelisons, whose Bybee Pottery lay south of Lexington in the crossroad hamlet of Waco.[33] The core of the picturesque timber shop dates back to the 1840s, when it was built by the present owner's great-great-grandfather. As the oldest functioning pottery shop in the United States, the Bybee Pottery was placed on the National Register of Historic Places in 1978. It also is the only old-time pottery in Kentucky, from what must have been many, to have survived. That pot shops once thrived during the nineteenth and into the twentieth century in such locales as Paducah, Richmond, Louisville, Lexington, Bell City, and elsewhere in the state is documented. From what is known and can be stylistically determined, it would seem that the ceramic production in this border state was strongly under the influence of the neighboring states of Ohio, Indiana, West Virginia, and more distant Pennsylvania as well of its neighbors to the south. Clear traces of this mixed heritage can be seen today in the ware produced at Bybee.

31. The contributions of the Coopers are considered in Stuart C. Schwartz, *The North State Pottery, Sanford, North Carolina* (Charlotte, N.C.: Mint Museum of History, 1977).

32. On the various members of the Cole family, see Auman and Zug, "Nine Generations of Potters," 166–74.

33. For the Bybee Pottery and the Cornelisons, see Counts, *Common Clay,* 1977, 88–97. The Kentucky tradition was explored in a symposium held in March 1997 at the Hopewell Museum in Paris, Kentucky, and given visual form in an exhibition dedicated to the old potteries of Waco presented that same year at the Southern Folk Pottery Collector's Society in Robbins, North Carolina. See the society's *Newsletter* 13 (Winter 1997): 2–3.

Walter Lee Cornelison was conscious in 1981 of his lineage and of the historical importance of maintaining the family's traditions. Although the Bybee Pottery does produce slip-cast and jigger-turned ware, Cornelison himself was actively turning on the wheel, exercising a quite literal "pride of place." Most of the ware he turned was utilitarian in nature, inspired by the traditional shapes produced by his ancestors. An earlier generation at Bybee turned swirlware similar in appearance to that of the Catawba Valley potters of North Carolina, but the modern production was best recognized by its "Bybee blue" glaze and by its use of sponging, an application procedure not found in any general use elsewhere in the South and of certain northern influence.

Georgia

Georgia once rivaled North Carolina in the number of potters who worked in the state (over four hundred).[34] As an immediate heir to the pottery-making traditions of Edgefield, South Carolina, alkaline glazes formed an important part of the Georgia repertoire, rivaled, in the years following the Civil War, by an increasing use of Albany slip and some limited use of salt glazing. The South Carolina potters were joined in Georgia by transplants arriving from North Carolina. Although Georgia inherited many a potter, it was also the birthplace of one of the most active potting clans in the South: the Brown family, whose various members have ranged over almost every state in the region. Although the Browns no longer were active in Georgia, Horace V. Brown Jr. had a clear memory of what the family's work was like. He had assisted his father, "Jug" Brown, until he left his family to begin his life and career anew in the pottery districts of Mississippi and Alabama. Forty-five years later, Horace Jr. not only kept his memories of potting days alive but also conserved his father's treadle wheel behind his house in Acworth, Georgia.

Georgia pottery production was concentrated where the best clays were to be found, from middle Georgia northward into the foothills of the Appalachians. In 1981, thirteen of the old potteries still survived, although several of them had been forced to restrict their output to unglazed horticultural or patio ware. This latter category included the firm of F. W. Franklin in Marietta, whose kilns now stood idle as imported flower pots were unloaded to stock what had become a garden supply outlet. In 1981, the

34. For a general survey of the potting tradition of Georgia, see Burrison, *Brothers in Clay*.

predominately horticultural firms also included the Merritt family's Middle Georgia Pottery near Lizella, the Wilson Pottery near Lula, and the Craven Pottery, Ferguson Pottery, and Hewell's Pottery at Gillsville.[35]

Of the producers of largely unglazed garden wares, the most impressive in operational size was the Craven Pottery factory, established in 1971. Its owner, Billy Joe Craven, who was descended from the Cravens of North Carolina (reputedly the oldest potting family in the South), oversaw the most modern handmade pottery business in the region as well as a fleet of trucks that brought his products into garden supply stores throughout the Southeast. Craven's neighbors, the Hewells, had concentrated for a number of years on similar garden furnishings but already had recognized the interest of collectors of folk pottery and were beginning to revive their family's production of glazed pottery in traditional form.

Apart from the modern garden-ware potteries, Georgia's tradition has been one of stoneware. Northeastern Georgia was a pocket of pottery production centered around the mountain town of Cleveland (in 1981 also celebrated as the home of the popular "Cabbage Patch" dolls) and the adjoining Mossy Creek area of White County. Here, several members of the Meaders family, Georgia's best known potting dynasty, were at work.[36] The family actually was a newcomer to the field, not starting up until 1893. Their utilitarian forms were covered in an alkaline-ash glaze they termed "Shanghai" (a term possibly suggesting the glaze's purported Chinese origin?) or in variations of Albany slip. Lanier Meaders (then fast establishing a reputation akin to that of North Carolina's Burlon Craig) operated his father's shop in the rolling North Georgia hills of White County just outside of Cleveland. His father, Cheever, had died in 1967, but Lanier continued to produce the

35. Interviews with various members of the Hewell and Wilson families are given in Wigginton and Bennett, *Foxfire 8*, 287–344.

36. On the Meaders dynasty, see John Burrison, *The Meaders Family of Mossy Creek: Eighty Years of North Georgia Folk Pottery* (Atlanta: Georgia State University, 1976); Joan Falconer Byrd, "Lanier Meaders: Georgia Folk Potter," *Ceramics Monthly* 24, no. 8 (1976): 24–29; John Coyne, "A Dynasty of Folk Potters: The Meaderses of Mossy Creek," *Americana* 8, no. 1 (1980): 40–45; Ralph Rinzler, "Cheever Meaders, North Georgia Potter (1887–1967)," in *Forms Upon the Frontier: Folklife and Folk Arts in the U.S.*, ed. Austin Fife, Alta Fife, and Henry Glassie (Logan: Utah State University Press, 1969), 76–78; Rinzler and Sayers, *Meaders Family;* and Sayers, "Potters in a Changing South," 94–97. Interviews with Meaders family members appear in Wigginton and Bennett, *Foxfire 8*, 81–208.

drippy green alkaline glazes his family and their neighbors always had favored. To the utilitarian line of his father, Lanier had added the popular face jug, now sold largely to city-dwelling collectors of folk art. His mother, Arie, used to make clay roosters and grapevine-decorated jars, but ill health and advancing years had forced her to stop turning. Her artistic urges were satisfied currently by making delightful appliqué-decorated pillow shams. This decorative side of the family's taste recently had been picked up by Lanier's younger brother, Edwin "Nub" Meaders, who had left a packing house job to return to making pottery at his own backyard shop. Both of the brothers preferred the old methods of turning pottery, including treadle wheels and a wood-fired, cross-draft tunnel kiln.

Their cousin, Cleater James "C. J." Meaders, was a bit more modern and experimental in his approaches. Cleater had been taught to turn in his family's workshop in Mossy Creek but had left for a career in the civil service. When he retired near Macon, Georgia, a few years prior to my visit, Cleater set up a little pottery shop behind his house, reminiscent of that of Boyd S. Hilton in North Carolina's Catawba Valley. Cleater turned his clay on a treadle wheel but fired his ware, of necessity, in an electric studio kiln. He often carried his greenware to Cleveland to fire in Lanier's wood-burning kiln and was toying with the idea of building one of his own on family property there. His ware was glazed using recipes based upon the Albany slip combinations used along with alkaline glazes by the older generations of Meaders family potters.

Others, such as brothers D. X. and Bill Gordy, had long before abandoned their father's line of utilitarian jugs and churns in favor of more decorative items designed to appeal to the tastes of a gentrified clientele. Bill Gordy had worked as a journeyman turner throughout much of the South, particularly in North Carolina, before settling into a successful business at his Georgia Art Pottery in Cartersville, Georgia. Clearly, his new line of more decorative ware had been inspired by the successes of the North Carolina potteries in which he had worked as a journeyman turner; his forms and glazes, however, were distinctively of his own invention. His brother, equally determined to venture into new directions, had built a shop near Greenville, Georgia, where he was exploring local mineral deposits for the innovative glazing materials he created to decorate his art-craft porcelaneous stoneware.

In Meansville, a few miles to the east of D. X. Gordy's shop, Marie Rogers, widow of local turner Horace Rogers, one of the last of Georgia's utilitarian folk potters, had recently renewed the family tradition by calling upon the

lessons given her by her husband and family members and had begun to produce small traditional wares, proudly embellished with the old Rogers Pottery stamp.

Alabama

The westward demographic expansion of the South during the early nineteenth century brought a number of potters into Alabama from North and South Carolina and Georgia, as well as down from Tennessee. As one might expect, this migration produced a stylistic blending of ceramic traditions. Some two hundred potters are known to have been at work in Alabama during the nineteenth century, concentrated especially in the east-central (Randolph County), northwest (Lamar and Marion Counties), and Mobile Bay areas.[37] By 1981, only five shops were in existence. In Randolph County, only the occasional activity of D. M. Pound was keeping the last vestige of a great local tradition alive. Among the best known of that area's early potters were members of the Boggs family, long active in Piedmont, North Carolina. Relocated to Prattville, just north of Montgomery, the remaining Boggs Pottery had become a leading producer of simple, unglazed garden ware. Horatio Boggs was proud of his collection of ancestral alkaline glazed churns and, aware of the revival of public interest in "folk" pottery, was encouraging his son, Wayne, to add more traditional wares to their extensive inventory of horticultural ceramics. One of the turners working for the Boggs Pottery in 1981 was Ralph Miller, whose nephew Eric Miller ran a horticultural pottery in Brent (Bibb County), south of Tuscaloosa. Here Eric and his family, including his uncle, Kenneth Miller, continued to make Albany-slip pottery of the sort made by the Millers ever since Abraham Miller arrived in the state from Lancaster, Pennsylvania, sometime during the 1860s.

Albany slip became the great competitor of alkaline glaze during the last part of the nineteenth century throughout the Deep South, and it gradually won out in most places. It was easier to use and more predictable in the firing. The clay for Albany slip was shipped from New York state in barrels in powdered form and was still the most popular glazing material for the few surviving folk potteries in Alabama and Mississippi.

Some of the most typical examples of Albany slip (and the similar Michigan slip) in the early 1980s was coming out of Norman Smith's rustic workshop in Perry County, Alabama, located between Montgomery and

37. See E. Henry Willett and Joey Brackner, *The Traditional Pottery of Alabama,* exhibition catalog (Montgomery, Ala.: Montgomery Museum of Fine Arts, 1983).

Tuscaloosa. Of all of the surviving potters in the South, Smith, at age seventy-seven, was perhaps the most traditional and unspoiled.[38] Isolated, even less "discovered" and certainly less self-conscious than either Burlon Craig or Lanier Meaders, Smith kept doing it as he had been doing it for over sixty years. He had been slowed by age, emphysema, and arthritis but continued to turn out the practical, heavy-walled churns, bowls, cups, and jugs still demanded by his rural neighbors and increasingly desired by the occasional passing motorist and pottery collector.

In the summer of 1981, it was uncertain who would take Smith's place as the principal folk potter of Alabama. One candidate was Jerry Brown of Hamilton, the son of Horace V. "Jug" Brown of the ubiquitous Brown family of Georgia. After Jug Brown had left his family and home state in about 1935, he had worked for Homer Wade Stewart in Mississippi, married his sister, Hattie Mae Stewart, started a second family, and moved to Alabama. After her husband's death in 1965, Hattie produced some pottery herself and then began assisting their son, Jerry, in setting up his own shop. Jerry Brown was about to embark upon his new career, mindful of the heritage passed on to him from both sides of his family and of the awakening interest of collectors of authentic Americana.

Mississippi

Once home to at least a hundred potters, Mississippi could count only three active potteries during the decade prior to the interviews.[39] Many of the state's first potters had moved in with the settlement of the region from the other southern states, and the names of Dorsey, Leopard, Lloyd, Pitchford, Ussery, and Vestal in Mississippi are familiar from potting dynasties working in Georgia, Tennessee, and North and South Carolina. Others came down from the Midwest, and still others had come as emigrants from Britain and Germany. This mix produced certain regional variations, such as the straight-sided pitchers of northern inspiration that had been favored by Joe Duncan (1909–1963), who had operated a shop in Amory (Monroe County).

38. An interview with Norman Smith and his wife, Irene, appears in Wigginton and Bennett, *Foxfire 8*, 256–86.

39. On Mississippi potters, including the Stewart family, see the essay by Georgeanna H. Greer, "The Folk Pottery of Mississippi" in *Made by Hand: Mississippi Folk Art*, ed. Patti Carr Black and Charlotte Capers, exhibition catalog (Jackson: Mississippi Department of Archives and History, 1980), 45–54.

The potters of Mississippi, in their turn, became inspirational for the craft's development in Texas. Although alkaline glaze had its place in Mississippi, the later dates at which most of the state's turners were at work favored the wider use of Albany slip and, then, Bristol glaze. The counties of Itawamba, Winston, Monroe, Lauderdale, and Marshall were particularly prolific in the number of their potteries. In the early 1980s, Louisville in eastern Mississippi was home to two potteries run by members of the Stewart family, and Howard Connor was at work in Ashland, near the Tennessee line above Oxford.

Gerald Stewart of Louisville in Winston County in the eastern part of the state had retired for a time, but the revived interest in folk pottery then underway elsewhere in the region encouraged his return to the wheel shortly before he was interviewed. His nephew, Bill Stewart, living just down the road, was the second youngest of fourteen children and had taken over the family pottery some years earlier. Bill Stewart continued to make the standard items his father and grandfather had turned out: Albany-slip glazed churns, jugs, pitchers, urns, and feeders for chickens, dogs, and rabbits, as well as unglazed stoneware flower pots, planters, and flue liners. Bill Stewart was less optimistic about the future of the turner's trade than his uncle and had stopped production on a regular basis in 1980; he was working in town as a garage mechanic, an occupation he found less satisfying but more dependable. His family hoped that he might be able to return to the pottery full time because he appeared to be the last chance for keeping the production of traditional ware in Mississippi alive. This fact was made clear when the pottery run by Howard Connor was visited. Once a productive turner, Connor had all but abandoned the wheel in favor of running a garden-supply company producing outdoor decorative sculpture cast in concrete. His once-active line of pottery was reduced to unglazed birdhouses, and his large beehive kilns sat virtually unused in front of the store.

The Outlook in 1981

In the summer of 1981, the future of folk pottery in the South appeared as varied as its types and turners. On the negative side, traditional pottery making already had vanished from South Carolina, Florida, and Tennessee (a state that once could boast 350 potters), and its continuation in Mississippi seemed problematic at best. The existence and renewal of the folk pottery traditions elsewhere in the South appeared dependent upon an immediate recognition of the historical and artistic importance of the craft coupled with

financial support from the general public. Both of these factors needed to be sufficiently present to entice a future generation of turners into taking their places at the wheels of their parents.

On the positive side, interest in the history and continuation of this regional tradition was on a rise. The majority of the remaining potteries were receiving increasingly strong support from the buying public; folk pottery was becoming a fashionable assertion of a taste for craftsmanship and a statement of post-bicentennial patriotism. Folklorists and historians of material culture also were paying more deference to the southern folk potter, some of whom were being officially honored at the state and national levels. Much of this attention was being given under the general umbrella of institutes and public programs established specifically for the purpose of studying and encouraging the material culture of the South. The Center for the Study of Southern Culture, founded by future National Endowment for the Humanities director William Ferris at the University of Mississippi, took a leading role in this endeavor, joined by museums and state agencies throughout the region such as the Mint Museum in Charlotte and the McKissick Museum in Columbia and by individual researchers such as Georgeanna Greer, Joey Brackner, Terry Zug, Daisy Wade Bridges, Brad Rauschenberg, Charles Counts, John Burrison, Stuart Schwartz, Dorothy Cole Auman, George Terry, Leonides Betts, and Frank Willett. Encouraged by Ralph Rinzler of the Smithsonian, the tradition of southern folk pottery also was being accorded appropriate recognition at the national level as well. This notice, expressed through exhibitions, traveling programs, and forthcoming publications such as Nancy Sweezy's *Raised in Clay* and a lengthy essay in *Foxfire 8,* was further enhancing the interest of the buying public in the work of the southern folk potter. Jugtown and the other potteries of Seagrove, North Carolina already had achieved a certain celebrity. It now seemed that the turn had come for the rest.

On balance, then, the making of traditional pottery in the South seemed to have a reasonably optimistic future when I made my foray through the region in the summer of 1981. Certainly, the continuation of the tradition seemed assured in both North Carolina and Georgia. In these two states, it did not appear endangered by any lack of popular interest—far from it. The future for traditional pottery in North Carolina seemed particularly promising, as the interests of folk art collectors and the legendary fame of the Busbees's Jugtown continued to keep demand high for the Seagrove area potters. Interest in alkaline glazing and in the face jugs produced in the Catawba Valley also suggested a bright future there, and continued success

for the three potteries near Asheville appeared certain. The real danger seemed to come from the possibility that the next generation might not accept the tough life of the potter. Reassurance could be found, however, in the frequently expressed declaration of the potters interviewed that "once you try turning, it just gets into your blood and you can't help but come back to it." Overall, in both North Carolina and Georgia, the return to the wheel of such family-connected potters as Boyd S. Hilton and Nub Meaders seemed to reinforce the truth of this declaration. In both states there was an accelerated interest in traditional pottery on the part of the public that would only be encouraged over the next few years by a series of books and exhibitions devoted to its study.

Although only one traditional pottery had survived in Kentucky, it seemed safe to say that its century-and-a-half-long history was in no danger of extinction. The future of pottery making in Mississippi looked doubtful, but in Alabama, even if there were to be no successor to Norman Smith, there still remained two operations to carry on the pottery traditions of that state, and Jerry Brown offered the promise of adding his own proud heritage to the mix. As far as Mississippi was concerned, the jury was still out.

If we could do it, I would want it made the same as my daddy and granddaddy made—to me that was pottery.

—Annette Brown Stephens, June 23, 1981

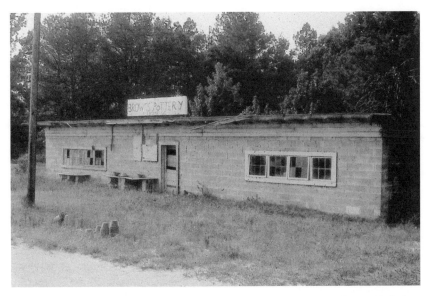

The Otto Brown Pottery (erected in 1962), Bethune, S.C., as it appeared in 1980, before its demolition.

Interior of the Otto Brown Pottery, Bethune, S.C., in 1980, before its demolition. Note the greenware.

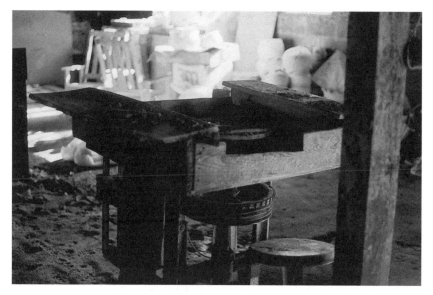

Interior of the Otto Brown Pottery, Bethune, S.C., in 1980, before its demolition. The wheel was used by Jimmy Brown (donated by Frances Brown Thompson and her children to the McKissick Museum in 2001).

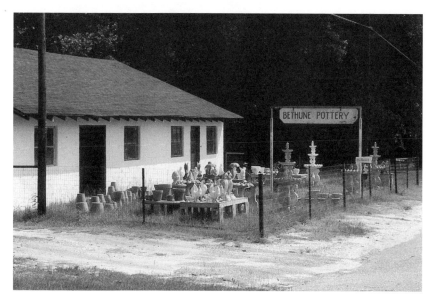

Bethune Pottery building, 1981. It was erected by Oscar Brumbeloe, ca. 1931–32, and owned by Annette Brown Stephens and Leroy Stephens.

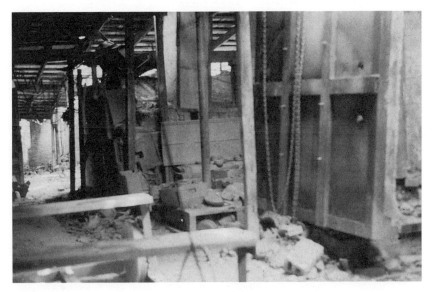

Matthews Pottery with line of Outen family kilns dating from 1927, 1951, and 1961, Matthews, N.C.

Bybee Pottery with original log pottery building of 1840s, Waco, Ky.

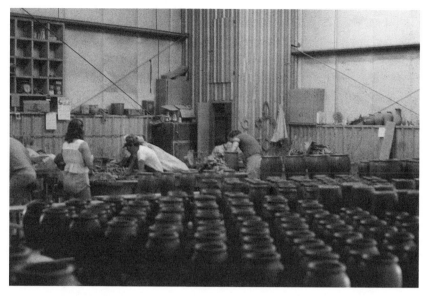

Drying room in the Craven Pottery, Gillsville, Ga.

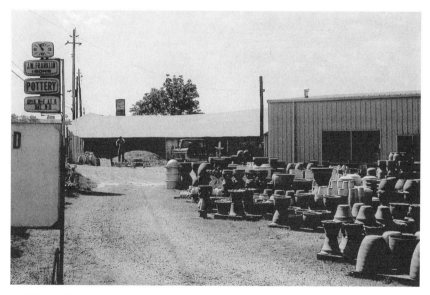

J. W. Franklin and Sons Pottery, Marietta, Ga.

Hewell's Pottery, Gillsville, Ga.

Bill Gordy's Georgia Art Pottery, Cartersville, Ga.

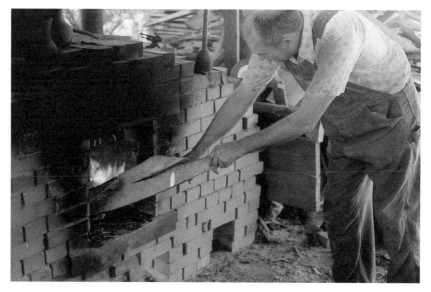

Edwin Meaders Pottery with Edwin Meaders' burning kiln, Cleveland, Ga.

Marie Rogers Pottery with Rufus Rogers's shop in foreground and that of Horace Rogers in rear, Meansville, Ga.

33

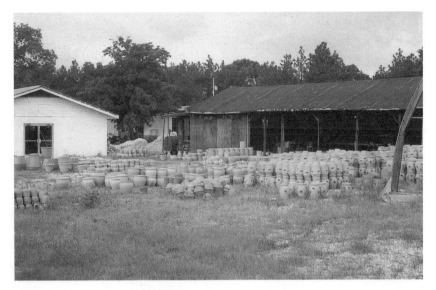

Boggs Pottery, Prattville, Ala.

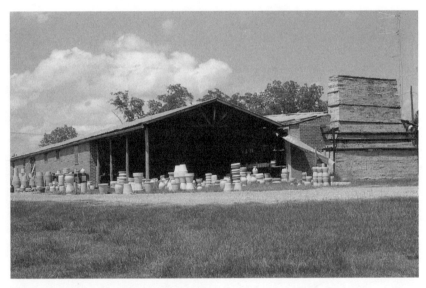

Miller Pottery, Brent, Ala.

Norman Smith Pottery with "mud (pug) mill" for processing clay in foreground, Lawley, Ala.

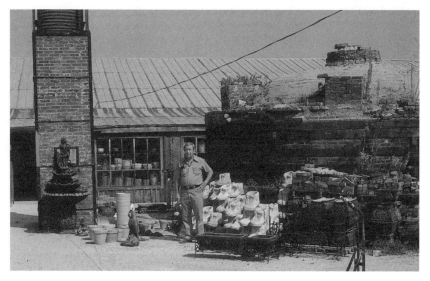

Connor Pottery with abandoned round downdraft kiln and external chimney, Ashland, Miss.

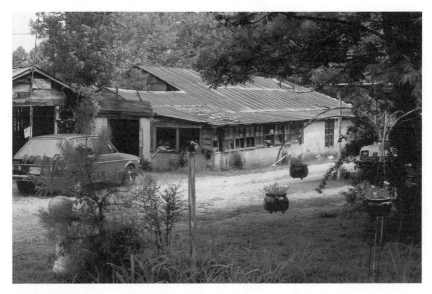

Joseph Duncan Pottery, Amory, Miss.

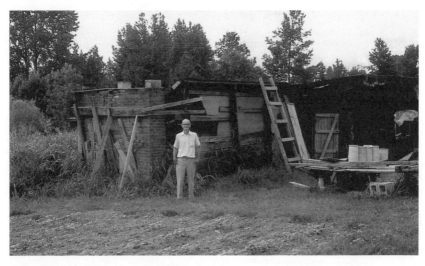

Gerald Stewart Pottery, Louisville, Miss.

BIOGRAPHICAL SKETCHES
OF THOSE INTERVIEWED

South Carolina

Annette Brown Stephens (b. 1959), Bethune, Kershaw County; interview recorded on June 23, 1981. Annette was the granddaughter of James Otto Brown (1899–1980), who operated the Brown Pottery just to the north of Bethune. Following her marriage to Leroy Stephens, Annette and her husband acquired another local pot shop, the Bethune Pottery, which had been operated by a succession of potters since 1931 but no longer produced pottery, marketing local clays to ceramic studios and selling concrete garden ornaments instead.

North Carolina

Boyd Robert Hilton (b. 1949), Walnut Cove, Stokes County; interview recorded on July 11, 1981. The son of Boyd S. Hilton, Boyd R. was inspired to learn the potter's craft through a ceramics course he took and by his awareness of his family's long connection with the pottery tradition. He encouraged his father to turn and assisted him in getting his pot shop set up on the family farm in the Catawba Valley community of Blackburn.

Boyd Shuford Hilton (1916–1985), Blackburn, Catawba County; interview recorded on July 10, 1981. John Wesley Hilton was the patriarch of this extensive Catawba Valley potting family, the most famous member of which was E. A. Hilton, who made the transition from utilitarian to art pottery in the late 1930s. Boyd S. Hilton's father, Curtis (1873–1960), worked at the shop

operated by his brother George and Luther Seth Ritchie, but when that enterprise closed about 1910, he abandoned the potter's life for that of a shop-keeper. His son, Boyd, did not begin turning until after he had retired from a career in the merchant marine and returned to the family farm in Black-burn. There, under the guidance of Enoch Reinhardt and Burlon Craig, the lone potter then at work in the area, he began turning as a hobby. His ini-tial efforts evolved into an occupation of constant experimentation toward perfection. He excelled in the production of glass-glazed swirlware, thus continuing a locally developed tradition.

Kenneth Outen (b. 1934), Matthews Pottery, Matthews, Mecklenburg County; interview recorded on July 9, 1981. The Outens had been in the pottery busi-ness since the 1870s, working in North and South Carolina. Kenneth Outen had inherited the family's pottery in the town of Matthews, east of Char-lotte, from his father, Rufus Frank. When I visited the pottery, it was mori-bund, existing as a gardening center, but Outen proudly displayed a line of old family kilns still standing across the road (all have now vanished).

Kentucky

Walter Lee Cornelison (b. 1929), Bybee Pottery, Waco, Madison County; inter-view recorded in August 1981. Cornelison is a fifth-generation potter, turn-ing wares in what is Kentucky's sole surviving traditional pottery. Although the operation he oversees produces mold and jigger-turned ware, Walter continues to turn at the wheel set up within the old log pot shop of his fam-ily's Bybee Pottery.

Georgia

Horace V. Brown Jr. (1912–?), Acworth, Cobb County; interview recorded on June 15, 1981. Brown worked for both his grandfather Ulysses Adolphus Brown, and his father, Horace "Jug" Brown, at the family pottery in the Buckhead area of Atlanta until the latter left his family and moved west to Alabama and Mississippi about 1935. Never a turner per se, Horace Jr. left the business for careers as varied as milk salesman, railroad worker, store owner, restauranteur, and landscaper.

Billy Joe Craven (b. 1947), Craven Pottery, Gillsville, Hall County; interview recorded on June 17, 1981. A descendent of the legendary Peter Craven, who supposedly began turning pots in Randolph County, North Carolina, about 1760, his branch of the family began working in Georgia when John V. Craven opened a pottery in the Mossy Creek area of White County in 1850. Due to later family connections with the Hewells, it was from them that

Billy Joe learned to turn and to run a pottery business. In 1981, the Craven Pottery was in its tenth year of operation. Clearly a born entrepreneur, Billy Joe Craven had created the largest hand-turned pottery manufactory in the Southeast, delivering its unglazed garden wares to retail outlets throughout the region in a fleet of its own trucks. Less than two decades after the interview was recorded, Craven, Inc., as the firm was known, expanded beyond the manufacture of pottery and was listed as the largest employer in Banks County.

Robert Franklin "Bobby" Ferguson (1933–?), Gillsville, Hall County; interview recorded on June 17, 1981. The son of William Patrick Ferguson (1908–1968) and the great-great grandson of Charles H. Ferguson, who had moved to Georgia from Edgefield, South Carolina, Robert had rejected the potter's life for that of the trucker. Shortly before he was interviewed, however, he had begun hauling ware for the Craven Pottery and, inspired by that association and by his own family's long potting tradition, had set up a shop and tunnel kiln in the back yard of his house, where, assisted by his son, Joseph Daniel, he was turning out small decorative pieces that he marketed through the Craven Pottery.

Lamar Franklin (1914–1992), J. W. Franklin and Sons Pottery, Marietta, Cobb County; interview recorded on June 4, 1981. His grandfather opened the family pottery in Marietta in 1901, and although almost swallowed by Atlanta's urban sprawl, the Franklin Pottery at 899 Franklin Road continued to operate. The old beehive kilns were no longer used as the firm had turned to importing unglazed garden ceramics.

Dorris Xerxes "D. X." Gordy (1913–1994), Primrose Community (Greenville), Meriwether County; interview recorded on June 8, 1981. A son of traditional potter W. T. B. Gordy (1877–1955), D. X. Gordy took over his father's shop but gradually moved away from the standard items of folk pottery, retaining the old methods of production but seeking out new forms and decorative treatments and experimenting with glazes. Of particular interest was his use of painted country scenes to enliven his finely turned ware.

William J. "Bill" Gordy (1910–1993), Georgia Art Pottery, Cartersville, Bartow County; interview recorded on June 15, 1981. Like his younger brother, Bill Gordy began his potting career in the shop of his father but left it to work as a journeyman turner in several of the North Carolina potteries (including the Hilton, Kennedy, and Herman Cole shops) that had begun their transition from the making of utilitarian storage vessels to brightly glazed

items designed to attract the eye of the passing tourist. When Bill returned to his home state to set up his own shop in Cartersville in 1935, he brought with him new ceramic concepts and was the first of the Georgia potters to initiate the changeover from traditional forms and sizes to the newer art pottery styles that appealed to an increasingly urbane clientele.

Ada Adams Hewell (1891–1993), Hewell's Pottery, Gillsville, Banks County; interview recorded on June 17, 1981. The wife of Maryland "Bud" Hewell (1891–1964), Ada married into the pottery business, and although she did not turn herself, she was active in assisting in the business of her husband.

Carl Hewell (1913–2000), Hewell's Pottery, Gillsville, Banks County; interview recorded on June 17, 1981. The elder son of Maryland Hewell, Carl, together with his brothers, took over the family pottery and assisted in its first transformation from a traditional "jug" shop to a producer of hand-turned garden ware.

Chester Hewell (b. 1950), Hewell's Pottery, Gillsville, Banks County; interview recorded on June 17, 1981. The son of Harold Hewell and the fifth generation of his family to turn pottery, Chester Hewell was instrumental in introducing a number of popular items, such as jack-o'-lanterns, into the regular line of garden ware. At the time he was interviewed, inspired by the success enjoyed by Lanier Meaders, he had begun experimenting with the production of traditional stoneware pottery.

Grace Nell Wilson Hewell (b. 1933), Hewell's Pottery, Gillsville, Banks County; interview recorded on June 17, 1981. Herself a member of a potting family, Grace worked alongside her husband, Harold, as one of the few female turners in the region and was instrumental in keeping the Hewell family pottery alive and assuring its continuation by encouraging her son, Chester, and then his sons, Matthew and Nathaniel, to pursue their family's occupation.

Harold Hewell (b. 1926), Hewell's Pottery, Gillsville, Banks County; interview recorded on June 17, 1981. With his brothers, Jack and Carl, Harold operated the Gillsville pottery inherited from his father, Maryland. At the time of the interview, production at Hewell's Pottery was almost entirely limited to hand-turned, unglazed garden ware largely marketed through wholesale distributors.

Henry Hewell (b. 1924), Hewell's Pottery, Gillsville, Banks County; interview recorded on June 17, 1981. Maryland Hewell's second son, Henry, left

the family business for a career in the Marine Corps but, upon his retirement from the service, had returned to Gillsville to once again take his place at the potter's wheel.

Jack Hewell (1914–?), Craven Pottery, Gillsville, Hall County; interview recorded on June 17, 1981. A descendent of the founder of the Hewell potting dynasty, Nathaniel H. Hewell (1832–1887) and son of Maryland Hewell (1891–1964), Jack shared ownership of Hewell's Pottery with his brothers, Carl and Harold. When he was interviewed, however, he was helping Billy Joe Craven with the turning at nearby Craven Pottery.

Matthew Hewell (b. 1972), Hewell's Pottery, Gillsville, Banks County; interview recorded on June 17, 1981. Both Matthew and his younger brother, Nathaniel, were taking their turns at the wheel by the time these interviews were conducted and would follow their father's lead in taking up the revival of traditionally fired and glazed utilitarian ware and the popular face jugs.

Johnny Hudson (1907–?), Historic Westville, Stewart County; interview recorded on June 6, 1981. After he was laid off from a local paper mill, Johnny Hudson came to Historic Westville Village, where he assisted D. X. Gordy in establishing the recreated pottery and in building the groundhog-type kiln adjoining the village's recreated pottery. After Gordy's departure, he remained at Westville, overseeing the firing of the kiln and filling in at the wheel whenever there was a hiatus between professional potters.

Arie Waldroop Meaders (1897–1989), Cleveland, White County; interview recorded on June 16, 1981. Arie Waldroop was born in western North Carolina, but in 1912 she moved with her parents to White County, Georgia, where she married Cheever Meaders two years later. Although she often assisted around the shop, it was not until after her children were grown that she became seriously involved in the production. From about 1957 until her husband's death in 1967, she decorated wares with fanciful plant and animal motifs and turned small items on the wheel. She assisted her son Lanier, who took over the shop, for a year before she retired from potting and turned her attention to making appliqué pillow shams that preserved her whimsical folk patterns.

Cleater James "C. J." Meaders Jr. (1921–2003), Byron, Houston County; interview recorded on June 5, 1981. A grandson of John Milton Meaders, who founded the family pottery in the Mossy Creek district of White County in 1893, and a cousin of Lanier and Edwin Meaders, Cleater was active as a potter in his youth and resumed that career after he retired from the U.S. Civil

Service in 1979. In 1981, he was working at his home in Byron, near Warner Robins in south-central Georgia, where he was experimenting with glazing formulas and either firing the results in small electric kilns or hauling his greenware to burn in Lanier's groundhog in Cleveland.

Edwin Truitt "Nub" Meaders (b. 1921), Cleveland, White County; interview recorded on June 16, 1981. The son of Cheever and Arie Meaders and brother of Lanier, Edwin Meaders only took up turning pottery on a permanent basis after he had retired from other occupations. He built a pot shop and groundhog kiln in 1980 and began turning ware displaying a decorative sensitivity inherited from his mother. He is particularly noted for his ceramic roosters and grape-decorated vessels.

Quillian Lanier Meaders (1917–1998), Cleveland, White County; interview recorded on June 16, 1981. A son of Mossy Creek potter Cheever Meaders, Lanier was active as a turner in his teens, but after military service he worked in other trades. Following his father's death in 1967, he inherited both the pot shop and the interest of the Smithsonian Institution. That, coupled with the ill health that forced him to quit his job, led him into a full-time career at the wheel. His skill and demeanor soon brought him what was equivalent to "national treasure status" and widespread celebrity for his alkaline-glazed face jugs.

Marie Gooden Rogers (b. 1922), Meansville, Upson County; interview recorded on June 7, 1981. Marie Gooden married into a potting family and was given some informal instruction in shop operations and turning by her husband, Horace Rogers. After his death in 1962, Marie decided to keep the family tradition alive and, in 1967, began making small pieces, including face jugs. Her pottery, turned on the old Rogers wheel but fired in a small electric kiln, soon attracted the attention of the Atlanta Historical Society, which began selling her ware at its Tullie Smith House property.

Wayne Wilson (b. 1940), Wilson Pottery, Lula (Alto), Banks County; interview recorded on June 17, 1981. Wayne was the son of Hallie A. Wilson (1911–?), who had been trained in the shop of Maryland Hewell and in that of the nearby Holcomb Pottery. In the 1950s, Hallie set up his own shop at its present location and in 1975 turned its operation over to his sons, Jimmy, Jackie, Ricky, and Wayne. In 1981, like the wares produced by the Hewells and Cravens in nearby Gillsville, the Wilson Pottery's ceramic line was limited to hand-turned horticultural wares.

Alabama

Horatio Manning Boggs (1912–?), Boggs Pottery, Prattsville, Autauga County; interview recorded June 9, 1981. Descended from a branch of a pottery-making family active in Alamance County, North Carolina, that had migrated southwestward in the 1830s, Horatio had been running the Boggs Pottery, located just north of Montgomery, since the end of World War II. Although commercially restricted to the production of garden ware, Horatio and his son, Wayne, had begun experimenting with glazed small wares.

Hattie Mae Stewart Brown (1913–1996), Hamilton, Marion County; interview recorded on June 12, 1981. The daughter of Mississippi potter Homer Wade Stewart, Hattie Mae married journeyman potter Horace "Jug" Brown, who was working in the Stewart's pottery in Louisville, then run by her brothers, Tom and Gerald, and moved with him to Sulligent, Alabama, where they opened a shop in 1940. After her husband suffered a stroke, she and her sons attempted to maintain the pottery. Following Jug Brown's death in 1965, Hattie Mae relocated to Hamilton, where she was encouraging her son Gerald to continue the merged traditions of the Brown and Stewart families.

Hendon Eric Miller Jr. (b. 1950), Miller Pottery, Brent, Bibb County; interview recorded on June 10, 1981. Since the retirement of his father, the family pottery had been managed by fourth-generation potter Eric Miller. This Alabama potting dynasty had been founded by Abraham Miller 1842–c. 1928), who had come to Alabama from the North. Despite conflicting family legends, it would appear that Abraham Miller actually was a Lancaster, Pennsylvania, native who arrived in Alabama shortly after the Civil War and went to work for the French potter Francis LaCoste, who had a shop near Mobile. Miller married LaCoste's daughter and eventually moved north to open a shop of his own in Perry County. The current Miller Pottery was founded by Eric's father in 1964.

Ralph P. Miller (1904–?), Boggs Pottery, Prattville, Autauga County; interview recorded on June 9, 1981. A second cousin of Eric Miller, who runs the Miller Pottery in Brent, Alabama, Ralph had been working as a turner at the Boggs Pottery in Prattville since 1945.

Norman E. Smith (1904–1990), Lawley, Chilton County; interview recorded on June 10, 1981. Mr. Smith began working in the pottery operated by his stepfather in 1920 and opened his own shop in 1932, some four miles distant,

in Lawley. Among the most traditional of southern potters, he wood-fired his tunnel kiln and until 1970 turned on a treadle wheel, only changing to an electric one because of failing health. Assisted by his wife, Irene, he turned functional wares, both unglazed and glazed in Albany and Michigan slip. Formerly, he also produced pottery covered with a Bristol glaze complemented with a light blue glaze made with feldspar, zinc, and cobalt. Some of his smaller pieces appealed to tourists, including miniature churns and a very popular jug-shaped pig casserole.

Oscar L. Smith (1905–?), Lawley, Perry County; interview recorded on June 10, 1981. Oscar Smith had retired due to ill health when this recording was made. He had operated the family pot shop together with his brother, Norman, for several years and then continued to run it after his brother left to build his own place in 1932. Like the ware of his brother, that of Oscar was heavy, serviceable pottery covered in either Albany or Michigan slip.

Mississippi

Howard Connor (1923–?), Ashland, Benton County; interview recorded on October 1, 1981. Howard Connor was born in the Mississippi River town of Wickliffe, Kentucky, the son of Missouri-born journeyman turner and pot shop owner, Charles Tipton Connor (1878–1954). C. T. Connor established a pottery in 1940 at Ashland, Mississippi, less than twenty miles from the Tennessee border. At one time, the Connor Pottery was an extensive operation producing both hand- and jigger-turned wares and employing about thirty workers. After a devastating fire in 1967, Connor gave up pottery production in favor of wholesaling the wares of others and the casting of concrete garden items.

Verna Suggs Duncan (1909–?), Amory, Monroe County; interview recorded on June 12, 1981. Verna assisted her father, William D. Suggs (1878–1945), at his pottery in Smithville (Itawamba County) in eastern Mississippi. After her marriage to Joseph Duncan (1909–1963), her husband learned to turn and also worked in the Suggs pot shop. Following the death of W. D. Suggs, the couple opened their own pottery in nearby Amory in 1949. After Joe Duncan's death, the Amory shop ceased producing its own ware but continued to function as a pottery outlet.

Carrie (Mrs. Winifred W.) Stewart (1911–?), Louisville, Winston County; interview recorded on June 11, 1981. Carrie Stewart came into the pottery business with her marriage in 1930 to Winfred W. Stewart, the son of potter Homer Wade Stewart (1867–1932), who had set up a pottery in Louisville

in 1888). While raising fourteen children, Stewart assisted her husband in working in the shop. One of her sons, William, continued to turn ware until 1980.

Gerald M. Stewart (1917–?), Louisville, Winston County; interview recorded on June 11, 1981. A son of Homer Wade Stewart, Gerald worked in his father's shop and for other local potters before establishing his own shop near Louisville in 1965. He gave up turning in 1978 but resumed his trade in a small workshop behind his house in 1981, producing small quantities of Albany-slip ware in a shortened gas-fired tunnel kiln. His sister, Hattie Mae, married into another great southern potting dynasty, that of the Browns.

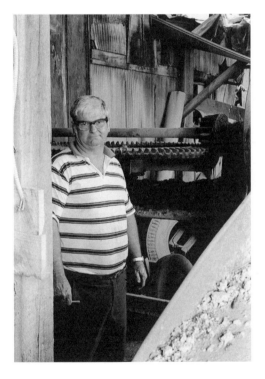

Kenneth Outen of Matthews Pottery standing in front of his grandfather's clay mill, Matthews, N.C.

Boyd R. Hilton at his father's house in Blackburn, N.C.

Boyd S. Hilton centering in his backyard shop in Blackburn, N.C.

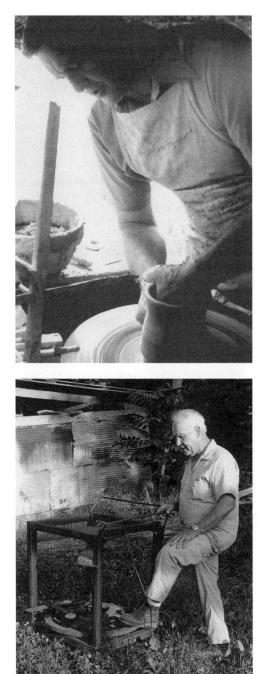

Walter Lee Cornelison turning in the 1840s pot shop of the Bybee Pottery, Waco, Ky.

Horace V. Brown Jr. with the wheel used by his father, Acworth, Ga.

Robert Ferguson with portrait head jug made by Charles P. Ferguson ca. 1900, Gillsville, Ga.

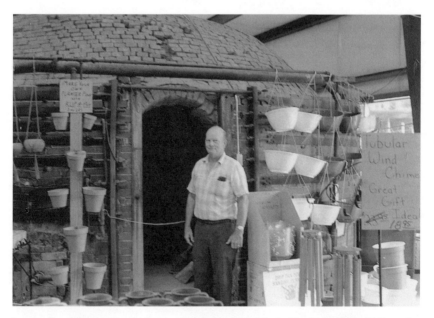

Lamar Franklin standing in front of the old beehive kiln inside the J. W. Franklin and Sons Pottery, Marietta, Ga.

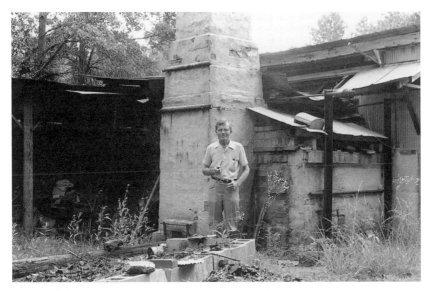

D. X. Gordy in front of his kiln, Primrose Community, Meriwether County, Ga.

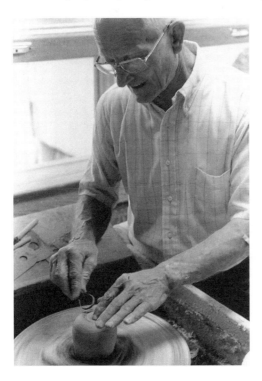

*Bill Gordy at his wheel,
Georgia Art Pottery,
Cartersville, Ga.*

Grace Hewell at the wheel, Hewell's Pottery, Gillsville, Ga.

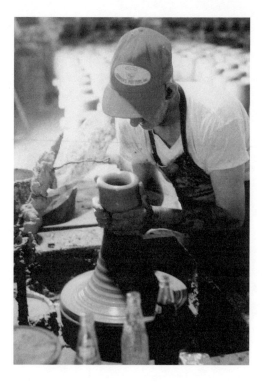

Jack Hewell turning at Craven Pottery, Gillsville, Ga.

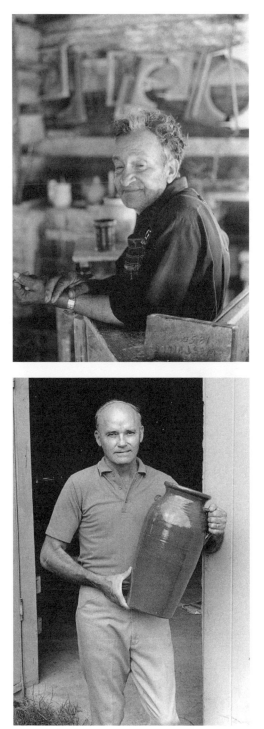

Johnny Hudson in the recreated pot shop at Historic Westville, Lumpkin, Ga. Note the pot lifters hanging above his head.

Cleater Meaders with one of his churns, Byron, Ga.

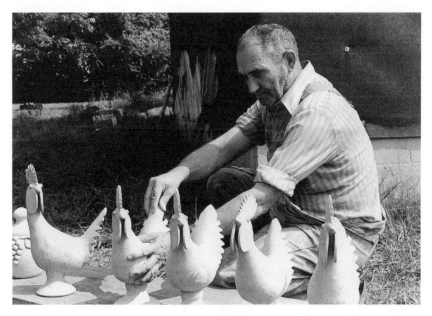

Edwin Meaders with greenware examples of roosters and grape-decorated jars, Cleveland, Ga.

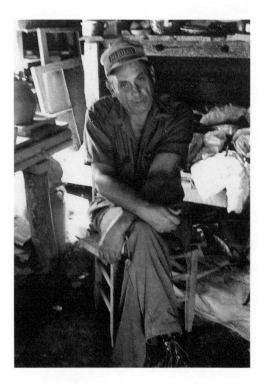

Lanier Meaders striking a pose, Cleveland, Ga.

Marie Rogers examining a recently turned face jug, Meansville, Ga.

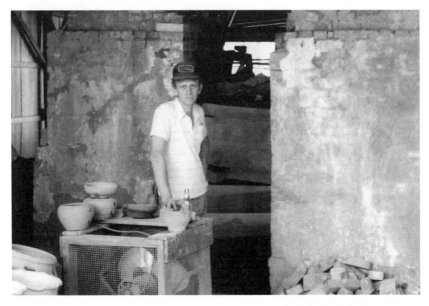

Wayne Wilson standing in front of wood-burning rectangular kiln built by Javan Brown in 1964, Lula (Alto), Ga.

53

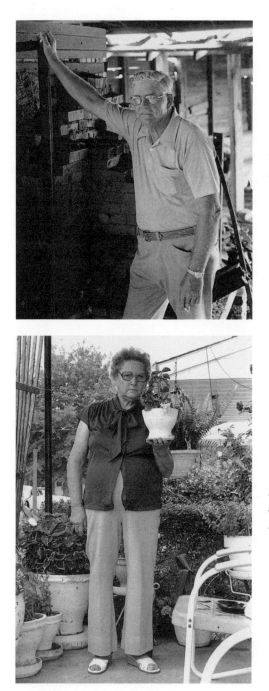

*Horatio Boggs at his
Prattville pottery, Ala.*

*Hattie Mae Stewart Brown
with some of her own pottery,
Hamilton, Ala.*

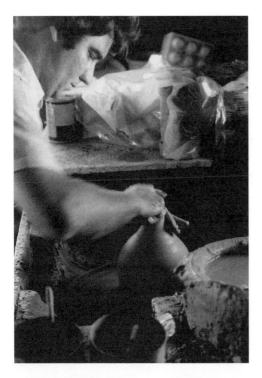

Eric Miller at the wheel, Brent, Ala.

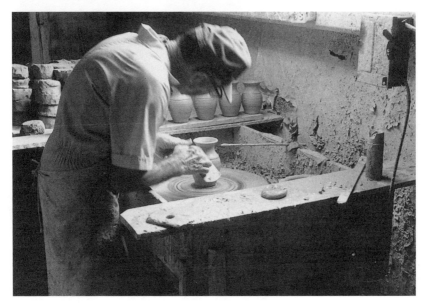

Ralph Miller turning vases at Boggs Pottery, Prattville, Ala.

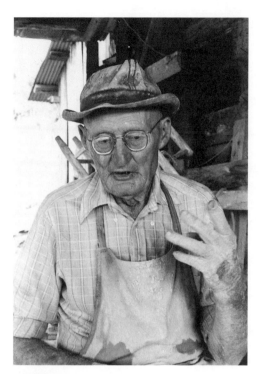

Norman Smith being interviewed, Lawley, Ala.

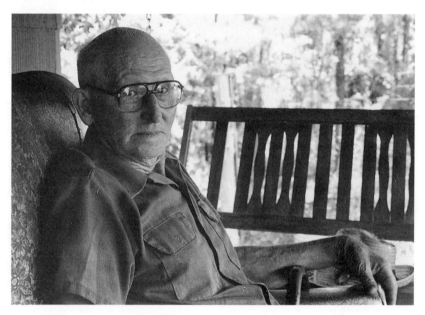

Oscar Smith on his porch in rural Perry County, Ala.

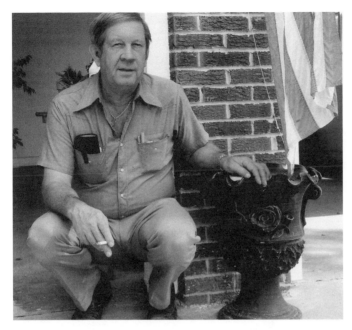

Howard Connor with an example of his ware, Ashland, Miss.

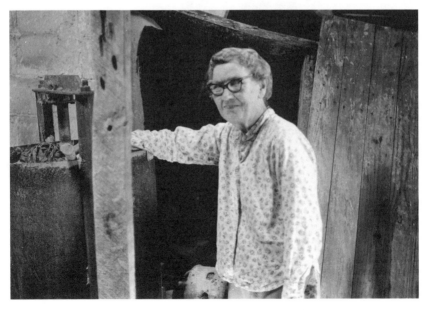

Verna Suggs Duncan in front of the Joe Duncan shop, Amory, Miss.

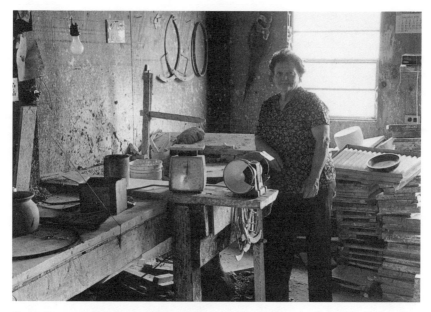

Carrie Stewart in the shop of Bill Stewart, Louisville, Miss.

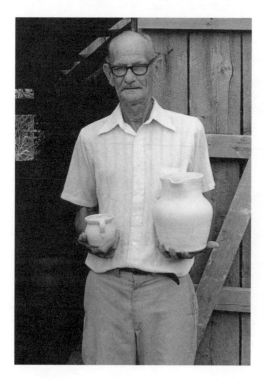

Gerald Stewart with some greenware examples, Louisville, Miss.

The Turners Talk

EXCERPTS FROM THE 1981 INTERVIEWS

ON BEING A POTTER

**Eric Miller* describes the
joys and miseries of the potter's life.**

CRM. Now, you really are in this as a business man, not as a hobby potter, but do you have a consciousness of the fact that you are a part of a long tradition, an old family tradition?

EM. Yeah, I think about it when the sweat is dripping off and I am about to burn up.

CRM. Why in the hell are you doing this now?

EM. Yeah.

CRM. Do you like it?

EM. Yeah, I like it, sure do. It's hard work, but it keeps you in great shape. If I'd quit smoking cigarettes, I'd be a good man. But it keeps your body tuned up. That's right, we dig our clay with a shovel, still dig it with a shovel.

CRM. You truck it in from . . . ?

EM. Over there on the mountain. But it keeps you in great shape. Yeah, it's hard work, but I like it. And next time I can go fishing when I am ready to.

**Bill Gordy explains
his different mindset.**

BG. You know, it's always been my philosophy, brag if you can back up your brag. In other words, if you can do it, tell the world you can do it. . . . If

*Interview segments included on the *Talking with the Turners* audio CD are designated with an asterisk.

I made something and I knew it was good, don't wait 'til the other fellow [says something], just put it on out there.

CRM. But that is very unusual, though, for a family-trained potter to even think that way.

BG. That's right.

CRM. What got you thinking that way?

BG. I think I was born with that instinct. No, I worked in the different potteries, and I could see—I haven't accomplished a whole lot—but anyway, I could see where things could be improved. I mean, it'd still be hand work, altogether hand work, but improved in quality. When I went in on my own, I started purifying my clay. It just had to be, because it don't cost no more to do it. Labor's all it cost, and a little electricity, and then I started to blending my clays. It gives you a better quality and it makes your glazes stick better. Just like anything else in research, so I didn't have a reason to have any trouble getting it out there.

CRM. When were you first written up? When was the first publication of your work?

BG. The American Ceramic Society gave me that with a picture and all, making pottery—that's way back in 1937 when I got it. . . . You see, when I was twenty-nine years old [1939], I went to the national meeting of the American Ceramic Society, and I carried pottery and put on a display of throwing and all, like that, beginning to show it and me being young, and I guess I'm rather partial. How in the world did you do it? Well, I was asked to do it.

A potter's perambulations
as narrated by Howard Connor

CRM. Now, your father [Charles T. Connor] was a potter in Wickliffe, Kentucky?

HC. No, now, he ran away from home in about 1895 and came to Holly Springs, Mississippi, where he worked as just a regular laborer and would play on the potter's wheel until he learned to turn, but he was crippled in one arm and they didn't want him to. They didn't think he could ever make a potter.

CRM. What pottery was that?

HC. It's the old pottery out on 78 Highway. In later years they moved it down in town or on the IC Railroad track.

CRM. That's not still in operation, is it?

HC. No, no.

CRM. Do you know whose that was?

HC. My understanding it belonged to several, names like Smyth, Anderson—I've forgot the others. . . .

CRM. You said he ran away from home. Where was his home originally?

HC. St. Louis. His mother—his people—ran a railroad boardinghouse.

CRM. So he came over to Holly Springs and linked up with that pottery there? Did he set up a shop there?

HC. No, as best I understand it, he'd hobo—old potters, they used to do that. They'd work here a while, skip out, be gone to another town, and I don't know what year he went to Marshall.

CRM. Now, this was down in Texas?

HC. Yes. He built the little shop, or bought it, I've forgotten now, and he kept it for a while, then Mr. Ellis, Sam Ellis Sr., come along. I don't know what year. He worked for the TP Railroad shop; he was a blacksmith. He'd come from England to Marshall, and he bought the shop from my daddy for nine hundred dollars.

CRM. When was that?

HC. The dates? He didn't write any of them down. After he had sold the shop, the next day or two, he hired back to Mr. Ellis and worked ten years and, I'm not positive, but I believe he went to Portland, Oregon. There he worked in a shop.

CRM. He really would do some traveling.

HC. Oh, gosh, yeah. I really don't know, from Portland, Oregon, how far he come back and worked. And then I do know in, I guess, 1927 or 1928, he bought the Toone, Tennessee, pottery. That's Hardeman County.[40] Then he run the shop several years. Then the merchants in Wickliffe, Kentucky, paid him X number of dollars to come back to Wickliffe and reopen a pottery there, so he did, and through some faults, some sales of coal mines, I guess it made a plop, so to speak, so he sold out.

CRM. That was the time you were born?

HC. No, he was back in Wickliffe before then. See, I was born in 1923. See, this all happened in 1929, I guess. In dates, I might be all fouled up in there, but then he went back to Marshall 'cause that was always home. He went back to Marshall and started back to work for Mr. Ellis for twenty dollars a week. That was during the Depression. That's when he built the two

40. On Charles T. Connor's connection with the Toone Pottery, see Samuel D. Smith and Stephen T. Rogers, *A Survey of Historic Pottery Making in Tennessee* (Nashville: Division of Archaeology, Tennessee Department of Conservation, 1979), 104–5.

kilns, the two of the kilns that's still in every-week use now. So he saved enough money out of the twenty dollars a week in there and bought the Toone Pottery back again went back to Toone, Tennessee—that's Hardeman County—opened it up, and operated it until he found a nice deposit down here. Then he built a small pottery in Benton County in 1940 or 1941, or in that time.

CRM. Was that on this location?

HC. Yeah, right here.

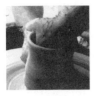

FAMILY ORIGINS
AND FAMILY TIES

Family origins and pot-shop beginnings
as recounted by Walter Lee Cornelison*

CRM. Now, your grandfather, Walter, was not the first Cornelison [potter] was he?

WLC. No, James Eli was, his father. I have sales records for him. It's an accepted fact. I talked to much older men that worked for him, and they told how years ago, how the pottery business existed, how they ran it and how they sold it. It was interesting, one of the ways—I've talked to men that said we hauled it [pottery] out of here on spring wagons and hauled it to different towns. Another man said we had another way of doing it; we were only about two miles off the river and we'd take it down and put it on flat boats, especially in the fall of the year, and we'd go up the river to the little mountain communities pulling in during canning time, and they bought the fruit jars and churns and things to can in, and then move on up the river a little bit to another community and sell it there. So it came into existence.

This pottery, or a pottery—I have to put it that way—has been in existence in this area for many, many, many years; maybe it dates back to the Boonesborough settlement. I don't know. Legend has it—now, this is strictly legend, by the historian of Madison County, Dr. J. T. Dorsett of Estill—that the people of Boonesborough did, indeed, find the clay here and, out of necessity, started using it. This certainly is on their route from Boonesborough

down to the river, from Boonesborough to Estill County, where they found their iron ore—the old iron furnaces are still there. So from Boonesborough they spread out here. They had to go the other way to get their salt and salt lick, and [I] just suppose they found their clay here and iron ore in Estill County and they used them. But, there, because of the accessibility of this clay, there has been four or five potteries within a three- or four-mile radius of here down through the years and due [to] deaths in the families, which often happened to pottery families. Another generation doesn't carry on.

I know of one family that came in here, that was sent for, they were German potters, a family by the name of Zeittel, that they sent for. They came in here and started a pottery, people—there were several German families. My family is Dutch, but the Zeittel and Baumsgart family, the Cornelison family, the Frenstraup family—all these families were at one time or another involved with the pottery business in this small community in a two-or three-mile radius.

CRM. Now, you said you had records, records of family business?

WLC. Well, I had records back to, sales records, from my great-grandfather. I won't go any further back. The reason I say that is there is a possibility there is another generation back there. I can't get him in this pottery, but I have him as a potter living in this area. He could have been in one of the other potteries. I often wondered if, indeed, they were potters when they came here from Holland, but I can't find anything.

CRM. Did they come through Pennsylvania?

WLC. They came through the Peter Stuyvesant colony in New York. There, I have land grants from Albany, New York, that show three land grants to the Cornelison family from the Peter Stuyvesant colony. They came from there, and then one of the boys obtained a land grant in North Carolina for his services in the Revolutionary War. He got down in North Carolina and then came from the mountains into Kentucky. Now, whether he came here knowing the clay—you know, it would make a nice story for you to say that that's the way it happened, but, frankly, I don't know. They kept so few records about the potteries or anything that they didn't have to back then, and they didn't. They spent their time making pottery.

Verna Suggs Duncan discusses her family's connection with pottery and turners.

CRM. The Suggs family was a pottery-making family? . . . And your father was involved with pottery making, right? What was his name?

VSD. Yes. W. D. Suggs, Bill Suggs.

CRM. And when was he born? Can you recall?

VSD. Oh, I can't think right now.

CRM. When did he die?

VSD. Mother was Lulus [?] Wigginton Suggs, and she was born in 1888, and Daddy was ten years back.

CRM. So, 1878. When did he die?

VSD. Forty-five.

CRM. I see, 1945. Was he making pottery all his life?

VSD. He was involved in it most of his life.

CRM. And where was this?

VSD. Edge of Monroe and Itawamba County join, just a little piece from our pottery.

CRM. Was that near Smithville?

VSD. Three miles east of Smithville.

CRM. Were there a lot of potters in this area then during the twenties, thirties, forties?

VSD. The closest one to us was William Davis, and at one time Daddy and William both lived in Itawamba County as neighbors a number of years, and when one come to Monroe County it wasn't too long 'til the other one came. They was close friends, but the Davises died out and his son operated it for a little while, but they had a hard go. That was when things was hard times and you couldn't make it.

CRM. This was when? The twenties and thirties?

VSD. The thirties. And Daddy operated on. He did it in a small way with a few hands.

CRM. Did you stamp your ware? Was it marked? What was the name that was generally on it, both for your father and for your husband?

VSD. Well, my husband had a partner, Dewey Stone. So it was "Stone and Duncan." Stone disappeared. He didn't stay too many years; a few years and he went to the Stewarts.

CRM. The Stewarts, down in Louisville?

VSD. Well, before then, and he built him a kiln and a shop. Never did fire a kiln and went to Louisville and stayed down there a while and I think went back to Texas or something.

CRM. He was from Texas, Mr. Stone was?

VSD. He was from Dallas, Texas. His brother Louis, I believe it was, worked for my daddy. He had a number of different people that worked during the different times.

CRM. Can you recall any of the other names?

VSD. Well, Jim Humphries. Johnnie Humphries, his son, and a Mr. Cobb Moore, and—

CRM. Any Browns? I keep running into Browns.

VSD. No—well, I believe he did, a short time, and then he disappeared. They traveled around.

CRM. Do you recall which Brown it was?

VSD. It was a short time. It was after I married and don't recall.

CRM. It wasn't Horace Brown?

VSD. No, Horace Brown lived up in Alabama. He was a friend of ours, too.

CRM. Where was your shop? It was near Smithville. When did you move down here to Amory?

VSD. This is the only one we've ever owned.

CRM. So when you got married, you and your husband left the other.

VSD. We lived there nine or ten years; about ten years we lived and worked the pottery up there, and I taught school. . . .

CRM. And then you moved down here? And when was that? How long have you been here, in Amory?

VSD. We been here thirty-two years.

CRM. On this site right on East 278?

VSD. Yes.

Hattie Mae Stewart Brown
talks about the life of a potter.

HSB. My husband [Horace V. "Jug" Brown], he came to Louisville—he was from Atlanta—and his daddy owned a shop, and he was reared up in the shop, and all the boys worked together. . . . That was Horace Brown Sr., and if you ever go through Atlanta, he could tell you more about the Brown generations than I could. He's got a son there, his name is Horace Vincent Jr., and he's a potter—he can make pottery. He's my husband's son; he had two families. He and his first wife, they're separated. He had a fine pottery in Atlanta. Said it would take six hands to wait up, a dozen hands on Sunday afternoons, to fill his customers. He lived on Buckhead, and he had a pottery. He was just a young boy back then; he can tell you a lot about it. He got separated and he come to Louisville, then he worked over here at Bexar, Alabama.

CRM. Oh, that's just up the road. I passed right through it.

HSB. He come from there down to Louisville. That's where me and him met. He worked for—my daddy done gone on. He done expired and died.

CRM. When did you meet your husband?

HSB. Thirty-seven, and we got married in '39. He worked for my brother, my oldest brother. He'd taken over my daddy's.

CRM. That was Tom?

HSB. Tom, Tom Stewart, and he run one, and my other brother—two brothers down there. My little brother, W. W., he never did take any interest in making it. . . . We moved back to Alabama when we got married in '39; we moved to Bexar. We didn't stay but six months, then we moved to Sulligent.

CRM. That's just down the road from here.

HSB. We reared our family in Sulligent, Alabama.

CRM. That's where you had your pottery, then?

HSB. That's all we did for a living, make pottery, and it was hard to sell back then 'cause you had a lot of competition.

CRM. This was still the forties into the fifties. Was there a lot of competition?

HSB. Yes, there were.

CM. Were there a lot of potteries around there?

HSB. There was one in Amory, one over here in Tuscaloosa. . . .

**Bill Gordy and his wife speak about
family and his brother, D. X. Gordy.**

BG. It was within the family that we would criticize each other if we didn't do it right. Yeah, my daddy, he was a perfectionist too. And my mother was an artist, she did—oh, she could do dogwood, anything, sculpture. So it must have rubbed off on me, a little bit of it. But being brothers, you know . . . you know, I don't believe I've got but one brother that tells me I do good work. The rest of them don't brag on me at all. That's the way it goes, you see.

Mrs. Gordy. Did D. X. have anything to show you?

CRM. Oh, yeah, I got some pieces from him.

Mrs. Gordy. It was under the bed or somewhere.

CRM. No, it actually was in his kitchen cabinet. He has not turned for about, I guess, a year or two. He's been so busy fixing up that house, see.

Mrs. Gordy. You come back in ten years, and if he's living, he's still fixing that house.

CRM. That's a lifetime occupation. The downstairs is just about finished.

Howard Connor talks
about a family of potters.

CRM. Your father was the first potter in his family since they ran a boardinghouse in St. Louis?

HC. Well, all of them—it was thirteen in the family. It was at least five potters in the family 'cause each boy learned pottery.

CRM. What were their names?

HC. It was Tom Connor, T. D. Connor, Dan Connor, my daddy, Charles T. Connor—that's all, really, I can remember.

CRM. Was their father involved in pottery?

HC. My daddy's father was a ship builder.

CRM. What was his name?

HC. Dade Connor. He lived to be ninety-six years old.

CRM. Died when?

HC. Don't know. He's buried in Belleville, Illinois, 'cause I've lately discovered some new kin there. I thought they was out—we'd run out—but my grandmother and granddaddy were buried in Belleville. . . .

CRM. Was your mother a potter? Did she turn herself?

HC. No, no.

CRM. What was her name?

HC. Mary Josephine Connor. Dunaway was the family. Mayfield, Kentucky.

CRM. Was her family a potting family?

HC. No, tobacco farmers, and her daddy had a general merchandise store and was one of the largest landowners in Graves County, Kentucky. Now, my grandfather on my mother's side and my daddy built a little pottery in Bell City, Kentucky, where they made the brick and burned them on the ground, built the kiln, built the little log shop, everything from scratch.

CRM. But your mother's father was not a potter; he just helped to finance it?

HC. No, no, right, I imagine.

CRM. In Bell City?

HC. In Bell City, Kentucky, where there still is a little pottery there yet. I went up there to take some pictures of the old kiln that my daddy and mother built. It stood 'til about four or five years ago. The day I went up there to take the pictures, don't you know it had been torn down.

CRM. Which pottery is that in Bell City?

HC. Nance Pottery. . . .

CRM. You said you had brothers. Did they go into the pottery business?

HC. I had a brother that did. It was kind of my brother's pottery up until 1967, when I bought him out. He got bad health, and in 1970 he died—Alfred Connor.

CRM. Was he the only brother who was also involved in the pottery?

HC. Yes, now, he was always the salesman. He didn't learn to turn much; he could turn a bit. Of course, I guess, you probably know I went and represented Mississippi in 1974 at the Smithsonian in History and Archives, and I made pottery on the potter's wheel for a week. . . .

Harold Hewell* chats about his family and their potting connections.

HH. Dad [Maryland "Bud" Hewell] worked over at Lanford, South Carolina, for about three years. He stayed over there about three years. That's where I was born.

CRM. Who was he working for then?

HH. A fellow by the name of Bud Johnson.

CRM. That's long gone, that pottery.

HH. I don't think there is even a site there now.

CRM. What sort of ware were they turning out? The jugs, churns, crocks, that sort of thing?

HH. Yes.

CRM. He was working over there about four years?

HH. Three or four years.

CRM. And then came back to this area again? Did he set himself up a shop?

HH. Yeah. He set himself up a shop.

CRM. So you have got right now how many generations working in the shop?

HH. Well, we just got—the boys are starting, and if you'd count those—we got three generations.

Robert Ferguson discusses family background.

CRM. Now, your father was a potter, too, was he not?

RF. Yes. W. P. William Patrick Ferguson.

CRM. People knew him as Pat Ferguson?

RF. Correct.

CRM. And was the family involved with pottery before him?

RF. Oh, yeah. Oh, yeah. Well before him.

CRM. So your grandfather was involved, too? Do you recall their names?

RF. My grandfather's name was Charlie Ferguson. Now, my great-grand-father, I don't know.

He died when my daddy was nine years old, I mean my grandfather did, so that puts Great-grandfather way on back. But they was all involved with pottery.

CRM. Did you get taught by your father?

RF. Yeah, I just took it up from him. He had a little pottery here at that time.

CRM. Right on this site?

RF. Yeah, it was down below the house here.

CRM. I guess he was using, what, a groundhog-type kiln?

RF. Yeah, we had an old wood groundhog.

CRM. What type of ware did you learn on?

RF. Just red clay stuff. You know, no glaze stuff.

CRM. Did you ever turn full time?

RF. Well, back when I was real young. But then I took to the road and I have been on it ever since.

**Kenneth Outen* describes how his
family got to Matthews, North Carolina.**

KO. The pottery here has been here for sixty years. My grandfather started it in 1923.

CRM. What was his name?

KO. William Franklin Outen.

CRM. Do you recall his date of birth and date of death?

KO. His date of death was 1946. He was seventy-six. Then my daddy ran it for fifty years. He came up here when he was about eighteen years old, and he died about six or seven years ago. He was seventy-two.

CRM. What was his name?

KO. J. G. [John Gordon]. Of course, I ran it for about twenty-five years up until 1978.

CRM. You are not running it now.

KO. Not the plant part of it.

CRM. Not the plant part of it, but you have this wholesale / retail outlet.

KO. Yes, and, of course, we branched out into other products. . . .

CRM. Now, you said they came up here. Where were they from origi-nally?

KO. Originally, Grandpa had a pottery down at Catawba Junction . . . before he moved up here. That was probably around in 1921, along in there.
. . .

CRM. Now, your grandfather was, of course, a turner himself, and your father was too?

KO. Right.

CRM. Have you turned at the wheel yourself?

KO. I turned for about six or eight years. . . .

CRM. Did you have people working for you?

KO. Yeah, we run a crew of about seven or eight people.

CRM. Were any of them sort of traditional potters?

KO. Some of them were and some of them weren't. I had a brother that helped turn some—Donald Outen. He was around fifty years old when we first did it. He was sixty-six when he was deceased.

CRM. What were the names of some of the other potters that worked for you over the years?

KO. Well, let's see, I had quite a few. We had a lot of them out of Charlotte that went to Peace [Queens] College that turned some for us. Most of them made just small stuff, kind of an art pottery. Years ago we used to have—the Browns used to work for my grandfather. They used to come down and turn for us. Otto was one of them. He'd just turn for maybe two or three months out of the year, just whenever he would need, you know, really need some extra pottery turned.

CRM. How many wheels did you have when you were turning by hand?

KO. Three.

CRM. Were they treadle wheels?

KO. No, all electric.

CRM. I guess your grandfather had started on, of course, a kick wheel?

KO. Kick wheel. Of course, that was before we had much electricity.

CRM. And then you switched into electric during your father's period?

KO. Yes. In fact, the first electric motor we might have used was put in that plant down there and it dates from, I believe, 1933.

CRM. Has the pottery always been known as Matthews Pottery? Was it ever known as Outen Pottery?

KO. No.

CRM. But the Outen family has always had it?

KO. Right.

CRM. Now, from your grandfather to you . . . you're a third-generation potter. Were there any potters [in the family] before then? Great-grandfather? Or your grandfather started it?

KO. Yeah.

CRM. Did you ever hear why he got into it?

KO. Well, he worked for a brick company in Cheraw [S.C.] when he was real young, and he just drifted from there over into the hand making of pottery.

CRM. And was he from South Carolina originally?

KO. Right.

CRM. So it's really, ultimately, a South Carolina family then?

KO. He was raised up in Cheraw, South Carolina. . . . And he moved from Cheraw over to Catawba Junction.

CRM. And had his pottery there, then? As a one-man shop?

KO. A family shop.

Ralph Miller* tells of his potting
heritage and the family's Yankee origins.

RM. I've did this all my life. Even when I started out, when I was about eleven years old.

CRM. How did you get your training?

RM. Doing.

CRM. What started you into pottery? The Miller family has been involved—

RM. My father, my grandfather, all down the line. It's always did that you see, and I—

CRM. Now, I understand the Millers originally came from the North, is that right? Pennsylvania?

RM. Grandfather come from Buffalo, and he went to Baldwin County and started out there.

CRM. When did he come down to Baldwin County?

RM. Before the turn of the century. Right after the Civil War. He was in the Civil War. He was in the Union Army, and after it was over with, he drifted south. Now, why, I don't know. He met my grandmother down there; they married. They started out like pioneers. They went over to Mississippi and put up a pottery and stayed there a few years, then come back to east Alabama and put up a pottery and eventually settled over here in Perry County and stayed there.

CRM. Was your grandfather a potter when he came? He was a potter up in western New York state?

RM. He came from Buffalo. I don't know. As far as I know, he was, and he settled over there in Perry County, and he stayed there the rest of his life, and he died at eighty-six.

CRM. He was eighty-six when he died? When was that about? Do you recall?

RM. About '28.

CRM. Now, was your father also a potter?

RM. Yes, sir. He died about twenty years ago.

CRM. Other members of the family too? Is that correct?

RM. I got a brother that works over there yonder for Eric Miller, south of Brent.

CRM. Works for Eric? Now, what relation is Eric specifically to you? A cousin or—

RM. Yes, that's right, cousin. His father was—he's a second cousin—his father is first cousin.

CRM. What's your brother's name?

RM. Kenneth. He might not be over there today. His wife works for Sears, and every day she takes off, they go fishing.

**Carrie Stewart speaks of
pottery-making beginnings.**

CRM. Where does the Stewart family come from? Were they here before, and was there anyone who was a potter before Grandfather Stewart?

CS. Well, he's the first one I knew.

CRM. They came right from this area? Did they come in from anyplace else, do you know?

CS. I don't know if he lived here all his life or not. He didn't talk to me about that much. They came here and settled this place when you could homestead; that's how long ago it was. All of his sons, too, knew how to make it.

**Gerald Stewart talks about
family origins and potting beginnings.**

CRM. Where did the Stewarts come from?

GS. Carolina.

CRM. From North Carolina or South Carolina?

GS. South Carolina.

CRM. Do you know where in South Carolina?

GS. No, I sure don't. Somewhere in South Carolina.

CRM. How did they start off in the pottery business?

GS. My father, he had a cousin who was a potter, and he learned with him. He was a Morton, sure was.[41]

41. The Morton from whom Homer Wade Stewart learned to turn probably was the G. W. Morton listed in the 1880 census as working in Winston County, Mississippi, and

CRM. And he was a Mississippi potter?

GS. Yes, that's where he learned from—and another one too, one of his cousins, a Mr. Crowell.[42] He worked with them. He learned the pottery and went into business for himself when he married.

CRM. Were there a lot of potters in this area then?

GS. Well, right smart of them, good many.

Horace V. Brown Jr. talks about close ties and separations.

CRM. When was your father born?

HVB. I don't know. You know, it's really pathetic. We have very little data on the Brown family. There was no records kept, like the Bibles and all that stuff. Well, we did have a lot of pictures. They came out from the *Atlanta Constitution* one time, and they stayed out there nearly a week, from start to finish, taking pictures, how the pottery was going. We had a lot of those, and then him and Ma separated and the pictures got lost.

CRM. About when did he leave the area to move west?

HVB. He left here in the early thirties. 'Cause we was married in '33 and he was already gone. . . . Now, old Otto and Javan. Javan was a good turner, and Otto was too.

CRM. They both worked here at various times?

HVB. At various times. Otto and Javan. I don't think Davis ever did, but Otto and Javan and Bobby—he lived with us for a long time, and Willy lived with us for a time.

CRM. What happened to them, do you know?

HVB. Bobby died years ago. We didn't know he was dead until several years later.

CRM. The date I've got here is that he died sometime in the forties. Does that seem about right?

being thirty-seven years of age. See Georgeanna H. Greer, "The Folk Pottery of Mississippi," in *Made by Hand: Mississippi Folk Art,* ed. Patti Carr Black and Charlotte Capers, exhibition catalog, 50 (Jackson: Mississippi Department of Archives and History, 1980).

42. This probably was Churchwell Crowell, listed in the 1860 census as a potter in Newton County, Georgia. His descendent (and cousin of Gerald Stewart), George Crowell, was working as a potter in the Louisville, Mississippi, area in 1950. See Howard A. Smith, *Index of Southern Potters,* vol. 1 (Mayodan, N.C.: Old America, 1986), 41, and John Burrison, *Brothers in Clay: The Story of Georgia Folk Pottery* (Athens: University of Georgia Press, 1983), 313.

HVB. Well, I wouldn't be so sure 'cause he'd been dead a long time before we even knew about it. We used to be very close, all us Browns, and then everybody moved out.

CRM. You really started right here in the Atlanta area and then just spread out from here in all directions.

HVB. They'd stayed close together for years and years and then started spreading out and spreading out, and then they kinda lost one another.

CRM. Do you think that was due to the fact that the economics back then, there wasn't enough pottery demand in the one area to support that many people?

HVB. It's possible.

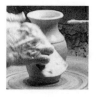

GROWING UP
AND BEING TRAINED

Norman Smith*
talks about the early days.

NS. My name is Norman E. Smith, and I was seventeen years old when I started to making pottery.

CRM. When were you born, sir?

NS. Nineteen four.

CRM. Nineteen four, and you were seventeen when you started?

NS. Yes, and I'm seventy-seven now, and I told my girls I was going back to starting off. My dad always talked about being *in* the pottery business. . . . And I wasn't but about ten years old. Anyway, my mother died in 1918. And so my daddy-in-law, my grandpop—[my] step-granddad had worked around a pottery—got to talking to him again. He found where he could get an old kick wheel, about six inches too high. But he finally went and got that and put it up for anybody to learn on. I never had anybody to show me nothing. I learned how to make 'em.

CRM. What was your father's name?

NS. E.B. Smith, Elbert Smith. They was four of us brothers. But they always could get in with the girls and talking to them. So on Sundays when I wasn't in the field, I just stayed on the wheel. I didn't do nothing but stay on the wheel and drank whiskey.

**Verna Suggs Duncan discusses how
her husband got involved in pottery.**

CRM. Were the Duncans potters also?

VSD. No, my husband [Joe Duncan] was never involved in it until after we were married.

CRM. So he married into the business?

VSD. He took up the trade.

CRM. Did he learn to turn also?

VSD. Yes, he did it from the beginning to the end. He did all phases of it.

CRM. Did your father train him?

VSD. No, he just purely learned by experience.

**Howard Connor* remembers
his earliest days at the wheel.**

HC. Well, my daddy started me—mother, really. I was about five or six years old playing on the potter's wheel. She would sit me up by the wheel.

CRM. This was a treadle wheel?

HC. Treadle, and started from there. . . . Well, now, when I started, other kids had gone to school, I guess to pacify me, to get rid of me, or playing, you know, like mothers used to do. She would carry me to the pottery, and he had an extra kick wheel, and she would set me up in there. See, the regular potter's wheel, you don't sit down. She would set me up in the wheel crib and she would fix little pieces of clay that I would play with—'cause I have a piece of pottery that I made when I was around five years old, and she just glazed it and fired it in the kiln. . . .

Candlestick holders! I bet I've made a million. . . . When I started to learn to turn, when I got big enough, you know, he put me on a wheel—'bout like the one out yonder—he put me on a wheel and he started me off on candlestick holders, and I made 'em 'til I could see 'em at night, dream about 'em, everything else, and I begged him, "Dad, let me make something else Dad." "No, you're not going to make anything else. . . . " "But, Dad . . ." "Until you have mastered them. When you do, you can make anything you want." And that, today, I think is what's wrong with people go to teach you to make pottery. They let you make any kind of piece, a teacher will, and whatever it turns out to be, "Oh, that's nice." It's a bowl, and the one will be a straight-up piece but wrong to teaching. To learn to throw, you must take about three or four pounds of clay and handle that first and throw it. . . .

'Cause I can be turning on the potter's wheel, like one-gallon jugs, and I can talk to you and turn that jug and all and I'll make one not even thinking, 'cause I use the same. And then I use the gauge on my wheel where they don't use that. . . .

**Boyd R. Hilton makes a contrast
between himself and his father.**

CRM. You were saying about the [potter's] wheel.

BRH. The wheel that came from the original L. S. Ritchie shop up here . . . lay down here in the tractor shed for years and years and years, even when my grandfather [Curtis R. Hilton] was still alive. . . . And Grandfather died in 1960, and it slipped away before that part of my education was ever brought to light, and so about the fall of 1976, I guess, I had been to Burlon Craig several times and had visited the Seagrove area a little growing up, and my wife originally was from the Sandhills area of North Carolina —West End—so she was in the eastern end of the pottery [area] and knows a bit about the pottery and collected a few pieces over the years, coffee mugs at college and that kind of stuff. There is a studio potter named John Nichols who was originally from South Carolina—Newberry, South Carolina, as a matter of fact—who came to Stokes County about '73 or '74. Stokes County is, of course, north of Winston-Salem. I moved up there for my job with Duke Power Company, and he was teaching classes and putting on shows for festival days and that kind of stuff, and Susan got to know him and decided we would go and take a class jointly that fall. It's supposedly in the blood. I've got ancestors who have thrown pots, so maybe I have a little ability too. So, prior to the birth of our daughter, Susan and I both signed up for his classes that met once or twice a week during the fall session, and I liked it. . . .

I made the usual little pieces that I was thrilled to death with that could hardly hold water and gave those as Christmas gifts that year . . . and decided that maybe this was a hobby I could get interested in, so, since I have a little bit of mechanical skill, I threw together a wheel—very crude by most people's standards, but a motorized wheel. I continued practicing in my basement and developed a pretty good relationship with my pottery friend and got good advice from him.

CRM. This was before your father started?

BRH. About the same time. Just about the time I built my little wheel, I pushed him into [thinking that] maybe we had better set up Grandpa's wheel —the wheel head. The wheel head was originally from Ritchie's shop and

was so well worn that the finger grooves were down in it. So much turning had been done on it that grooves or valleys were worn into the wheel. So I came down one weekend and we checked it out on one of the large lathes over at the plant based on true and brought it back and proceeded to build a wheel . . . and therein lies probably one of the first distinct differences between his pots and my pots. I had formal instruction from a studio type potter, and that obviously has affected my work or my style or my choice, and he is essentially self-taught and in the years that followed made several trips up to Burlon Craig and would sit and watch him turn; and so the Burlon Craig influence, you might say, leaked over onto my father, and mine is essentially from a studio potter that was Penland trained and this kind of stuff, more modern art ware.

Wayne Wilson* remembers
learning from a master.

CRM. You were saying that you learned more from Javan Brown than from any other turner?

WW. I would say so. . . . He was little bitty and real independent and fair. When you worked for him, you done it his way, and, I don't know, I come to respect him and I buckled down and I learned a lot of things—his way. I found that a lot of things I'd learned proved to be pretty good.

CRM. You were saying that he used to come in with a suit on?

WW. Every morning. He would come in with a suit and a bow tie. He'd come to work with a suit and a bow tie on.

CRM. Now, he wouldn't work with a suit and bow tie?

WW. He'd change clothes.

CRM. He would come to work with a suit and bow tie, change into work clothes, then change when he left! He was turning pottery right up to the end.

WW. That's what I heard.

CRM. And they were being fired at his son's place, Evan's place. He was making face jugs and devil jugs, with horns, and they were being sold just like that. Glazing with Albany slip glazes. They've been selling just like that. Real collector's items. Did he ever make face jugs while he was here?

WW. No.

CRM. I wonder where he picked that up.

WW. I don't know. He could do anything when it come to a piece of clay. And if he couldn't turn it on a wheel, he would make a plaster mold and cast it. But there wasn't anything he couldn't make.

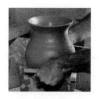

RECOLLECTIONS OF
CHANGES AND TRANSITIONS

D. X. Gordy describes
a pottery evolution.

DXG. First you would like to know about my being here at this place, and I'm going to start all the way back from the beginning of my time. My daddy had this pottery shop at Fayette County, a place called Aberdeen. He was there about ten years. I was born in Aberdeen and lived there 'til I was about nine years old. Anyway, while he was there, he made mostly jugs and churns and other crockery, and about ten years after that he moved to Alvaton. I was nine years old. That was in this county, Meriwether County, so he was in Alvaton about seventeen years. There he made probably more jugs than anything. Made lots of churns, crockery, flowerpots, but then—that was back in the thirties—and the demand for churns, jugs, crockery was going out. They seem to be coming back now, for sentimental reasons probably, and they are still usable, especially [for] canning—you can use them no matter what, you can use them. They're particularly pure. I've never known any impurity to come off of it, into any food or anything, but people got to buying cheaper things. . . .

So then he decided the demand was about to go out and we needed to change and I didn't mind that 'cause the change we was making, I was—I had art on my mind as well as the pottery. So he thought he would sell something people wanted, but it had to be in a different place. We were over there at that time, you might say almost in the creek swamps. We built that one for the reason the clay was there, and we used a tremendous amount of clay at

that time—sometimes we'd work up a ton and a half. So we moved away from there over here because this was the only paved highway through Meriwether County at that time and it was the main route from Columbus to Atlanta and was, and it still is, called the "Presidential Route." This is the route that Roosevelt would go from Warm Springs to Atlanta. So we had quite a bit of traffic on this road, and we only had twelve miles to move over here. So we decided that we could go into more of an art-type pottery. At that time . . . we made a lot of novelties, we called them. We could sell a lot. . . . You had to make a living, but—souvenirs, people called it, but I got tired of it. That wasn't what I wanted. But I made 'em because we could sell them and that was the living. But as time went on then, I got completely disinterested in making souvenirs. I made lots of them for the gift shop at the Little White House at Warm Springs.

Horatio Boggs discusses necessity and transitions.

HB. During the war we made churns, jugs, and pitchers, but after the war we started to make flowerpots and haven't made anything else since.

CRM. Why did you switch? What were the reasons? Why did you switch from the traditional jugs, churns, crocks into garden pottery?

HB. Well, there was a demand for flowerpots, and you don't have to glaze it, and you got the same price per gallon. It were foolish to make a churn. Of course, it's not that way anymore at all.

CRM. Things have sort of come full cycle. You were saying earlier that you were really one of the first, or the first person, to start in a full-scale production of garden ware.

HB. Yeah, I sold mostly in Florida, then all I made went to Florida. At that time, why, Alabama didn't need many pots, but you could sell it to tourists in Florida, tourist trade. And we hauled all over Ohio and Wisconsin, and it was fairly scarce and we was first. Of course, with handmade pottery, you never get that big, you never get big. There is no way. As you are making it by hand, you are limited. But there was never any trouble selling what we had made.

Eric Miller discusses lifestyle changes in rural Alabama.

CRM. When you started out, when your father started out, I expect there were a lot of potteries in the area?

EM. Yeah, there was almost one in every community.

CRM. That's before people could get the store-bought glass, and plastics later, and this sort of thing. I've been driving by, looking at houses and front porches, and now all you see are these plastic milk containers and so forth, and I guess you have to—thirty or forty years ago you substitute pottery churns for those milk containers.

EM. That's right.

Billy Joe Craven* describes
the birth of an enterprise.

BJC. In prior years in this area, I've known as many as five potteries being in Gillsville, Georgia, and all the potteries seemed to do the same thing that their forefathers had done. They did it this way because Grandpa done it this way or because my daddy done it this way. I came up with some ideas to produce pottery by making a lot of the work more mechanical. We have over a period of ten years done a lot of the experimenting and failure and learning, and we have mechanized our pottery here to the point of everything being mechanically handled except the actual making of the pottery on the potter's wheel.

CRM. So all of the drudgery, the noncreative drudgery, is mechanized?

BJC. That's right. Our clay is fed into a bin with a front-end loader, and from there it is mechanically handled all the way through to the potter's hand. And then, after the pottery is made, it is on racks that have wheels and it's very easy to manipulate into the kiln area.

CRM. Earlier you were pointing out that the last phase of the drying is actually turbo-dried.

BJC. Yes, we're using a heat extractor off of our kiln, and we dry our pottery in approximately seventy-two hours from the time it's made until the time it's ready to go in the kiln.

CRM. That new kiln of yours really impressed me, too.

BJC. Our kiln is a natural-gas updraft kiln, and it's called an "envelope," meaning that it has two beds and the kiln itself moves over the beds from one bed to the other. This allows you to load and unload one kiln while the other kiln is being fired. And the efficiency of the kiln is about 95 percent, I think, because it's totally insulated with a fiber material, and we're using a close-burning method of firing that gives us a uniform and even firing. We've got about twenty degrees variation in the kiln. That's pretty hard to create in a kiln that size. . . .

CRM. Can you tell me how many tons of clay you use?

BJC. We're using approximately twelve tons of clay per day with a production of fifteen thousand gallons of handmade pottery per week. . . . We have tried to diversify our business over the years to where we could stay busy in our seasonal business on a year-round basis, and to do this we have started to acquire other operations. We acquired Collins Distributing Company in 1977, and along with that came six employees and five trucks and a lot of equipment that we now own. We maintain and operate this company as it's been operated for the past twenty-five years, before we acquired it. Last year we started a company called Brown Earth Potting Mix. We manufacture potting soil for the garden centers, and this all, combined with our warehouse sales and retail sales here at Cravens, has allowed us to never have a person unemployed at any time, even though we are in a seasonal business.

INTO THE BUSINESS

**Cleater Meaders describes
how he came back to turning.**

CRM. How did you come to Byron?

CM. Well, the reason why I ended up in Byron here is that before the war,
World War II, we were six of us boys in the pottery business there in Cleve-
land, and we all started coming of age, and all six of us couldn't make a liv-
ing in that one shop, so we started kind of separating out. To start with one
of my brothers, Frank did most of the pottery making as far as turning the
pottery. We more or less sort of assisted him and separated our jobs, and each
one had a particular job. He took a job at Ford Motor Company in Atlanta
and moved out, and the rest of us kind of picked up the responsibility for
the part he did. My oldest brother and myself started to do all the turning.
My oldest brother, Lambert [1908–1975], he was doing most of the large
turning, and I was doing most of the small stuff, say, from two gallons down
I was making. He was making all the large stuff.

And then about that time, under the Roosevelt administration, they
started this NYA [National Youth Administration] school, and they started
a ceramics shop over at Clarksville—at [the] time it was Habersham Col-
lege, now it's the North Georgia Trade School—and they came over and
employed him to teach the pottery making. It was a combination of ceram-
ics and everything, but he was in charge of teaching them actually how to
turn a piece of pottery and wood firing and clay and things of this nature.
So when he left, that kind of narrowed it down and more or less left me

there, and then he wanted me to come over there to go to school and learn a little bit more about what these engineers from Georgia Tech could teach 'em. So I stayed over there about a year and a half, and then Bauer Pottery Company [?] up in Atlanta came up there wanting some people to come down and work. They had been in business there for about a year or something like that, and they was thinking of trying to make some handmade pottery. I went from there to Atlanta, and I worked a year and I kind of got diversified into working in ceramics, making master molds, and did a little turning for them on special occasions, but he didn't really have a set-up to make pottery to that extent. It was only on special orders that I turned anything there.

And then the war came on and I took a defense job with the Civil Service in Mobile, Alabama, and I went to Mobile in '41, in November of '41. And after the war I came back and settled there, and the first thing I did after I got back was build me a potter's wheel. In fact, it's the one I am using now—still using it. And I started working down there making pottery and working with schools, working with Boy Scouts, letting them learn their, earn their, merits, degrees, things of this nature.

CRM. That was in Mobile?

CM. Mobile. There was a ceramics shop out there in it that found out about me, and I made some pottery for them. Made it in my own shop, but when they had orders for some handmade pottery, I made several pieces for them. And then, of course, way down there, I had no way of firing. I didn't have a kiln or anything in Mobile. I'd pack it in my truck or car and head for Cleveland, Georgia, and then [laughs] I'd get up there with my cousin Lanier, and then we would—my uncles back then, there were two uncles who were still in it. There was uncle Cheever and uncle Q. [Lewis Quillian Meaders, 1885–1977], and they would fire for me and I would take it back, and then, in '65, they closed that Air Force Base and moved me up here. In fact, I was supposed to go to California, to Sacramento, but that was too far from north Georgia [laughs], and so I came to Byron, and the first thing I did was I built me a shop back here, which we will visit later on, and I've been—bought me an electric kiln. I'm still using the basics that we were taught all these years, other than the fact that here I use the electric kiln, but there again I still take a lot of my pottery to north Georgia to be fired. Been intentioned to build me one here, but I'm kind of wish-washy whether I was going to live here or move back to Cleveland and up there, and so right now I think I'll just live at both places. I may still build me a shop—I built me a

shop up there now, but I'm just using it for more or less storage. Since I've retired—I been retired for a little over a year, nearly two years now—and I've gone into it nearly pretty much full time. Demand keeps increasing and increasing, and once you start, you can't get away from it.

Gerald Stewart tells how
he and his brother got started.

CRM. Did you learn from your father?

GS. I learned from my father.

CRM. And did you take over his shop when he died?

GS. Yeah, I just kept on, me and my older brother, Tom; he was a potter too.

CRM. When did Tom die? It wasn't too long ago, was it?

GS. No, he hasn't been dead but—time passes so awfully fast, I can't remember.

CRM. Well, anyway, within the last ten years.

GS. Seven or eight years he's been dead.

CRM. So then there were three Stewarts [Gerald, James Thomas, and Winfred] with shops right in this area?

GS. Right.

CRM. Were you always located at this particular site?

GS. Me? No, I was down yonder at the old home place. Now, that was where I was born and where you ate dinner. Now, my brother, he moved over onto Highway 14 and built him another one. Of course, we all worked together.

As he works, Bill Gordy reflects on
his auspicious and itinerant beginnings.

CRM. Mr. Gordy, when were you born? You said you were seventy-one.

BG. May 18, 1910, the day that Haley's Comet came over. And last year Mount Helen erupted on my birthday. Quite a day!

CRM. Must be something to it—cosmic forces at work.

BG. I was born in Fayette County, Georgia, what is called now Peachtree City. It's still called Shakerag District, and I grew up mostly in Meriweather County near Warm Springs. Warm Springs is in the same county. I've been here forty-one years this July—no, forty-six years this July. I worked in North Carolina several years. I used to work for the Coles.

CRM. Which Coles?

BG. Herman Cole, the brother to—the son of J. B. Cole. Herman had a place just below Raleigh, at Smithfield on the Neuse River, and I, looking back over the years, I appreciated working there because, I guess, the days of working right there, at Hilton's, at Kennedy's, and even from my daddy, they put the pressure on you. You did it right or you got out; they didn't tolerate you. Especially the Coles. Now, that Cole. . . . They paid good money. We made the equivalent then to over a hundred dollars per day now, working there. We made good money then. . . . That was back in the Depression years, and we would make around fifty to fifty-five dollars a week—executive pay.

CRM. That was unusual though, wasn't it?

BG. The potters were unusual, too. And I don't mean I was one of the best. But we were making . . . everything that we made nearly went to Macy's in New York. A truckload went out every Friday, and you made by catalog. In other words, if you started on one piece, let's say it was a particular vase and that vase was number 111, and maybe you looked down on the order to Macy's and it said 200, and you made 200 or about 210 before you stopped. You'd go down the next order and maybe it would be 500 cups, and you'd make nothing but cups until that order was completed. And there several of us making, myself and the Craven boys.

CRM. Which Cravens were working there?

BG. Well, there was . . . one of them is dead now. Charlie was the oldest; he's living. Farrell, he was working.

CRM. He died just a few years ago [1972].

BG. About three or four years ago. We put out a lot of pottery there. We worked in different rooms, though. We didn't work in the same room, and as of today, if a potter was working under those conditions, very few would. . . . Things have changed so that people just won't take that discipline, you know. You were under strict discipline, which to me is good. I don't mean I'm the best in the world, but it helped me to be good. Of course, I worked for the Hiltons; that was the first place in North Carolina that I did work in.

CRM. When was that?

BG. Nineteen thirty-two and part of '33, in the worst of the Depression. Yeah, I worked there for thirty cents an hour. But thirty cents would buy two pound of country sausage. I never was out of job for very long at the time because I—I wasn't exactly a pusher, but I could make a fella see where he needed me.

CRM. After you left the Hiltons you went to . . . ?

BG. I went to Kennedy Pottery Company up in Wilkesboro. Right on the spot where the pottery is now, I mean where the pottery was, is the Holly Farms Chicken processing plant. Right on the spot—they bought the whole area. Of course, the Kennedys, they weren't millionaires, but they got rich and he left all of his kids in good shape—they didn't have to work either.

CRM. None of them went into pottery, did they?

BG. Yeah, they ran it. After I left, it got to where they couldn't get a good —they couldn't get potters. You went through a certain trend now that most of the potters wanted to be on their own, and Kennedy's case, a lot of them wouldn't work for him due to maybe you'd work six months and he'd say, "Well, we got a good supply on hand and I'll lay you off now for three months." What are you going to do when you are laid off? You gotta eat. You didn't have welfare and you didn't have unemployment [insurance].

CRM. So you had to go somewhere else.

BG. To another pottery. So people just got tired, but that was the way it was then. There was a few others like that, and I used to tell him when I was working there, "Well, why don't you stock up and reach a little out for business?" And, of course, I worked in the pottery part where it was all hand work; the other part made pots by machinery.

CRM. Stamp press or something like that?

BG. Yeah, they made 'em, thousands upon thousands. They carried pottery to South Carolina, North Carolina, Virginia, did part of Tennessee and [so on]. . . . But I enjoyed living there. It was in the Blue Ridge Mountain area, but I had my desires to come back here.

CRM. How long were you with Kennedy?

BG. About three years.

CRM. And then you went to Herman Cole?

BG. No, I went to Kennedy's and then went to—first I went to Smithfield and then went to Kennedy's in the spring, in April of nineteen and thirty-three, and then in the first of '34, I went to Cole's, to Herman Cole's in Smithfield, and then I came back that fall to Kennedy's. Kennedy told me, if I'd come back, "I'll pay you as much money as Cole is paying you." So I come back and I stayed there a couple of more years, and then I came here.

Lanier Meaders talks of fate.

CRM. Did you always want to do this?

LM. I never wanted to do anything in my entire life.

CRM. You were just left with this, huh?

LM. I was just forced to it.

CRM. You worked with your father for years, right?

LM. A little bit. He was the kind of man nobody could work with.

CRM. He'd have you in if there was a big order or something like that had to be done to help out?

LM. Well, if I didn't have anything else. I worked on public works up until '67. Of course, when I would get out of a job then, back here I'd come. And he couldn't work with anybody.

CRM. It's basically, I guess, you and the clay, and it's an individual's work; it's not a group effort.

Billy Joe Craven recounts his "accidental"
entry into the potting business.

BJC. My immediate family, my father and mother, were both farmers or worked in mill jobs. My father still works for the Hall County; my mother now works in the pottery with me. They were not in the pottery business at all. My daddy used to peddle pottery he bought from other potteries in the area. My great-grandfather was in the pottery business in White County, Georgia. His name was Isaac Craven. My grandfather's name was Bill Craven. When they were active, it was about the turn of the century, 1890 to 1900.

CRM. Your grandfather was not involved in pottery?

BJC. No, he was not involved at all.

CRM. So it was Isaac, then it skipped two generations, and then you?

BJC. Yes, that's right. We started this business in 1971, my wife and I. We had been married about five years.

CRM. Who is your wife?

BJC. Karen Brownlow Craven.

CRM. The Brownlow name was a well-known name in pottery in Georgia.

BJC. Yes, her grandfather was also in the pottery business. His name was Jerry Brownlow, and they were in White County, Georgia, within a half-mile of where my great-grandfather was in the pottery business. But we didn't know each other until we were late teenagers, and it was a coincident that we came from the same background. I worked with Hewell's Pottery, which is a local pottery, for approximately nine years prior to starting this business. I started to work with them when I was just a kid in school and was partners in the business there for approximately four years before starting this business, between 1966 and 1970. I went to work for them in 1963,

and I worked just as a laborer around the pottery. That's where I started learning how to make pottery. After work every day, I would go in and work on the pottery wheel or play on the pottery wheel for a while, and I picked up the trade working there.

CRM. Were the Hewells teaching you?

BJC. Very little instruction came from Mr. Hewell himself. One of his brothers, Carl Hewell, taught me a lot in pottery.

THE DISTAFF SIDE

**Marie Rogers* talks about
how she became a potter.**

CRM. Your husband [Horace] died in 1962, is that correct?

MR. Yes, he was already a potter. When he come out of service, we moved the pottery to here. His daddy [Rufus Rogers, 1881–1954] was getting really too old to fool with it, and my husband always wanted to fool with—make —pottery . . . and we moved it over here—just the wheels. Well, they tore down the old kiln and used what they could or did.

CRM. Bricks? Just moved the bricks over?

MR. Yeah. So one of the Stewarts [Tommy] started to turning for him, and his dad would do some turning for him when he was able—and my husband. I would go out when they would leave that evening and try to turn. And I would watch them, and then I finally kept trying, and then my husband would show me some, and I listened to how they'd fire, and I helped half of them do the glazing. I watched them do the glazing and how you strain it and stuff like that. So I got to where I could make one or two pieces. After you learn how to center one to one, you can do pretty good from then on, but you have got to learn how to center.

CRM. So after your husband died, did you just sort of take over? Or was there a lapse in the period between your husband's death and when you started seriously doing it again?

MR. Oh, yes. I waited a while before I started.

CRM. When did you start up again? On your own then.

MR. I imagine he had been dead about five years before I tried it, you know, getting started 'cause I had—one of the girls was eleven years old and the other fourteen years old, and I was staying pretty busy with them. . . .

CRM. Were there potters in your own family?

MR. No.

CRM. So you married into it?

MR. Yeah, I married into it. Sure did.

CRM. What sorts of ware do you turn?

MR. Just little pitchers, and I can make bowls and I make face jugs. That's about it.

CRM. I noticed some bean pots in there too.

MR. Yeah, I can make a bean pot.

CRM. Small ware basically.

MR. I don't try to make anything too large.

CRM. How do you see yourself as a potter?

MR. I just enjoy doing it.

CRM. Now, you are firing with an electric kiln now. Have you ever thought—you said you were thinking—

MR. Gas kiln.

CRM. Would you be building it yourself or . . . ? Because that's quite a job.

MR. Well, I wouldn't be afraid to try it. [Laughs.] But I just go to bed at night and go to thinking about things that you can do, you know, and all. But I believe, though—I've seen them do it.

CRM. Framing it up and everything? Centering it?

MR. I believe I could make me a small one if I wanted to. If I take a notion to lay brick, it doesn't bother me. I mean, I wouldn't want to build a house, but it wouldn't bother me. I believe I could do it.

CRM. Especially since you have no particular time set. Just do it. You're working; you are full time employed at Penny's? Where is that?

MR. Forest Park [Atlanta suburb near Hartsfield-Jackson Airport].

CRM. Forest Park? Just where is that?

MR. About forty miles. [Laughs.]

CRM. Forty miles? You drive forty miles, then come home and turn pottery?

MR. That's right. There's six of us that ride together, and I just drive them six once a week. But I don't mind. I used to. I thought when I first started, Oh, I won't like this, but it don't bother me now. . . .

CRM. Did you have any problems as a woman turning? Traditionally, the turners have been men, although I am not really quite as certain about

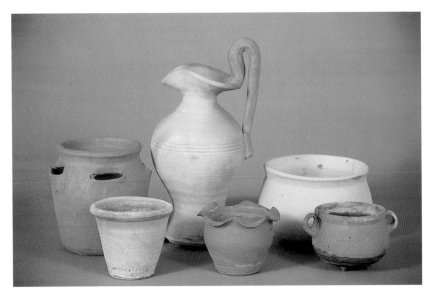

Otto Brown Pottery, Bethune, S.C. Unglazed horticultural ware, ca. 1975–78: Rebekah pitcher, strawberry planter, hanging basket, miniature washpot planter, and flower pots.

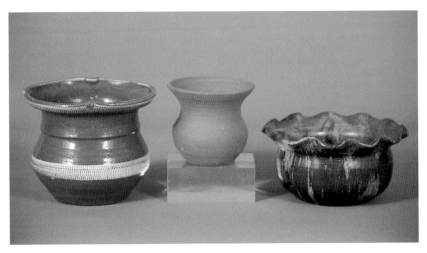

Matthews Pottery (Kenneth Outen), Matthews, S.C. Glazed and unglazed flower pots, ca. 1978.

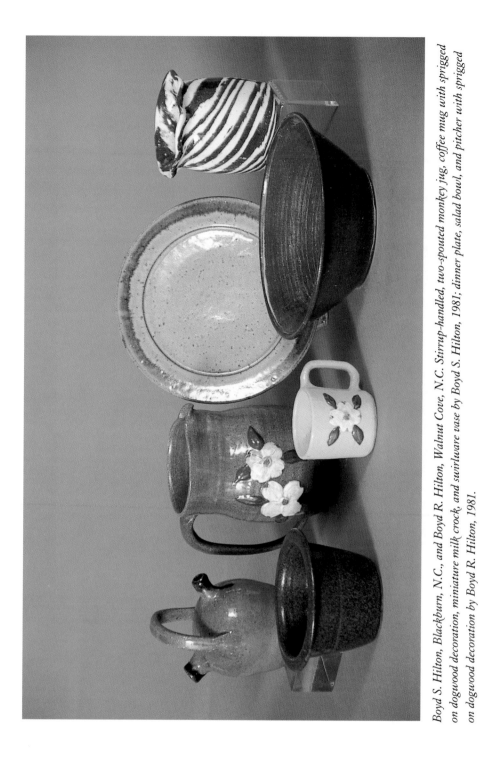

Boyd S. Hilton, Blackburn, N.C., and Boyd R. Hilton, Walnut Cove, N.C. Stirrup-handled, two-spouted monkey jug, coffee mug with sprigged on dogwood decoration, miniature milk crock, and swirlware vase by Boyd S. Hilton, 1981; dinner plate, salad bowl, and pitcher with sprigged on dogwood decoration by Boyd R. Hilton, 1981.

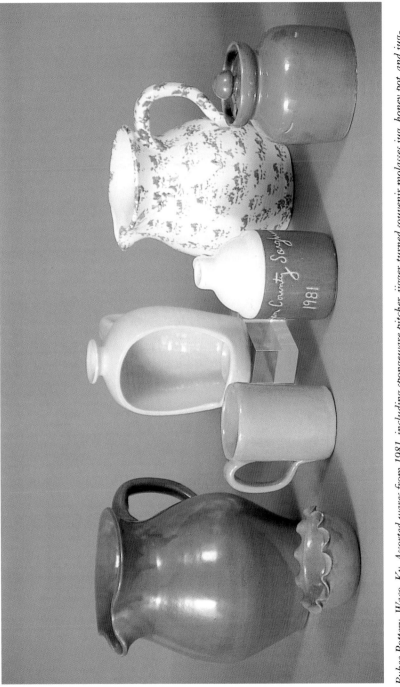

Bybee Pottery, Waco, Ky. Assorted wares from 1981, including spongeware pitcher, jigger-turned souvenir molasses jug, honey pot, and jug-shaped candle screen.

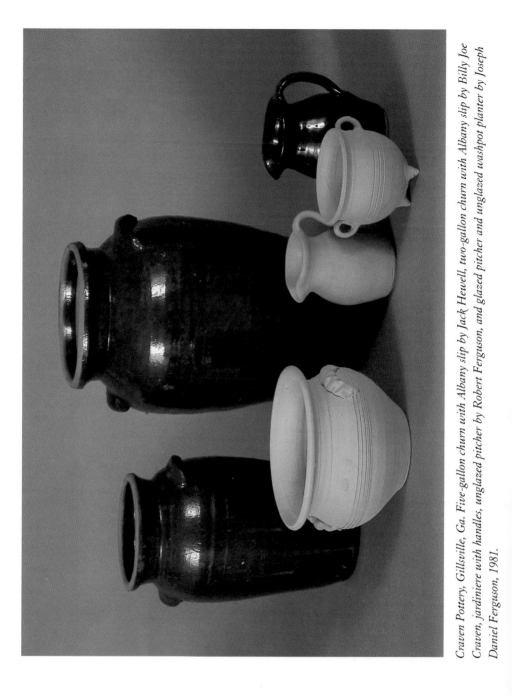

Craven Pottery, Gillsville, Ga. Five-gallon churn with Albany slip by Jack Hewell, two-gallon churn with Albany slip by Billy Joe Craven, jardiniere with handles, unglazed pitcher by Robert Ferguson, and glazed pitcher and unglazed washpot planter by Joseph Daniel Ferguson, 1981.

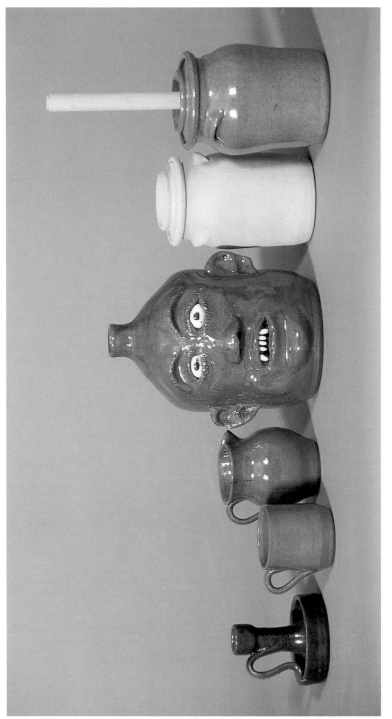

Cleater Meaders, Byron, Ga. Unglazed and glazed miniature churns, face jug, candle stick, coffee mug, and cream pitcher, 1981.

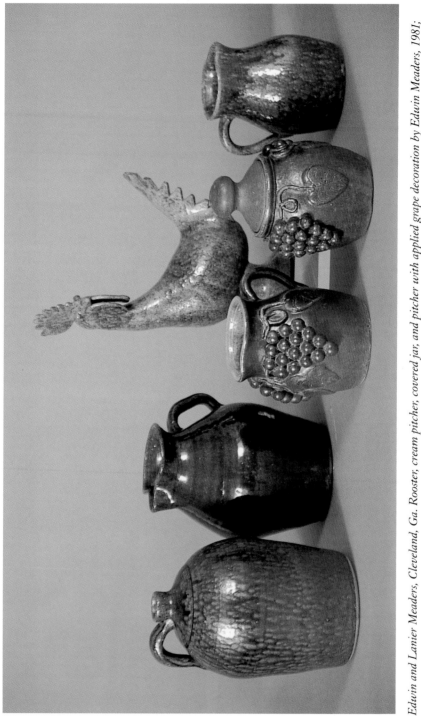

Edwin and Lanier Meaders, Cleveland, Ga. Rooster, cream pitcher, covered jar, and pitcher with applied grape decoration by Edwin Meaders, 1981; pitcher and one-gallon jug by Lanier Meaders, 1981.

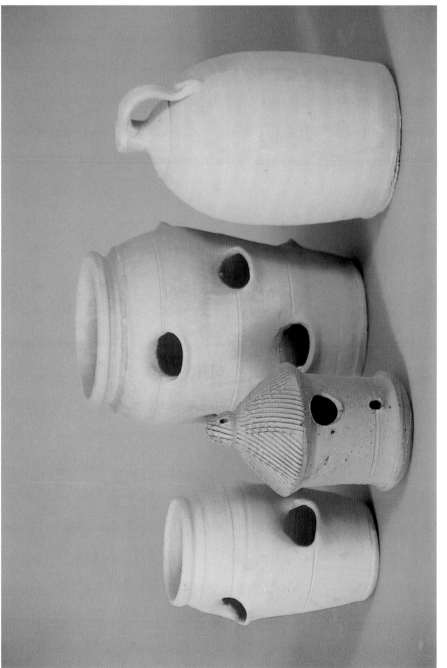

Hewell's Pottery, Gillsville, Ga. Unglazed horticultural ware, 1981: large strawberry planter by Henry Hewell, small strawberry planter by Kirk Hewell, one-gallon jug by Harold Hewell, and birdhouse.

Hewell's Pottery, Gillsville, Ga. Unglazed jack-o'-lantern and two miniature jugs with experimental glazes by Grace Hewell, 1981.

Hewell's Pottery, Gillsville, Ga. Unglazed large vase by Chester Hewell, two vases by Nathaniel Hewell, and miniature vase by Matthew Hewell, 1981.

*Wilson Pottery,
Lula, Ga. Unglazed
two-handled urn
and cactus dish,
1981.*

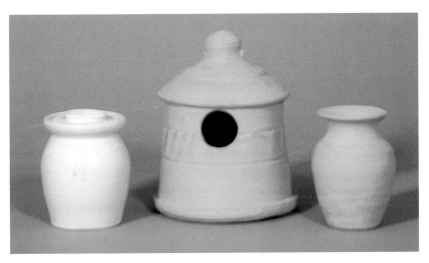

*Boggs Pottery, Prattville, Ala. Unglazed gourd-shaped birdhouse, and miniature churn
with white glaze by Horatio Boggs; vase turned by Ralph Miller, 1981.*

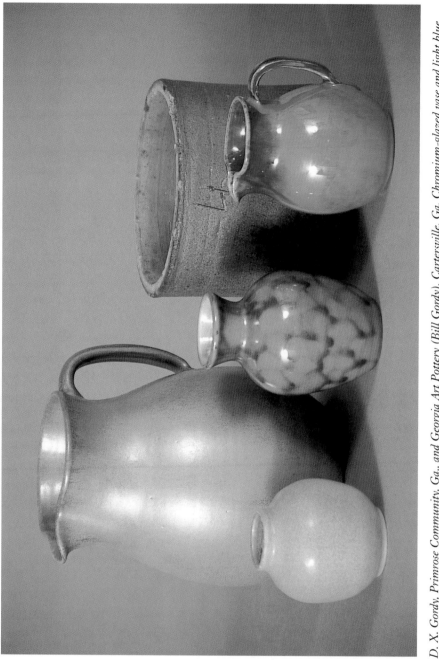

D. X. Gordy, Primrose Community, Ga., and Georgia Art Pottery (Bill Gordy), Cartersville, Ga. Chromium-glazed vase and light blue matte glaze vase by D. X. Gordy, 1981; mountain gold-glazed pitcher, blue-glazed creamer by Bill Gordy, 1981; and kiln sagger from Georgia Art Pottery.

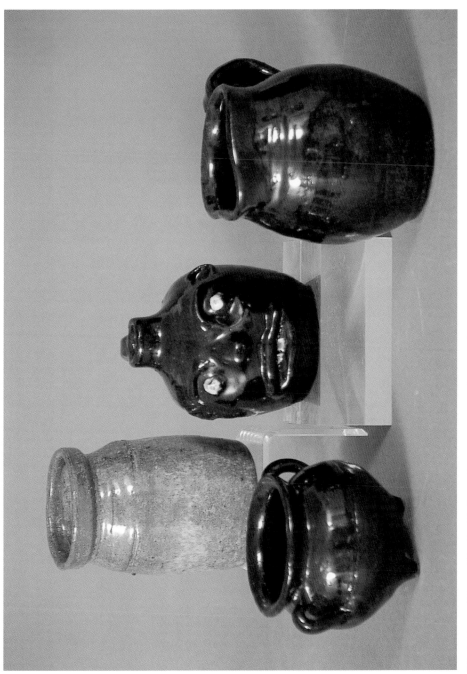

Marie Rogers, Meansville, Ga. Pitcher and miniature items: face jug, churn, and washpot, 1981.

Hattie Mae Stewart Brown, Hamilton, Ala. Flower pot with saucer and ashtray, 1965.

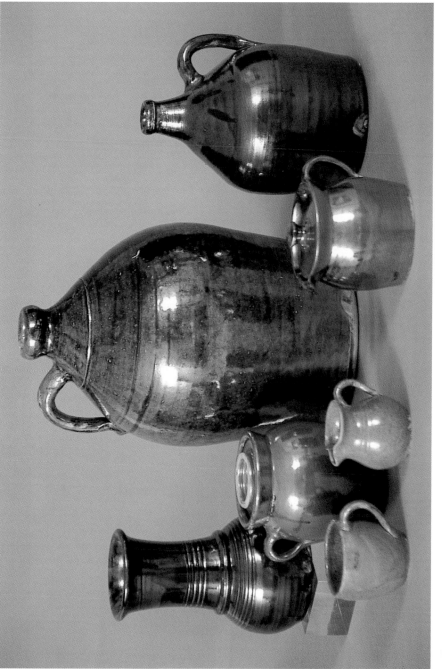

Miller Pottery, Brent, Ala. Three-gallon jug and vase with Albany slip by Kenneth Miller, 1981; one-gallon jug, lidded pitcher, miniature churn with Albany slip, and coffee mug and creamer with blue Bristol glaze by Eric Miller, 1981.

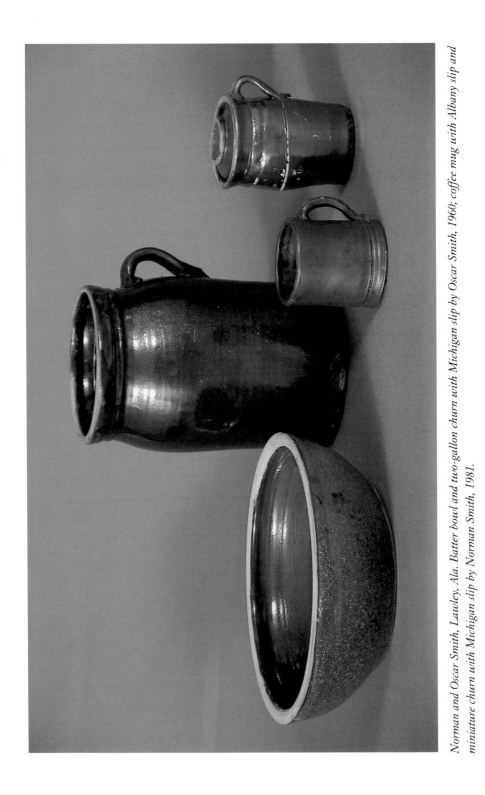

Norman and Oscar Smith, Lawley, Ala. Batter bowl and two-gallon churn with Michigan slip by Oscar Smith, 1960; coffee mug with Albany slip and miniature churn with Michigan slip by Norman Smith, 1981.

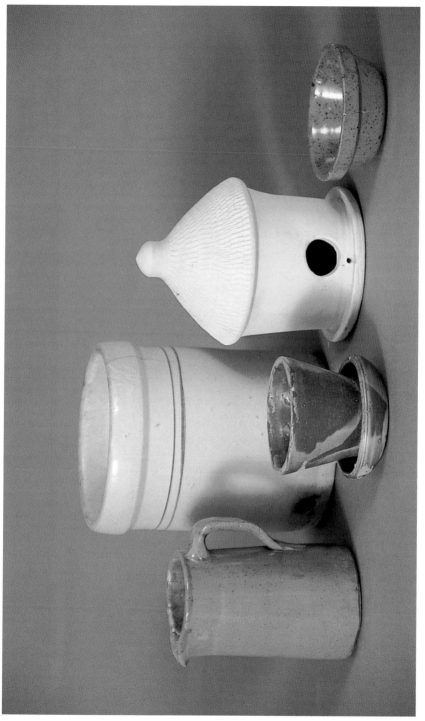

Joseph Duncan Pottery, Amory, Miss., and Connor Pottery, Ashland, Miss. Pitcher and jigger-turned bowl with blue Bristol-based glaze, flower pot with attached saucer with green Bristol-based glaze, and large horticultural pot with white Bristol glaze and cobalt blue banding by Joseph Duncan, ca. 1960; unglazed birdhouse by Howard Connor, 1981.

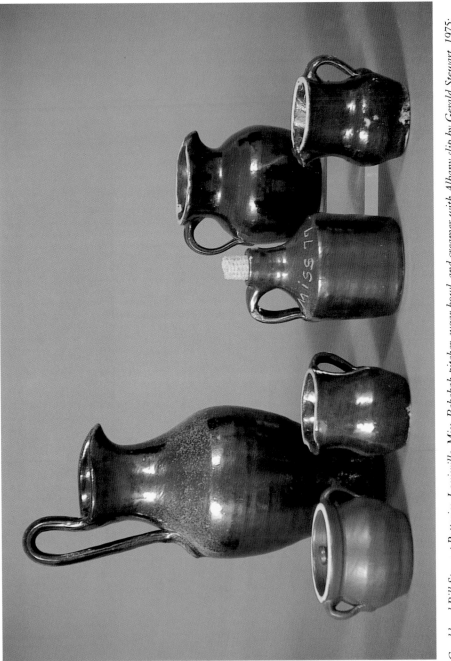

Gerald and Bill Stewart Potteries, Louisville, Miss. Rebekah pitcher, sugar bowl, and creamer with Albany slip by Gerald Stewart, 1975; milk pitcher, creamer, and miniature souvenir whiskey jug by Bill Stewart, 1979.

this as some people say it is. How do you feel about yourself, as a woman, as the turner?

MR. Well, I guess it's according to what you want to do.

CRM. You have no particular thought about it?

MR. A long time ago I guess they'd a thought something about it 'cause all the women had to do all the cooking and, well, a long time ago when they did make pottery it was a full-time thing for women to cook and do all the washing and the clothes and tending to children. Now we have such a lot of things. You have washing machines and dryers, and so much food is already ready to eat and you just don't have all that work to do, and you just have more spare time and you can do things.

CRM. Were your husband and his father interested in having you learn to turn?

MR. Yes, my husband. He was thrilled to death when he would see me trying, you know.

CRM. So he encouraged you all the way?

MR. Yeah. . . . Well, what do you think about women that turn?

CRM. I think it—I was supposed to do a paper this fall, I may do it next fall. At one of our regional art conferences, it was suggested to me that I do it in a session devoted to women in the arts and whether or not there would be anything in the area of traditional pottery, and I thought, first of all, well no, and then I began looking, and I was thinking of Neolia and Celia Cole up in North Carolina and Dot Cole Auman—and there are more women doing it now than one really thinks about. And in many cases, as in your case, for instance, as in the case of the Cole sisters up in Sanford, North Carolina, and Dot Cole Auman over in nearby Asheboro [Seagrove], it's the women who have, in large measure, kept the tradition going—where there are no sons surviving or they just have had an interest in the family and the tradition, they have kept it going. And I am very glad to have found you because you are part of that, too. I think it's a very interesting—it's a change because there was one folklorist who published an article several years ago saying that women have never turned pottery and are not involved with it, and I don't find that quite true. It may have been true actually in the past, although I wonder about that, and it's certainly not true now.

MR. Now, you take—some places you can go—you take that, who was that now? Gordy. He's got a brother in Cartersville. Well, he has a daughter that helps him a lot.

CRM. Sure, and his wife was involved with it too.

MR. I don't think she could turn, could she? But I know his daughter, 'cause I've been up there, and she would make a lot. She was making these little small pitchers, and he said she was a good potter. . . . But I just like to fool with it 'cause you get your mind off everything. Sometimes people will sit around and say, "Oh, I don't have nothing to do." But I can't get around to everything I enjoy doing.

CRM. When you started up yourself in sort of a full-time / part-time way that you do now, did you think that about in those terms—as giving your-self something to do—or did you think about it as continuing the tradition from your father-in-law and your husband?

MR. Yeah, well, I thought about that, and I really wanted Norma [her daughter], and I knew that none of the rest of them knew anything about it, and I just thought it would be great, you know, to carry it on.

Carrie Stewart remembers
cows, kilns, and children.

CS. I'm Mrs. Winfred W. Stewart, Carrie Stewart. My birthday is 10/30/11, and I have been married to this Winfred W. Stewart fifty years in August, and we have been on this place the time we been married, and dur-ing that time we were blessed to have fourteen children, all of which who are living and making their own living now. The baby one is twenty-eight years old. They have done quite well. Since they can make their living, I think that would be what I would tell you, that they have done real well and they don't have to call on me for anything, and my husband's father when we moved here was making pottery. He had a little pottery shop.

CRM. What was his name?

CS. His name was Homer Wade Stewart, and after he deceased . . . in 1932, and since that time, my husband continued to—for a while we didn't make any pottery, we only farmed, but we needed a little more support for the family, so he got for it to making a few pots.

CRM. When did he start back? Do you recall? Was it in the thirties or the forties?

CS. Forties, I suppose. And we was a family job. We all did our little turns, and in the meantime he had a dairy and we worked on a farm, and the time we didn't do that we were working in the shop. There was no wel-fare for us. No food stamps, no nothing. We had to work for a living, and with the help of the Lord, we did make it. And before my husband passed away—now, I don't know what year we sold our place to the boy, the youngest boy, but he built this shop.

CRM. What is his name?

CS. William Harold Stewart.

CRM. The son that bought the shop, he was born in 1949?

CS. He was born in 1949, but I don't remember the year we sold the place to him, but he has been operating it until last year, and there come such a slow demand that he couldn't make a living by making pottery so he's working at [unintelligible] Motors as mechanic now.

**Verna Suggs Duncan talks about a
lifetime connection with pot making.**

CRM. How did you feel as the wife of a potter?

VSD. Oh, I love it. When we first quit operation, the place was covered in pottery, and people would say, "Oh, you ought to sell that." And I said, Lordy, I just cry when I sell a piece 'cause when it's gone, it's gone, there is no replacing. Every potter has his own art. Nobody—you can copy it, but you can't make it look exactly like it. It's just like painting a picture, it varies. You can copy the style, but there will be a difference there. It won't be the same pottery. . . .

**Edwin Meaders talks about
his mother and her contributions.**

CRM. Did you work with [your father] at his pottery?

EM. I worked with Daddy from the time I was big enough to work in it, and I guess I was the last—well, Momma and him worked together the last few years after the kids got to, you know, where they could take care of theirselves.

CRM. She's the one who started doing the little animals, the roosters, that sort of thing?

EM. Yeah, she started making the pheasants, quail, then she started making roosters.

CRM. Is she the one who started out putting the grapes [on pottery]? Was that her idea?

EM. As far as I know, she is the one that started it, and I don't know of anybody else that did that, and, oh, it was nice stuff, too.

CRM. When did she start doing that sort of thing?

EM. Well, it's been, I guess it was—I don't know exactly the date, but I guess it's been close to twenty years.

CRM. She is still living, isn't she?

EM. She is still living, and she helps me out with it now. She helped me with my glaze and told me what I ought to make.

CRM. She had been around that shop for so many years.

EM. And she knows what goes good, you see. She's helped me a whole lot. She tried for years, before I ever decided to settle down to it, to get me to work at it.

Hattie Mae Stewart Brown*
talks about pottery involvement.

HSB. I would like to have a little place of my own. I could make stuff up to a gallon to sell. Those little ash trays, I made. I've got several other pieces I made. When my husband—he had a stroke before my children even got gone. That's the reason this boy got so good; he took over his daddy's shoes and he was a real good potter.

CRM. Did you learn from your father, from your husband, or a little bit of both?

HSB. Oh, I learned from all of them. I was in it all my life; started up in it, worked in it all my life.

CRM. So the pottery that you'd be selling in your family shop would have been both your husband's ware and your own, occasionally? Was there any difference in the ware your husband made and the type of ware you made?

HSB. Now, my husband could make a heap better pottery than I could make or anybody else. My husband was a real good potter.

CRM. You were saying that your husband was turning the larger pieces.

HSB. Up to fifteen-, twenty-gallon pieces he could make. Now, that's a large piece of pottery.

CRM. Was that pieced together, spliced?

HSB. They wouldn't hold up; he had to piece 'em. It took a lot of patience with that, too. And a steady nerve. After he got sick, though, he got so where couldn't do anything, and me and the kids were taking it over, and we run it so that we got it to where we made enough money so we could live off it.

CRM. When did your husband become ill?

HSB. Sixty—I think it was '61 he had a stroke.

CRM. When did he die?

HSB. In '65. He died in '65.

CRM. So in those four years, you and your sons were operating it?

HSB. He existed as a complete invalid for four or five years. . . .

CRM. How did you feel as someone growing up in a pottery-making family and as a potter yourself? Did you really enjoy it?

HSB. Yes, I really enjoyed working with pottery. I always did. It was hard labor. Then after I had my family of kids—I had two children of my own—when he got disabled, I just had to take the lead, and we didn't get enough out of the pottery and I had to go out and get a public job . . . , and I worked two years in a pants factory making pants.

Grace Nell Wilson Hewell
describes her love of pot making.

CRM. How long have you been turning?

GWH. Let's see, I got married in 1950, and I been making pots ever since 1952.

CRM. Did you just decide that you wanted to do it, or did your husband ask you to do it?

GWH. No, he didn't ask me to do it. I just always said that, when I married, whatever my husband done that was what was what I was going to do, whether he was a mechanic or a farmer or whatever, and he happened to be a potter, so I decided I wanted to make pottery.

CRM. Some people have said that women haven't done any turning. They may work around the shop a little bit, but they never do any turning. What do you think about that?

GWH. Well, I think women are missing out on the best part of the deal . . . 'cause, see, what I do, I make a lot of pots and I finish pots for my son, Chester, my husband, Harold, every day, and for my brother-in-law, Carl. I finish pots for them every day—every pot they turn and when somebody is on vacation. I finish pots off for Henry and his son. I finished off 1,700 pots Monday, putting holes in them—strawberry jars—and turned 210 pieces of pots myself.

CRM. How do you like doing it?

GWH. I love it. I'd have to like it to do as much as I do. I made 735 pots in one day and done a lot of finishing, so one day I'm gonna break a record, one day when I haven't got a lot of finishing to do. I've been making 400 of these this morning, and then I'll have all the strawberries of Chester, Harold.

CRM. Are these the tops for the pumpkins?

GWH. Jack-o'-lanterns. I'll be turning four hundred of these, and then this evening I'll be finishing every one of those strawberries. . . .

CRM. Do you do this all through the week?

GWH. Every day. I even do all my housework, gardening, the yard, flowers. I do everything. I don't have no help. Don't want none.

CRM. It must sit pretty well with you.

GWH. It does. I enjoy it. There's one customer that comes here that said I never have done a day's work in my life. He said I liked it too good; it wasn't work.

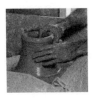

FROM CLAY PIT
TO POT SHOP

Edwin Meaders
talks about his local clay.

CRM. Where do you get your clay?

EM. Well, I get my clay about two mile and a half from here, in White County. It's a natural seam right here in the county.

CRM. I know Lanier said he got his clay—he had a big load— he got it from down near Macon, Lizella, but you are using the White County clay?

EM. And it works good. It's good working, good firing, good glazing, and I don't refine it. I just dig it right out, prepare it, and go to use it.

CRM. Do you have a mud mill here?

EM. Yes sir, I have my own clay mill, even got me the thing to beat glass in.

Bill Gordy remembers
old limitations.

BG. When my daddy grew up, you had to settle for what you had. You'd get your clay down here on the river, and you didn't know if it would work, and maybe you'd get another clay over on another river. Maybe you had two clays. But blended clay is far superior.

Carrie Stewart
discusses clay sources.

CRM. Where do you get your clay? Do you have a clay deposit here?

CS. When the children were young and all at home, they would just dig it out of one hole or another. After this boy started working, he had someone who hauls clay—and I don't remember the name—he would bring it by truckloads.

CRM. But it was local clay, though?

CS. Oh, yes, it's about ten or fifteen miles from here.

CRM. So you have an electric wheel now? It used to be a kick wheel?

CS. Yes, we started with a kick wheel. Our oldest boy, Charles, rigged this turning [wheel].

CRM. When was that? When did you change from kick to electric? Do you remember that?

CS. I can't remember when [probably early 1950s], but I remember he was the one who had Taylor make that head and rigged up the motor and all that. They had to kick until then. Had a kick wheel.

CRM. It's a rough job.

CS. Hard job.

Cleater Meaders discusses
the virtues of stoneware.

CJM. Basically, the number-one seller right now, as far as I am concerned, is tea pitchers, anywhere from a half-gallon to a gallon. When you drink tea that's been in a stoneware [pitcher], it has got a taste that nothing else has. Like these mugs that we are drinking this tea out of now; it just gives it a taste that you just can't get out of a glassware or a plastic.

CRM. And it stays cooler longer, that's one of the great advantages.

CJM. It stays colder longer—cups, too, as far as drinking coffee out of it.

WHEN THEY TURNED

**Marie Rogers talks of
farming and potting.**

CRM. So you can see yourself continuing this sort of evening/weekend
occupation? Of course, that is the way a lot of potters really worked, didn't
they, as farmers and then also as potters?

MR. Well, that's what my husband and them would do. They would farm
part of the time, and . . . when it went to raining or something they would
make pottery, and then in the winter time when they didn't have anything
else to do.

**Horace V. Brown Jr.
recalls seasonal ware.**

CRM. Your father's pottery was not a seasonal sort of pottery? You know,
some potters, they farm part of the year and do potting the rest. This was a
full-time operation?

HVB. Yes. My dad did farm some at one time, but not a whole lot of
farming. Well, what happened was that your flowerpots was your season,
like in early spring. Then in the fall, your churns was in season for kraut and
pickles and stuff like that, see. So when a flowerpot season would begin to
go out, you'd start making churns for the fall, and when the churns started
to go out, you'd start making flowerpots for the spring until he got into the
vase thing.

HOW THEY TURNED

**Marie Rogers comments
on the vocabulary of turning.**

MR. Now, we always say "turned." Now they "throw." I don't know what the difference is. I was raised to saying "turning."

CRM. I was discussing that with Cleater Meaders the other day, and we both were saying that the implication of "throwing" pottery sounds rather damaging, as if you would be throwing pottery across the place. Turning is what you do. The wheel turns and you turn the clay with it.

MR. I can't understand it. These people that's doing the pottery now, that go to school or do any, they always say, "We're throwing it," and I say "turn," and I've asked a lot of them, "Am I saying it wrong? I've always heard it's, you know, it's turning."

CRM. That's how you can tell a traditional potter from a studio potter.

MR. Yeah, that's right.

**Eric Miller on
wheels and clay**

CRM. Have you used a treadle wheel or kick wheel?

EM. No, I never have. They changed over to electric just as I was getting big enough to start trying to do anything. They got electricity in, so they changed over.

CRM. Oscar Smith was just telling me just a little while ago that that made him throw his hip out.

EM. Yeah, I imagine.

CRM. Standing up using that—and that's why he had to stop; his hip just went out.

EM. I don't see how in the world. That was a job, to kick a wheel, turn thirty pounds of clay.

CRM. What sort of pounds of clay do you turn now?

EM. The biggest piece we make now, Kenneth [Eric's second cousin, b. 1921], he throws. He can throw a fifty-pound piece, but it's so hard, so hard. It's too hard.

CRM. Do you piece your churns? Or are they a single piece?

EM. He can throw a whole piece. I would have to piece it if I tried. About thirty-eight pounds is about as big as we turn.

Harold and Chester Hewell
look back on the turner's wheel.

CRM. Now all the stuff is hand-turned on an electric wheel.

CH. Most all of them gas and electric moved by hydraulics. We got a few that is just straight electric.

CRM. When did you switch over from the treadle, kick type?

HH. Well, they had—even back when Dad was in South Carolina—they had a gasoline-engine-fired wheel, but they had a lot of kick wheels back then. In fact, as late as 1940, someone still had a kick wheel. We got rid of all of our kick wheels. We don't have even a one. I wish we had kept one.

Edwin Meaders discuss the pros
and cons of foot and electric wheels.

CRM. Do you use a kick wheel or treadle wheel or do you have an electric wheel?

EM. I had a treadle wheel, but I built me an electric wheel.

CRM. It's a lot easier using an electric wheel.

EM. Yeah, it's easier, but I find me trying to work my foot sometimes.

CRM. Force of habit, eh?

EM. I had a habit of stopping my wheel with my foot, you know. . . . I've got a fella over here making me a treadle wheel now.

CRM. So you think you're going to go back and use that?

EM. 'Cause I can just control it better.

CRM. Will you use the electric for some things?

EM. It's just according to how I like that. He's been working on it since last spring. He's been working on it, and he's just about got it completed, and he's making a good one, that's what it is. . . . And I'm just thinking I'm

going to use that treadle wheel. There is just something about that electricity that I just can't get out of the habit. I just can't get used to the electric wheel. All my life since I first started and I could just barely see over the top of Daddy's lathe, and the treadle wheel is still in my mind, and I can't get it out.

CRM. That's the way it was done and that's the way you would like to do it?

EM. That's right.

**Howard Connor discusses
mechanized wheels.**

HC. We used a gasoline engine with the line shaft at Toone [Pottery in Tennessee] 'cause, see, we didn't get electricity in at Toone. . . .

CRM. So you had stopped using the treadle wheel.

HC. Yeah, gosh, I don't know, 'cause our pottery I'd always consider was updated. See, we had the gasoline engine that pulled the line shaft. . . . I always said, you know, you start a pottery under a shade tree, and I said, you know, we went back twenty years later, and you know what we found? That same old potter kicking that kick wheel under the shade tree. 'Cause I can actually go out and dig a hole in the bank out yonder or go out in the woods and cut a few posts and set up a clay mill and go to work. Old kick wheel. . . .

CRM. Did you ever use a kick wheel?

HC. Not a lot.

CRM. You grew up with a gasoline drive. Then went to electric?

HC. Kick wheel. Course, I'd have to use it a few days to get [the rhythm], but I do remember enough that my daddy said to me to pinch a piece on his left leg, and you couldn't. It was as hard as a wheel.

**A pitcher takes shape with
Cleater Meaders* at the wheel.**

CJM. People often wonder, why does a potter take and rub his hands over the bottom like this?[43] When you pull it, you kinda stretch that a little bit, and all you're doing is you are setting them pores back in it, otherwise the bottoms will crack out. It's just a matter of working the clay. I always try to pull the clay and leave the top smaller than the bottom. That way you always have control of it. This clay is real pliable. You can do just about practically

43. It took Cleater Meaders six minutes to turn the pitcher he was making as he described the process.

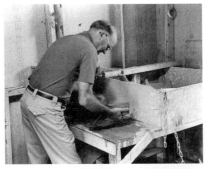

1.

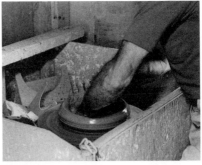

2.

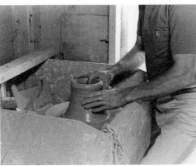

3.

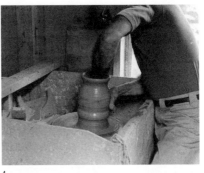

4.

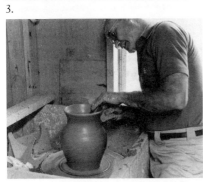

5.

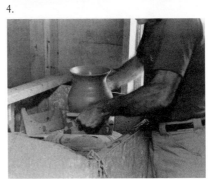

6.

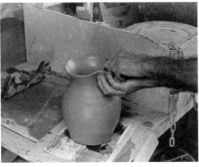

7.

Cleater Meaders turns a pitcher.

anything you want with it, like I say, without any ingredients added to it, it's just pliable and plastic to work with it. It shrinks a little more than other clay, so you have to compensate for that on everything when someone wants a different size. I pull most all of mine with my hand altogether, using my knuckle because my finger, my forefinger, as number one, and I apply more pressure on the outside than I do on the inside. I more or less just follow the inside with my outside hand and gradually bring it up. . . . As I said, kinda putting more pressure on the outside hand makes the bottom always a little wider than the top, but there again it's about the only way you can keep control of anything. I usually pull it about three times. By the time I've pulled it three times, I've got the clay pretty well even all the way through. Along about this time now, when I pull the clay straight up and got it even all the way through, now is the time a fellow has got to make up his mind as to what you are going to make. Another thing on pulling clay is that after the first pull, the less water you use on the clay is the thinner you can pull it. The more water you use it slows the rpm of your wheel down, and the less water you use, the thinner you can pull it. I've got a little bit too much clay here. I didn't measure for the regular-size pitcher I've been making, but it doesn't matter, they'll all sell. One potter can pretty well tell who made anything if he is familiar with him—like the Meaders here. I can look at one, or any of the rest of my brothers or cousins can look at one, and pretty well tell you who made it or if my father or one of my uncles had made an item. Even though they all basically look alike, they still have their—each has their little characteristics that's different from the others. My father didn't put too much shape to the neck of his pitchers. His pitchers are more or less straight up. I try to bring mine, the neck, in a little bit higher than he did and flair it out a little bit more at the top. The more you flair that top out and set your spout, it has less runback; it doesn't have much runback when you are pouring tea or something out of it. See that piece is about—oh, I suppose about thirteen inches high—and after it dries and burns, it will end up about eleven inches. Of course, that is just a wire, you see, that you separate it from the base with, and I've got some of these, what you call, bats—nothing but pieces of wood, but that's the name we're using—and I always put a piece of paper on the bottom of that. That wood on that thing, especially that plywood, will dry out the bottom fast and could cause a tendency to crack. I made me some metal ones. Of course, there again I worked in a metal shop, and to me they worked a little bit better and I can pick those things up— you see how easy they work on a pitcher. I can't pick up a heavier, it would have to have a handle like that five-gallon churn over there, and then, of

course, I am making this spout. I just guide it with these two fingers so you'll have a little kind of ice catcher, and then it will kind of keep the roll back off of it too. The handle will come later. It's too soft to put a handle on now, and all I'll do is just work up some clay by hand and work it out to the shape I want it, and tomorrow—as hot as it is, today, late this afternoon—I can put a handle on it, and I will. And that's another pitcher made for someone.

Walter Lee Cornelison
remembers the stoneware turners.

WLC. The people who turned for my grandfather—now, these are common terms. I don't know if you have heard these terms from other potters or not. They are common for us. We used to say our potters were heavy handed. Any potter that ever turned stoneware, he turned very thick because stoneware had to be because stoneware was stacked in the kiln without saggers, and when they got way up there, if they had left one piece thin, then it collapsed and that whole stand went down and knocked over against another stand and you had a mess. So they were pretty heavy when they came time to making art ware. They couldn't change or didn't change, and the pitchers, there was very little shape to them—just more or less the suggested shape and vases and things like that.

CRM. It is quite a change from doing the standard churns and storage pieces and stoneware to what you call art ware.

WLC. That's right. And thinning the walls out and things like that until they are, you know, desirable and that evolves slowly down through the years. Even some of the potters that were here when my father had it—he took it over when my grandfather died in 1939—some of the older men that were here still made their pottery that way. Then, as a new generation of potters come on, they started evolving until the shapes—they are better shapes in my opinion, and I'm not trying to knock the older potters because they did their thing in their way, the way it must be done. If anybody wanted to follow them and handle as much clay as they have handled and center it on a kick wheel and make it—and I am sure you've seen some of this in the South—it's fantastic the strength those men had in their hands and shoulders and arms to do that.

CRM. Do you know Burlon Craig over in North Carolina? He's a big bear of a person and doing alkaline-glazed stoneware in traditional shapes. He's just a big person.

WLC. I have seen small men that could do it. We had a man here who was slightly palsied, and it was fantastic to see him pull a large amount of

clay. His first pull he used that backhand draw to get it, and he would reach his hand in with palsy, and he would pull it up, and the ripple would run all through that clay all the way to the top. And he used what he called a draw rib, and he hooked that rib in under the clay like this, and he'd hook it and pull, and he would roll this rib around like this, and it was all out of there, and that first pull was straightened up. As a kid I stood awed by him.

CRM. Who was he?

WLC. He was a Cornelison, Webb Cornelison. He was a cousin of my grandfather, and he worked here for him and worked in other potteries around here. I don't know where he learned. I think his father was in the pottery, and maybe he owned a pottery here because he used to tell the tale that before he could go to school he had so many jars, fruit jars, to make. It was just that way—before he went to school—and he was a tremendous potter. Now, when it came to shapes and things like that, it might not be fair to him. I knew him when he was getting older, but the shapes weren't that good when I knew him. Never will forget one day he was making what we call an eighteen-inch vase like that. He made it and just set it off, and I was standing there watching it, just a kid, and that thing just gradually wilted over and dropped. Well, I thought that was the funniest thing in the world. I laughed, and he ran me right through that front door. His ego had been wounded, I'm telling you.

**Piecing a pot as
told by Boyd S. Hilton**

BSH. Now, have you ever seen anybody make a two-piece pot?

CRM. I've heard about them, but I've never been in a pot shop when someone was doing one.

BSH. Are you interested in that?

CRM. Yeah, that's an interesting process.

BSH. Well, we were talking previously about turners and throwers. A journeyman turner was not considered a turner if he couldn't make a ten-gallon jar. Now, that was one of the old criteria of being an accepted turner. If you couldn't make a ten-gallon jar unassisted, you were not considered a journeyman turner. Well, you can't make a ten-gallon jar out of a lump of clay in one piece. Mechanically, it's impossible, because if the clay were that stiff to where it would stand up, to make it out of one piece, it would be so stiff you couldn't mold it—form it—with your hands, and if you did, it would crack.

CRM. Not only that. The reach is a little bit difficult.

BSH. The reach is terribly difficult, but anything three, the old rule of thumb was, anything three—I'm quoting the old-timers—gallons or larger you made two pieces and there was no law against making a three-piece jar. According to how you felt about it and your skills and how you started.

CRM. A ten-gallon would be two or three pieces?

BSH. At least two. An expert potter could make it in two. So nowadays, a potter will tell you that if he's going to make a ten-gallon jar, he needs two wheels. And he will go and add a piece every day and build it on up the size he wants. You've seen these five-foot-high vases? That's the way they do 'em. In the meantime, the bottom portion is dried enough and then tough enough that it would take and hold up whatever you put on it the next day. And you'd have you another wheel over there to make you another collar and put on it and go on further up.

You understand that? But the two-piece wheel—the two-piece jar, that's what we were talking about. Anything three pieces, three gallon or larger, irregardless of shape—and there's no such word as "irregardless," and I know it—regardless of shape, you had to make it two pieces or more. And the way you did that, you made the top piece first, the top third or two-fifths or somewhere in that percentage—even half. You made that first but didn't complete it. What you did—there's two ways of going at it, and one of the old-time terms is "throwing off the ball." Or making the top first. And they do not mean the same thing. If you—we will take up the term "throwing off the ball." He will weigh up his clay, he will wedge it and work it on the wedging board, and he will go along here. Let's say he was going to make a five-gallon jar, which is a nice-size wine jar or pickle jar or home-brew jar. Well, he needs twenty pounds of clay, which is a sizable lump of clay. And he's got it wedged and worked to his satisfaction, and it is, from his knowledge, the right consistency, which is stiffer than if he was making a two-gallon size or a mug or a one-gallon jar or anything. He'll use a stiffer clay because he has to. He will throw that on the wheel and center it. And right then is when the sweat comes out; you start centering twenty pounds of clay on the kick wheel. It'll even bring the sweat out on you on the powered wheel sometimes to get it running dead true, and it's got to run dead true. You throw that mess of clay on that wheel, you've got to get it running dead true before you ever open it up or you'll never make your pot. If you are "turning off the ball," he will open up about the top third of that clay. If he gets it running dead true, he will make him a dimple in the top with the heel of his

hand, and he will open up according to his custom with his thumbs or with his fingers. He will open up down about one third of the total weight of the clay, and he will move that ring out to the outside edge of his ball.

CRM. He's not using a ball opener on this?

BSH. No, not using a ball opener. You can if you'll block the ball opener up 'cause I do it that way. You with me? I'm talking about the old-time way of turning off the ball. He will not use the ball opener. He will move the ball, pull it out, and he will have a nice big ring sitting there, which I said is about one-third of the total amount of clay or maybe two-fifths—it could even be half. He will pull that up in a thick cone. And make a round, flared-out top to it, sort of a collar. And the clay may be an inch thick up there, but he's got it in a cone shape. And he will not use his wedge, he will just use his fingers, and when he has that cone top part to suit him, he'll cut it off with his needle tool or his ice pick, whatever he's using, right at the bottom of the opened-up portion, leaving the solid mass in under it. You with me so far? And then he will hook his hand around it like this—and you can't get this on the tape, but you look at me. He will take his wrist and hook it over there, and he'll pinch that collar like this, and this is a real thick collar, maybe this big around on the outside layer, maybe no bigger than this around, and he's putting his hand around it right under that collar and pick it up and set it over on the bat. It will slightly distort, but his clay's so thick there's no problem then. He will set it over on the bat to get it out of his way. Then he will go ahead and make the bottom two thirds of the jar in the conventional fashion by centering what he has left. Using his ball opener and pulling it up and getting it all at the right height he thinks he's aiming at. I haven't lost you? He will not make it as big at the top as it will finish, but he will make it as big at the bottom as it is going to be because one of the secrets of making a two-piece jar is you can't work that bottom with all this gravity fighting you up here on the top after you set that top part back on.

CRM. That's what I've understood.

BSH. That's the reason you make it in two pieces, because you can't fight that gravity. If you get down in the bottom of that jar after you set that top on it, with your rib, and do much to it other than just a little smoothing job, it will squat purely from gravity. That top part of the clay is pushing the bottom down.

CRM. So the bottom part has to be finished?

BSH. The bottom, the very bottom six inches, especially, has got to be finished inside and out, because you can't work it once you set that big and

heavy top on there. If you've got twenty pounds of clay and you've got, let's say, seven pounds of it in the top.

CRM. This is determined in gallon capacity, not only from sight but also—

BSH. But also from experience and maybe craftsmanship.

CRM. The weight of the clay too?

BSH. The weight of the clay, too, and also perhaps he may even set his height gauge up, which ordinarily he doesn't do that until he gets the top on. Because experience tells him about how, and he can feel how thick the walls are, and he knows what shape he's aiming for. He will pull them walls up there and get him the thickness he knows will stand up according to the consistency of the clay and what size jar he's making. And he will flatten out the top of it. And all this has got to be running dead true, now, no wobble. He will flatten out the top of it, feel it with [his] finger or with his rib until the top is flared just a little bit right at the last quarter-inch, like this, to give him a little more welding space up there. He will reach over and get his same grip he had on the top part. In the meantime, he has measured. He knew exactly the diameter of this thing that he has on the wheel, both by his eye and by his stick, perhaps, or even by a rule, and he will go over and measure the bottom of his top part, and if it's not exactly the same diameter, he can, if it's too large, he can flare out what he's got on the wheel to match it. And if it's too small, he can run his fingers around the inside of this pot that's sitting on the vat and flare it a little bit. Or he can close up the top part, because the welded portion comes up about two-thirds in the height.

CRM. How does he keep working the continuation of the curvature?

BSH. That's way on down the line. We still haven't got this top on here yet.

CRM. I jumped ahead too far, okay.

BSH. He will set it down on there, and if he's been successful, it will match exactly the diameter. He hasn't distorted the bottom; he's only distorted it up there at the top. Then he will set it down on there and touch the wheel, the fly wheel, with his toe just enough to move the wheel around as he gets one hand inside and this big old mean thumb outside, and he will weld that clay together. A good potter can do it so that you cannot find the joint inside or out. He will go all the way around it just with this one hand in and his thumb on the outside, brushing it a little bit or pushing it a little bit or pinching it a little bit, whatever he thinks it needs, until he has this top on there—homogeneous is the word I am trying to say. With what he's

already got. Then he will start his wheel turning slow, and he will take the distortion out of the collar. And he will make everything run true again. He doesn't cut it off with a needle tool; he makes it run true, because it's still got to go back to running true, and he has distorted it. Then when he gets that done, he will come back in and he will flare out his welded end portion where the seam is to his approximate curvature. Right there, working inside with his hand and outside with his rib. And then, when he gets that done, he'll go to his height gauge, and if it's not [the correct height], he sees how much he's going to pull up the top portion, which is still thick and capable of being pulled up several inches.

CRM. He's left it thick deliberately?

BSH. Left it thick deliberately so he can handle it and so he can pull it up from the mound. And he'll pull it up just like he did the bottom part. The tips of those fingers and that right there knuckle does all the dirty work. You should have been able to see it 'cause my description might leave a whole lot of wrong impressions in your imagination, though I can see you are visualizing what I am saying.

CRM. Yeah, except, of course, it's sounding like it's taking hours, but of course it's not.

BSH. It doesn't. It doesn't take as long as I've took to tell about it. Then when he once gets that central curve flared out the approximate diameter, he will go ahead and thin out and pull up and form this top portion to whatever size, shape that he wants. If he's gonna make a jar he'll put a nice little curve in it up here, flare out the ring that makes the lip. If he's gonna make a pitcher, of course, well, then, well, he turns out a bigger ring and thins it out.

CRM. He can apply handles or whatever he wants to do.

BSH. And gets it ready for the handles and so forth. And if he's gonna make a Rebekah pitcher, that gets even much more complicated, but do you understand the general way? And he will go back down maybe, perhaps, six, [or] about four or five, inches from the bottom if he wants to get a little flair down there, but he will do it very gingerly, because if he starts working that clay down at the bottom with all that weight on it, it's gonna squat, even though it's stiff clay. You've got too much gravity to fight down there. That's the way they make a two-piece jar. And I saw many of them made.

CRM. That's why there are not too many of them made nowadays.

BSH. Yeah. Well, it's not too bad, but—until you get smart and try to make two-piece swirl. Then you're really up against it, because what you're trying to do is—

CRM. How do you match, how do you match that up?

BSH. You can't, but you try. And sometimes it comes out good.

CRM. Do you do much of that?

BSH. I try. I'm not good enough at it. I'll show you the only two-piece jar I ever thought enough of to fire. It's sitting right here. It won't take me but a second to get it.

Horace V. Brown Jr. describes the production line in his father's shop.

CRM. How many turners did you have in the shop when it was going [in the 1920s and early 1930s]? How many wheels were going?

HVB. Three. They had what you call racks, and of course the racks were on logs, really—the shop boards, they called them—and they would set stuff on them. They would pull that board out, and then you had a stand to set that board on, and whatever you was making—jugs, churns, flowerpots—when you filled it, then you'd just shove it back on the rack and pull you out another board and fill it up and shove it back in . . . and then they would go in the sun, and when they got, well, just as soon as they could be turned bottom side up—they used to call that finishing—they'd take that little whisker off the bottom, you know, where they'd cut it off the wheel. That they called finishing.

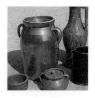

WHAT THEY TURNED

**Carrie Stewart recalls
what her family made.**

CRM. What sort of things did you produce, let's say, during the—you said your husband started back up again somewhere in the 1940s? What sort of ware did you produce? Did you produce garden flowerpots, garden things, or did you produce churns and jugs and crocks?

CS. Well, churns, jugs, pots, and flowerpots, Rebekah pitchers, birdhouses, urns, jars, dog waterers and feeders, rabbit feeders, chicken waterers. . . . They made lots of flue liners in that time.

CRM. Those will be coming back with wood stoves, I expect, too.

CS. We've had these few made over here for a year and they haven't sold.

CRM. What was your production level? That's a bad way to put it, but were you producing a lot when the pottery was full-time active in your husband's day?

CS. Well, I'd say this: it was according to how much grass was growing in the field. We would work in the field, and we had to milk cows, and what time we had left, we made some pots, you know, to help with the income.

CRM. Was the pottery turned all during the year or was it just during certain seasons?

CS. No, in the summertime mostly.

CRM. Right, because of the cold?

CS. Yep, it's cold and it freezes, you don't use it. It's ruined if it freezes, and it will freeze quicker than water. It will spew out like a road bank, if you have ever seen a road bank spew out.

**Gerald Stewart* describes the variety
of wares he and his family made.**

CRM. In what year did you turn your first pot? Do you remember?

GS. I was very small then; I was just a small boy. About twelve or thirteen years old.

CRM. And what sort of ware was your family producing then?

GS. Mostly churns—churns, jugs.

CRM. And when did you start doing the garden flowerpots, garden supplies?

GS. Along about 1930, 1935. My brother, he started making pots.

CRM. What was the largest size churn you were putting out?

GS. Ten gallon.

CRM. Ten gallon? That's a good size. Was that built up? Did you splice it together?

GS. Well, yes. I spliced it just one time.

CRM. That's a good long reach you have.

GS. Yes, that sure is.

CRM. Can you tell me something about the general shop practice when you were turning? What would the procedures be within the shop? You got your clay from nearby. That was hauled in for you?

GS. Yes.

CRM. And your Albany slip was brought in in barrels?

GS. Yes, in barrels.

CRM. What would you do? Would you start concentrating on one thing like, let's say, let's make crocks one day and jugs another?

GS. That's right. . . . I'd just go right down the line making them. I'd just work on one thing the whole day. I could make a hundred three-gallon churns a day.

CRM. That's a sizable output. . . . When we were in the shop a few minutes ago, you were making some grave markers. That seems interesting. Can you tell us something about those? Were they used all over in this area?

GS. Yes, they are used all over in this area. As I told you, they are used for their lot, to keep their lot. They put one on each corner.

CRM. You said you glaze the bottom part?

GS. No, the top, and bury it in the ground about eight inches, seven inches. You know, where a lawn mower can run over it without breaking it.

CRM. So you sell them as corner markers? Was your father doing that too?

GS. No, he didn't do that; now that's just something new.

CRM. Did they have them back then?

GS. Not as I know of.

CRM. Who came up with the idea? Did you come up with the idea? Or did someone come to you?

GS. My older brother, Tom. Sure did.

CRM. Had he seen them someplace before or just thought they would be a good idea?

GS. Well, I think somebody come see him about them, to make 'em, and that's how he got started. Of course, we got them markers all over this county and got some out of the county. Sure have.

CRM. These Rebekahs. Where did you get the idea for them? Or has that been a traditional in the Stewart family?

GS. It has.

CRM. Do you know where they got the idea?

GS. They come out of the Bible.

**Verna Suggs Duncan remembers
what they used to make.**

CRM. What sort of pottery did you produce through the years?

VSD. Churns, pitchers, flue thimbles, flowerpots, vases, birdbaths, birdhouses—flue thimbles, that was a good seller was flue thimbles.

CRM. So the general utilitarian ware the community wanted?

VSD. Yes, general pottery.

CRM. And did you produce both glazed and unglazed ware?

VSD. Glazed and unglazed. . . . The pieces that are scattered in my yard, round and about, are the pieces that was made here at the pottery, and people beg me for them and I gladly say no. I guess I could have sold some for a big amount. Well, I did sell one old ugly jug that I didn't care nothing about —I think it's ten or twelve dollars or something years ago—that I didn't like and didn't want. They were just, oh, so proud of it; it had a little face mounted on it. And that is just something the arts people collects or something.

CRM. Did your husband and your father make them?

VSD. No, we didn't make them; it was a gift to me, but I didn't care nothing about it.

CRM. Were there any of those, they are sometimes called "voodoo jugs" or "face jugs," made around this area too?

VSD. No, that was from the Browns that drifted around. Brown from over in Georgia made it at Daddy's pottery, that's where that came from.

CRM. Do you recall any of those voodoo jugs being made up here in north Mississippi, east Mississippi, at all?

VSD. I don't know of any that was made.

**Hattie Mae Stewart Brown
describes her husband's pots.**

CRM. What was your general workshop procedure? Would you do orders for garden pottery?

HSB. We got lots of orders for garden pottery.

CRM. And those were flowerpots.

HSB. Flowerpots, planters, we sold lots of them, flue thimbles. . . .

**Annette Brown Stevens* talks
about what her family turned.**

CRM. As you begin remembering, or from what you have heard, what sort of ware was he [her grandfather, Otto Brown] turning then? He was doing his own turning?

ABS. Oh, yes. They'd make—they were making washpots, and strawberry jars, they were making the thimble, the flue thimbles, the Rebekah pitchers. They made the little face jugs.

CRM. They made face jugs, too?

ABS. Yes. And flowerpots—all sizes. They had all sizes of Rebekah pitchers and flowerpots, too.

CRM. Were they glazing the ware at that time, too? I know in later years, when I knew your grandfather, he did very little glaze work. Were they glazing?

ABS. The only thing I knew they would glaze were the face pitchers. And they made dog dishes and rabbit pots and they would glaze them, and that's about all that I know they would glaze.

CRM. That was Albany slip glaze?

ABS. No, it was a gray color. . . .

CRM. Has your husband—have you—given a thought about what sort of ware you would like to produce? Would you like to continue with the garden ware or do glazed ware?

ABS. Well, if we could do it, I would want it made the same as my daddy and granddaddy made—to me that was pottery.

**Kenneth Outen talks
about what his family made.**

CRM. When did you stop turning here at Matthews Pottery?

KO. Well, we stopped turning for a period of about twenty years, and then back in '72 or '73, we went back to handmade. The demand for garden

pottery and this type stuff was beginning to come back, and we just went right back to the way it used to be.

CRM. What sort of hand-turned ware was that?

KO. It was just mostly bowls and this type stuff, and washpots and strawberry jars.

CRM. This was earthenware? And it was unglazed then?

KO. It was unglazed. . . .

CRM. You said your grandfather did Albany slip, and I presume it was stoneware then?

KO. Right.

CRM. And you also said you did some salt glazing. When your father took over, was it predominately then earthenware or were they still doing stoneware?

KO. It was mixed. We had one section that done the handmade stoneware; we had one section that made the flowerpots.

CRM. Do you recall about when the last pieces of stoneware were turned here?

KO. Around 1946.

CRM. About the same time you stopped doing the glazing?

KO. Right. Stoneware, you know, without the glazing is not very useful.

CRM. It was totally Albany slip as far as the glazes you were using? And that was actually Albany slip coming down in barrels from New York?

KO. Yeah.

Horace V. Brown Jr. discusses an addition to his father's pottery line.

HVB. The fire department and the state got together and, you know, there was a whole lot of chimblies [chimneys] on houses then and [he] did at one time get heavy into—they had to have this, what they call, a flue lining, and that got into a pretty good business, and that took most of the time, too, and that went away after they started making molds and stuff and square, and he didn't have the molds, so that's when he drifted into the art part of it then.

Bill Gordy discusses his preference for art pottery.

BG. Well, let's go back about twenty-five years. The last twenty-five years, pottery has skyrocketed, any craft has, not just pottery. People have

learned the value of it. Where prior to World War II, you just had a few people that [understood that] . . . but today it's different.

CRM. Now, when you started out, there was, of course, back in the late thirties, there was a continuing demand for, I guess we could call it, the traditional utilitarian pottery, the crocks and the churns. . . .

BG. Well, I never made many churns here. At the beginning of World War II, I did fire a little wood kiln, you know. At that time, we had saggers. When I came here, I had been making churns for several years. Frankly, to tell you the truth, I kinda like to make a churn occasionally, but I haven't made one in ages. I must say that I believe that I made as pretty a one as there was in the country, but there's no money in them.

CRM. So you stayed away from the churns and the jugs and the simple vessels, right?

BG. I stuck, more or less, in the pottery line—it was still traditional, but it was more in a Pennsylvania Dutch line, if you know what I mean. Early American.

CRM. Why did you pick that?

BG. Well, it's going to sell; you can sell it.

CRM. The people around here were a different sort of buying public?

BG. Well, really a lot of the southern potters, you know, are oriented from the Pennsylvania Dutch potters, and even though they were Yankees, but they were German in descent. No, I kind of grew up under that, and I worked with so many potters that worked the same way, you know. . . . I went in more for decorative as well as utilitarian type wares, too.

CRM. Was that partly under the influence of the Hiltons or the Coles up in North Carolina?

BG. No, I learned it from my own influences. You know, I'm quite a talker, and I could preach my way up. And then I had the early blessings of the University of North Carolina, Georgia Tech, University of Georgia, University of Alabama. When I was in my mid-twenties, I was a good potter. Well, people would read about it, and I'd go out prior to World War II and I'd put on an exhibition at some school, maybe Rich's in Atlanta, or Sears Roebuck's or someplace. I always got paid, except the schools didn't. . . . But anyway, I was getting known. Then I'd go up to Chattanooga, and to Nashville—I mean, Knoxville—and this goes way back. And I began to get known to the public, and I wanted to make something traditional but I wanted to make the best. I've always used the very best in materials. . . .

CRM. What gave you the idea of leaving the jug/churns/kitchen—you know, straight kitchen utility items—aside and getting into this?

BG. I can answer that one real easy. Work. That's hard work. You ever try splitting rails and digging ditches—that's making churns; any potter will tell you that. Another thing: when I quit, churns was selling, a five-gallon churn was selling—about the best you could get for a five-gallon churn was $1.50. That was starvation wages. I knew I didn't have to do it; I didn't want to do it. I learned the trade on churns and jars. Big pots. I appreciated I learned on big ware because it gave me a sense of how I could handle the clay on small ware. I do appreciate that, and I used to love to make a churn. I used to love to make a big jug. . . . No, I kept having the desire I'm going to quit these churns. I still make one, every now and then. If I make one today, it's costing thirty-five bucks . . . and it's going just like that. I might even get more than that. The last ones I sold, I sent them up to Washington, D.C. . . . They were real churns. My churns had the handle and an ear just like the old ones—early Georgia, South Carolina churns and Alabama. Georgia, South Carolina, and Alabama made them pretty much the same. You go to North Carolina, you got a different trend or design, but Alabama, Georgia, South Carolina were pretty much about the same.

CRM. You can throw eastern Mississippi in there too.

BG. Right, Mississippi, and even Texas.

CRM. Well, the potters from Texas came from this area. . . . You've been making pottery for fifty-four years. How has it changed? Has your attitude towards making pottery changed?

BG. I haven't changed it 'cause the people won't let me. I would really like to get in here, you know, since my pieces are made collector's items, I would really like to make a collector's item piece. In other words, when I say that—like a neat covered jar, vases, things I got in my mind I sometimes don't get to do—instead of, see, I'm just finishing up now; it's a hundred cups and I still got more. And then I've got to start all over again on cups. There's money in the cups, but it's not what I really want to do. I've reached the age now where, you know, I want to do what I want to do.

CRM. So you have got shapes and forms and concepts in your mind.

BG. Right. Just like painting a picture. I don't need anything to go by; it's already there.

**Howard Connor discusses
the wares his family made.**

HC. My daddy would never allow us to buy any pottery. The only thing we could sell was what we made. After my daddy passed away, though, then

my brother started in distributing and making pottery and adding other lines with buyers, making more a complete line.

CRM. What sort of things were you doing then? Were you doing glazed ware?

HC. Not as much glazed ware. More into garden pottery.

CRM. Was it still stoneware?

HC. Well, no. You wouldn't class it as stoneware. What we always classed as stoneware was glazed.

CRM. Yeah, but I mean, there is a difference in firing temperature. Stoneware is about 2,300 degrees and earthenware about 1,800 or so.

HC. No, no, we had to fire it about 2,000 degrees to body our clay. If you could cut your firing time your clay would body out at a lower temperature. But we were still using the same old stoneware clay, old Porter's Creek clay.

CRM. That's from here?

HC. Yeah, and from Jackson, Tennessee. That's the old Monroe Pottery that used to go back many years ago.[44]

CRM. You were getting your clay from there?

HC. Well, two places from up there; we'd mix it.

CRM. Now, you stopped turning for production yourself in 1967?

HC. Yeah, yeah, right, 1967.

CRM. Why did you?

HC. Well, we had a fire. The pottery burned on November 18, 1967.

CRM. Was it a kiln fire?

HC. No, the building burned. It destroyed the machinery, and we was employing somewhere around twenty-five people, 'cause we had about three or either four jigger wheels and two potter's wheels. We was running two kilns.

CRM. Who else was turning then?

HC. I had E. S. Harris and myself that turned on the potter's wheel. Of course, we had jigger wheels, the first ones in the area.

CRM. You said you used some molds for the chickens and the—

HC. Oh, yeah, we run around two thousand molds. We had the pottery in the old building; it was 150 feet long and 50 foot wide.

44. The Monroe pottery mentioned here was probably that operated from about 1880 to the early 1900s by Charlie Monroe in Madison County, Tennessee. See Smith and Rogers, *Survey of Historic Pottery Making*, 118.

CRM. It was quite an operation then?

HC. Oh, yeah, yeah. We run as high as thirty-five employees. . . .

CRM. What was the last sort of stuff you were doing?

HC. Garden pottery, birdbaths, and special pieces, stuff we had. People come by. *Better Homes and Gardens* give us an ad. They'd see the pictures, and they'd come and have you look at that picture and have you tell what size, you know, whether it's this wide or that wide. . . .

Do you know the reason why they went to a shoulder jug? To set it [the kiln] solid jugs and they didn't have stilts and other stuff like that. . . . You know why they made that shoulder jug? So that they can take a—they'd throw another piece, a collar, what's called a collar. They'd take the glaze of this shoulder. If you'd notice on a shoulder jug it's just made for it—you can tell a production. 'Cause they'd take the glaze off of here so that they can this collar down on here and set the next jug on top of that and that's why they sold shoulder jugs . . . otherwise they'd just have kept the old-fashioned jug shape. Then your "Jimmy John" jug was your, you know, a long spout with your handle on each side. Jimmy John jug they called it. Oh, I can throw, you know, make any of those pieces.

CRM. Now, were you all making the shoulder jugs?

HC. No. Now, you couldn't give a jug away when I come along. What could you use it for? Now, my daddy used to make all five-gallon jugs 'cause all your whiskey makers used to use that.

**Quillian Lanier Meaders describes
his adventures with face jugs.**

CRM. I've got one of your face jugs at home. There is a lot of demand for those, I expect.

LM. I guess there would be yet.

CRM. Have you stopped making them or slowed down a bit?

LM. Quit. I don't know whether I've just slowed down or quit on them. I just got to the point where they were hassling me.

CRM. I mean, as far as the work that goes into one of them because you can't turn them out like this [Lanier is turning pitchers while he talks].

LM. When you promise somebody something, it seems like everybody in the world is determined that you're not going to keep that promise. Well, I just quit.

CRM. Why do you think that there was that tremendous interest in face jugs?

LM. Well, it was something that never was made before, I reckon, in the history of the world.

CRM. Who started it up here?

LM. I don't know who started it. They've been around ever since I was in the army. But never in quantity. I reckon that every potter that's ever been has made one or two, but they never made them in any quantity.

CRM. Your father made them too, didn't he?

LM. He made one or two. He probably didn't make a dozen in his entire life.

CRM. It was a specialty of yours for a while, or at least people thought of them in that way. How did you get started in making them in quantity?

LM. Well, it was the Smithsonian that got me started on them. When they come here, they found one back in under here somewhere. You know, like a ferret they look everything over and they decided that would be a good item to make. They ordered some of them and I made them, a couple of hundred of them, and from then on it just became a full-time job.

Horace V. Brown Sr.* makes a face jug as remembered by his son, Horace Jr.

CRM. Now, Javan's and Davis's potteries up there, the Brown potteries up there [Asheville, N.C., area], they make what's called a face jug. You know, it's a jug that looks like a face. It's grotesque—a "voodoo jug," an "ugly jug," sometimes it's called.

HVB. I believe he started that. There was a piece that was on television here back a few months ago where this guy up and around Cleveland, Georgia—

CRM. Lanier Meaders.

HVB. Got a whole shop full of face jugs. Well, Daddy started that. And the reason he started that was a dentist. I don't know whether he liked to pull jokes and stuff like that, well, he'd fill 'em full of whiskey and give them to his friends. Well, it got to where Daddy'd make 'em and put like glass in the nose, and it would look like the nose was running and the effect that the eyes was running and some sometimes red stuff they'd put on 'em. Oh, he had all kinds of stuff.

CRM. When was he doing that? When did he start that?

HVB. Oh, I was a small kid.

CRM. Where did he get the idea to do that? The dentist suggest that?

HVB. Yes, that's where it come from. Yup.

CRM. The dentist suggested doing this?

HVB. Yes. From Tenth Street [in Atlanta]. I can't even remember his name no more. When you run a pottery, you have a lot of people coming in. They got a lot of ideas. Daddy said always to listen to what the dumbest person says 'cause you don't have to use what they say, but you can get an idea from them. But he wanted one made with a face on it. Now, I don't know where he got the idea, but that was way back, over fifty years ago.

CRM. Was this dentist from Georgia?

HVB. Yes, he had a place right off West Peachtree Street, on Tenth Street, and Daddy had gone down to have some teeth work done. He made friends easily. He could go anywhere and just in a little while he'd made friends. So this dentist and his wife came out to the pottery.

CRM. So he suggested doing that?

HVB. That's where the face jug come from.

CRM. And everybody else has picked up on the idea.

HVB. That's where the face jugs from. . . . When they started making the face jugs, they had a round showroom and had this, what they call, hardware, you know, cloth—rabbit wire—that was enclosed with rabbit wire. Course, the shelves for everything was in that circle there, and he had a lot of those face jugs in there. And a lot of times you'd come in the door and the women would see one of those ugly faces there and they'd say, "Ooh." And that's where the face jugs started, and it was started from a dentist, it wasn't from a potter.

CRM. I guess he especially liked the idea of seeing the teeth?

HVB. Oh, they had all kind of teeth they could stick, like chinaware. They'd crack up some and take some of that and make some teeth, and then they'd take even broken pieces of pottery and stick them in sometime. Oh, he had that red stuff you know—look like somebody'd hit him in the mouth, you know, and the blood was running out of it. He had all kind of things.

CRM. You don't have any of those around, do you?

HVB. No. I had one and I gave it to my cousin. Well, what I did with it, I had one and a policeman brought me some corn whiskey. Of course, that's been several years ago, and I put it in that face jug and I let him, my cousin's husband, have it—they was in the bonding business down in Atlanta, and he wanted to take it to the office and give everybody, his friends, a drink out of it. It was a really ugly one and it just got gone. Somebody stole it, I guess. I don't know what happened to it. I don't have anything of Daddy's. There could be a lot of stuff dug up in the yard of that shop. I was telling one of my sons not too long ago that in the next two or three hundred years, they

will be digging in there sometime finding all that pottery, and they'll say with all that Indians been here.

CRM. No, no, they'll know.

Quillain Lanier Meaders*
comments on being hassled.

CRM. So how many pitchers are you doing now?

LM. About 150 a firing.

CRM. How long does that take you?

LM. Oh, I make about anywhere from twenty to thirty a day. . . . Of course, that don't mean that they are finished.

CRM. That's setting out as greenware, right?

LM. Right. I could make fifty a day if I wanted to. You know, I've been hassled here 'til I've reached the point where I ain't going to be hassled no more. People come in and they want one damn piece and that changes the whole setup for the person that's started out.

CRM. One special piece?

LM. One special piece, and it don't make any difference that after it's finished it's just like all the rest of them; you can't tell the difference.

CRM. What you'd rather do, is do a straight line, do your fifty pitchers and then do your fifty this or that, so forth, and keep going in straight production?

LM. That's right. Or maybe a hundred of them.

CRM. That's because you'd have the rhythm of doing it?

LM. That's right. I really don't care any more whether I do anything at all anymore. I'd rather just be out of it.

CRM. But you can't—you're an institution. . . . Do you have any preferences in what you prefer to turn?

LM. No. That's one of the things that—part of the spokes in the wheel. I never know what I'm going to do; I never know what I turn. I might come up here in the morning with the intention of turning pitchers and can't even make a pitcher. I have to make something else.

CRM. So it's just how you are feeling? The hands do the talking?

LM. It's wherever the spoke on the wheel is at.

CRM. Do you get much call for the sort of old staple churns and stuff?

LM. Every day.

CRM. What do people use them for? Do they use them for the traditional picklings and storage stuff?

LM. A lot of people would use them for that if they could still get them. A lot of people still milk a cow. A lot more of them are going back to it.

CRM. Some of the potters were telling me that if they were making churns now, they thought they were sure they could sell all they could make.

LM. The thing about it is that they would have to have so much for 'em that they can't afford to buy them.

CRM. A thirty-, forty-dollar piece of pottery, I guess.

LM. Not that much But if a person would break even making churns, he'd have to have five dollars a gallon, and people just can't afford that.

Billy Joe Craven talks about garden ware.

CRM. In visiting other potteries, I've visited both the single-person, old-time potteries and I've also visited larger potteries that have gone into the garden supply business, and a lot of them have turned to stamped pottery, press mold, and that sort of stuff. You have not. You stayed with the hand turned. Why have you done that? In a sense that makes you—even though your company is very large, even though your methods and technology and the equipment you use and the production method is right up to date, even beyond "to date," you have maintained the hand-turned traditions. In that sense you are very much a traditional pottery. Why have you done that?

BJC. Competition in the mechanical-made pottery has been keen in the past few years, and the market has been fluctuating from very good to poor. The cost of setting up a mechanical pottery is probably the biggest factor that's kept us away from it. Our abilities to make it and the knowledge of how to make it certainly has not been the reason we're not making it. It's been that the initial investment, based on a competitive market—we've decided to stay like we are.

CRM. Do you see your customers actually preferring the fact that you can say "handmade pottery"? I notice your catalog, right in front of me, says "Handmade Pottery" in big, bold letters. Do you think that has a lot to do with it? Do you think people prefer that sort of aspect?

BJC. I think that handmade articles will always carry a merit with it. I think it definitely has an effect on it.

CRM. It indicates to people the quality and—

BJC. The traditional pottery.

CRM. Do you see yourself staying with the handmade?

BJC. Yes sir, I do. I have a son and a daughter and I hope that both of them will come into the pottery business. . . .

CRM. Leafing through your catalog, I notice a variety of shapes and forms. How do you select them?

BJC. The articles we make are what we call our standard items. Most of them have been made for a number of years—longer than I can remember —and they are sort of standard pottery items. We do vary from those if it's within the tolerances of sizes we make; we can make any shape or figure that you want as long as it's round and our tolerance of size. We take a lot of special orders. They'll send a blueprint or drawing of what they want, and we can make it within a quarter of an inch of specification, and a lot of times when we get ideas from pictures in magazines or just come up with ideas for different shapes for an article, we'll try and fill the market. And if it's good, we'll add it to the line. A lot of the items in that catalog there, we have developed ourselves. I'd say there are at least twelve articles in the catalog that's my original—we've made them first. And probably the other articles have been handed down for a hundred years maybe.

CRM. I notice that you do have one glazed item, a glazed churn. What sort of people are buying churns nowadays?

BJC. Very few people buy them to actually use them anymore. There are a few people making kraut still buy them, but I'd say 80 percent of that market are for the modern home fireplace as an ornament.

Boyd S. Hilton describes
a backward swirl.

BSH. In one of my wilder aberrations I decided I was going to make some right-hand swirl. Now, swirl, if you were going to set any of the swirl pieces down, look at them. A machinist would say that was left-handed swirl. If you put down gear or a threaded nut or threaded bolt, he'd say it was left-hand threads. You understand the term? Well, now, that's the natural way it turns, and that's the natural way swirl comes out, when the wheel is turning counterclockwise, looking down on it, which everybody that I know of, that's the way they learn to throw. You don't have to learn to throw that way, and a kick wheel will run each way you start it. All the electrical wheels usually run counterclockwise, but any way you start a kick wheel that's the way it will run. See, no problem. I was going to make some right-hand swirl, which one of my friends called backward swirl, which it is. 'Cause I've still got this vision of making two vases—same size, same shape—one setting on each end of the mantlepiece going like this, you understand?

CRM. Yes, exactly.

BSH. Well, now, that's a personal idiosyncracy with me. I've been laughed at about it, so I started to make some right-handed swirl. That's one of the

awkwardest things I've ever tried to do in my life. Here I spent three years with the same hand inside the pot and the same hand outside the pot working, trying to get 'em to work together and pull it up and shape it. Here you got to do the exact opposite. Running the wheel backwards—no problem. But you got to put your right hand in the pot and your left hand outside, and the mirror image of what each one had to do, it's awkward as all get out. I did manage to make a more or less matched pair of bowls the first time I tried. They weren't very big and they weren't a real pretty shape, but they were acceptable. And I had some fun with them, too. A collector friend, who is pretty sharp, when I shoved them under his nose, one on each end, I said, "Now tell me, what's the difference?" And naturally, the way I did it on purpose he couldn't see the forest for the trees. He stared, he turned them upside down. He looked at the size of the stripes. He looked at each individual shape for a full three minutes. And then I had to tell him. I said, "Look at which way the stripes go." And he said, "Oh, they're backwards." And he bought 'em.

**Harold Hewell talks about the
different wares his family turned.**

CRM. Now you are turning out, I guess it could be called, garden ware?

HH. It's a garden ware.

CRM. Have you always done that?

HH. No. In the early days it was stoneware, churns, pitchers, and jugs, things people used.

CRM. When did you stop doing that sort of utilitarian ware?

HH. Beginning to stop about the end of World War II and to shift into the other stuff.

CRM. Any particular reasons why you made the change?

HH. We had a market for this and didn't for the other.

CRM. Do you do any stoneware now at all?

HH. No, garden ware.

CRM. Do you get your clay from around here?

HH. Most of it's local.

CRM. You don't do any glazes now?

HH. We don't glaze at all.

CRM. You used to in the stoneware days?

HH. It was all glazed.

CRM. What did you do then, Albany slip?

HH. We used Albany and a homemade glass glaze like my daddy did about the thirties—a mixture of glass, ashes, and clay.

CRM. That was pretty prevalent throughout the area, wasn't it?

HH. Well, that particular glaze wasn't. They used an Albany slip.

CRM. And your father just liked this glaze?

HH. It suited the clay he was using at that time.

Edwin Meaders* discusses the variety of wares he is producing.

CRM. What sort of pottery do you mainly make now? I notice that, in the kiln, you have some vase shapes, some bowl shapes with the typical Meaders grape motif on it. And then you had some pitchers in there, right?

EM. Pitchers with grapes on 'em, and I've got, I believe they call 'em, canisters, a straight-up jar with a lid, and it's got the grapes on it. And I've got a pot that's—it's got a lid and it has the grapes on it. And then I've got pitchers that don't have no designs on 'em, just a plain, old-time lip pitcher.

CRM. It's probably like the type I saw down at Lanier's.

EM. Then I've got some little jugs, like the old—small, but they look like the big jug

CRM. The old syrup-jug type or whiskey jug, whatever it was used for. . . . And then this rooster, you have, too, that's a nice idea. That idea you got from your mother.

EM. That come from my mother. She'd been after me for a long time to make them. People had been asking for them. She'd quit making 'em back when they quit down there, and she was still getting orders on and on, people asking, and she told 'em she wasn't making 'em. So she got after me to start trying that, and I started last year making 'em. People just took to 'em.

CRM. Lanier doesn't do anything like that from what I've seen.

EM. Well, he makes a face jug.

CRM. He makes the face jugs, but he doesn't make any of the roosters, the sort of things your mother did. I saw one piece with the grapes down there that he had done several years ago.

EM. Well, he quit that and went to just a style of his own.

CRM. Your glazes are sometimes similar to Lanier's. Your style is different, though.

EM. Well, it's about on the same line, but it's just enough so that it won't be exactly what he does. . . .

CRM. Do you do face jugs, too?

EM. No, no I don't.

CRM. So Lanier does the face jugs and you do the grapes and the roosters, et cetera? So there is a difference then even within the same family? A different style?

EM. Well, the reason I don't do things 'cause he's took that up what he's done and I don't want to interfere.

CRM. So would you say, then, that his ware is more typical of your father and your ware more typical of your mother?

EM. Yes, and that is about the way it is.

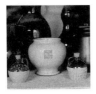

INNOVATIONS IN
TECHNIQUE AND STYLE

D. X. Gordy* talks of
heritage and change.

DXG. I thought I'd designed a new type kiln fired with wood, and this old book showed a kiln drawing where the kiln was built in Dresden, Germany, in the fifteenth century, so the pottery, my glazes, from what I have been told, is more oriental, but my methods go back to Germany, unbeknownst to me. So when you think of traditional art, I don't know. I been in pottery all my life. My dad made pottery, and he had uncles and great-uncles before him that made pottery. You think about tradition. I wonder what my tradition is. Pottery, of course, came down to me through him, but then my dad had people hired from everywhere and they were bringing in new ways of doing it. He had people from Pennsylvania and Texas and California working for him, and I remember lots of those people that were coming in and out, and each one would seem to have a little different way of doing it, so I wonder really where my tradition is. Other than that, I wanted to—in those days it was utilitarian ware—I wanted to make an art out of it, so I changed, but I still haven't changed my methods. . . . I try to do it different without changing. I don't want to change anything that's good, and I can't find any better method than the old methods of making pottery. I think it would be like changing brushes for the artist. . . . You can't take the brushes and canvas away from the artist and say, "Do something else."

So I think we already have the best methods—that is, as far as handcraft pottery goes.

Horace V. Brown Jr. recalls
potters, pots, and prices.

CRM. Your father had this big shop down—

HVB. Down in West Pace's Ferry. The expressway has took part of it. It's in the Buckhead area; well, it's three miles from where his shop was to the Buckhead area.

CRM. He had a number of people working for him?

HVB. Yeah, well, I guess Bobby, Javan, and all those guys worked for him when he had the shop there. They had a big round building, and that's when they started making the vases and stuff like that. Well, he was one of the first ones started that.

CRM. You mean the garden pottery?

HVB. Yeah, well, you know they used to take them and put the paint in a pail and put water in it and put paint in there and push the jar down and twist it and pull it back out. They made designs with different colors of paint on it. Well, that's what got it started—the reason he started doing the vase business. Used to be that jugs and churns and flowerpots was the thing, and I remember mostly jugs 'cause up in north Georgia they had the bootleggers. . . . Well, we had a lot of schools they came out. You know, they'd bring the children out and they'd watch them make the stuff.

CRM. This was when?

HVB. Oh, don't ask me years. I'm sixty-nine and it's been forty years ago. Well, when those people from Atlanta came out and then they finally started with this, I think Glidden started this paint. You'd put the water in, and you would pour the paint, and of course the paint floated, and they would just stick the vase down, and all the way down in, and twist it or shake it around and get all kinds of designs on it. That's when the vase business started, and the vases back then that you were selling for thirty or forty cent would be three or four dollars now. Of course, all the other potters picked up on this vase business. . . . My dad was going to buy some molds to make flowerpots, but he was making so many vases that he really didn't have time to make flowerpots.

CRM. He had started with the typical jugs, churns—standard utilitarian kitchen stuff—and by the end of the thirties had gotten into . . . ?

HVB. Well, no, I'd say that by the middle of the twenties, 1925.

CRM. He had gotten into the more artistic stuff?

HVB. Right, right.

D. X. Gordy experiments
with paints and glazes.

CRM. Where did you get the idea about painting on pots?

DXG. That came several years ago, before I decided I'd do it on pottery, but in school, as a child, I would draw, and sometimes they'd like me to draw pictures in their books. As time went on, I couldn't sell any. I'd do it because I'd like to do it. So, one day, I decided I'd try a vase. I didn't know anything about the paints that would need to go on pottery. So that led me then to think I'm going to have to experiment with them. So I'd get out and get my minerals and different things and I would make my—I would use these raw oxides as I found them. Sometimes they'd come out good, but most cases they'd come out bad because the colors wasn't stable. So I've decided again, I'd better read a little on that, and I got some books on making high-temperature stains and colors, and you have to fire them at a tremendous high heat so they won't fade out. So I got my minerals and I mixed them with water. I'd grind it and take them out, and take all of them out and dried it. Then I'd put it in the kiln and fire it at the hottest part I can find in the kiln. I set that right up next to the furnace. Get it hotter than I do the pottery so that it would be more stable when I came to draw . . . [unintelligible due to noise of passing truck] take it from the kiln. That makes it hotter than it was to start with. Those rocks are pretty hard; some of them are. So then I grind it twenty hours in my ball mill. First I puddle grind it with an iron mortar and steel, and then I put it in my ball mill and grind it twenty hours. I take that out and mix water—all I do is mix water with a little sugar in it —the sugar makes it adhere to the piece before it's fired . . . [truck noise] brush better and I found that works perfectly . . . [truck noise]. Sometimes in the high temperature it becomes more translucent and even transparent, but still all the color's still there. I have to like what I'm painting and I have to think what, how, is that going to look when it's fired, because the firing is going to change everything. I have to make the colors maybe a little deeper here, and then I'm doing a lot of subjects, scenes, make it look thicker one place with certain result than I would in another place where, 'cause just depending on the color of the oil, I have to darken my color. This way I have to build it up a little more to darken . . . [truck noise] that is, I scratch my design, and in most of my brushwork, I use that for the fine details, and then

I make all kinds of tiny animals and figures, people, and anything, but I can't give up my pottery and my glazes. I been experimenting too long with my glazes to give that up, so most of my pottery just have glazes without any other decoration.

Horace V. Brown Jr. remembers
European connections.

CRM. Did you help your father in the shop?

HVB. Yeah, I did for a long time. I guess one of the reasons that I never did go into the pottery [business] is that we had a German. His name was . . . I can't remember his first name, but his last name was Malettna [?], and he came out, and after Daddy got into the vase, art pottery of it, and he made some molds. We made a lot of vases, three or four foot high of different designs. And we shipped some to—I forgot what part—but Europe. We shipped a lot of them over there. It's been so long ago, I don't remember what part of it we sent them to, but we had one man there who just made crates to ship that stuff.

CRM. You actually had one person making crates? It was that big a business?

HVB. Right. And this Malettna, he taught me how to use the molds, and that was my job, so I never did get much on to the wheel.

Bill Gordy explains
his role in the transition.

BG. I said the day is coming around that the demand is for a different thing. It can be traditional, but it has got to be better. Well, I don't mean I had a better foresight than anyone else, but I saw it coming. I knew it was there, and I must say I'm the one that set the example for all the southeastern potters to try and improve their wares.

CRM. And also the fact that the business is not going to be in syrup jugs.

BG. Right.

CRM. I guess it was about that time—well, I guess it was after that, actually in the mid-thirties, that A. R. Cole and the others up in North Carolina decided to get out of the old traditional stuff and start doing this sort of thing.

BG. They had to do something better. What they were doing—first what they were doing then, the government would turn it down today; they would just not tolerate it. You see, they was making some glaze that was pure red lead, and they was using them themselves. I wouldn't use them. I was so afraid of it, I didn't even like to go into one of those places.

CRM. That is why, in the early nineteenth century, potters stopped using lead-glazed earthenware and got into stoneware, salt-glazed stoneware.

BG. That is true; it started in Europe.

CRM. Then they started going back into lead glazes when utilitarian stoneware wasn't popular anymore.

Ada Adams Hewell talks about her husband,
Maryland "Bud" Hewell's, efforts to modernize turning.

CRM. Where was he when he started the gasoline-powered wheel?

AAH. He was working for John Hewell, his half-brother.

CRM. Did he design that wheel himself?

AAH. Yes. He drew a picture of it and then carried it to [unintelligible] in Gainesville.

CRM. And they made it for him.

AAH. Yes.

CRM. Was that the first of that type around?

AAH. That was the first there was. And he had the first electric. They all went to it later on.

Bill Gordy on
ceramic schools

BG. Schools. They're not as close with secrets as they were, and not near, near as close, 'cause when you get a lot of people together you can come up with some good ideas, you know. Now, one of the things that's a little bit wrong with a lot of potters that are coming out of schools today—and I don't approve of it—they all get together and swap ideas and they're all—you watch now, you go to a craft show—every one of them nearly have the same color. You know what I'm saying; they swap formulas. Well, mine is differ- ent, and that's the way I want to keep it. . . . Now, you take D. X. down there. I could give him every formula I got. You think he'd ever use one? Never.

Wayne Wilson comments
on turning and wholesaling.

CRM. Now, all the pottery you produce here is handmade, right? You don't use any press stamps or molds or that sort of thing?

WW. No, all handmade. But really we haven't produced pottery like we should have. We got off into buying and selling pottery.

CRM. I noticed some stuff from Marshall [Texas] down there and from other places. Do you like that or would you rather go back?

WW. Well, making pottery is really hard work and you don't have all the pressures running this wholesale operation. I mean, you can make pottery, and with a lot of customers you can demand payment before you even deliver, and they'll do it. We were just setting here talking, me and my dad. We have about shipped the whole warehouse on the credit the last ninety days, this one-horse operation, and we just figured up today, our accounts receivable is $175,000. And if we were making pottery, we wouldn't have a problem like that. . . . If I really had a pick, I would take making pottery, but how do you stop something you've already started?

CRM. And you've already got customers for it. When did you start getting into the big wholesale operation?

WW. Probably thirty years ago. On a larger scale, ten or fifteen years ago. Of course, at one time we were one of the biggest handmade potteries around. We used to be located in Gillsville.

CRM. Whereabouts? Near the Hewells?

WW. Between the Hewells and Cravens.

CRM. So really right in town.

WW. Right now Cravens is the super biggie.

CRM. Right. I was out there this morning, and that was impressive. I've never seen anything like that in my life—and I've been to a lot of potteries —and I've never seen an operation like that. That's something else.

D. X. Gordy talks some
more about his painted pottery.

DXG. As far as in my designing, I read lots on art, as much as I can. I don't have time to read as much as I'd like to. But I like the Greek art. I think, as far as the art in my work, it probably inspired more of my work— the Greek art and architecture, I've always liked that.

CRM. There's your tradition for you, for painted pottery.

DXG. So I think you'll see some of that influence in my work. I don't copy the Greeks, I don't copy anybody, but all of us are influenced by something, somebody. That's our purpose in teaching others—to get them started and let them go their own way—but we are all going to be influenced. I see a lot of people that are influenced by their teacher, but I didn't have a teacher —Mother Nature. I was influenced by the things I see out there. And the ancient Greeks and the Egyptians and maybe American Indian. That's about

it. But when you put it all together and think of form, proportion, balance, you don't see a difference in all three. . . .

CRM. The basic rules of symmetry and proportion.

DXG. That's right. . . . I said I didn't have a teacher, that Mother Nature was my teacher, and for the most part she was, but my dad—I have to give him credit. He had the pottery shop. He didn't have time to do any teaching. He said it was there, you can do it if you want to. So just go ahead and do it and watch others.

CRM. You worked with him?

DXG. I worked with him. That's how it was, working together. He had these other people working, and I looked over their shoulders a lot of times when they didn't realize I was doing it, watching what they were doing. Then every opportunity I'd get—whenever I had an opportunity of a good artist painting. They may not know it, but I am watching everything they do. You put all of that together to do what you want to be.

Arie Meaders* speaks
about her decorative ware.

CRM. You started working in [your husband's] shop in 1945?

AM. Yeah.

CRM. When did you start getting the idea about doing something other than jugs, churns, pitchers?

AM. Well, I just hardly don't know what gave me the idea, but I could just see that something else could be made than jugs, pitchers, and churns. And they were pretty and they sold, but it seemed to me like I just wanted to do something myself. I just went at it.

CRM. Were you turning yourself?

AM. Yeah, I turned myself. I couldn't get him [husband Cheever Meaders] to turn the pieces I wanted. Seemed like I couldn't get it over to him what I did want.

CRM. Were you turning regular pieces in the shop as well? I mean, were both you and your husband turning the same sort of thing?

AM. No, we wouldn't turn the same sort of things. He would turn pitchers, churns, and jugs. Now, I commenced decorating his jugs and churns and pitchers way before we got into making the other sort of stuff. I decorated five-gallon churns and six-gallon churns with grapes and leaves on 'em and sold them things for five dollars apiece, and I should have had twenty-five or thirty for 'em.

CRM. Five dollars was good money then.

AM. Then it was. I thought it was pretty fair, yes. And I decorated his jugs and all such stuff as that. Then I decided we'd make something else besides that.

CRM. What did he think about that?

AM. Well, he kinda come over and decided that there's a little bit more money in that than there was in what he was doing, and actually he was getting to where he could hardly turn a big churn. The time had come to where his turning days were just about over, too.

CRM. And then you wanted other pieces? You were seeing the decorations in your mind?

AM. Yeah, I reckon. I could just see things and imagine 'em.

CRM. So when you started turning those special pieces yourself, what gave you the idea about the forms you were turning then? Had you seen things in magazines?

AM. Oh, yeah, and go places and see different shapes. Of course, I couldn't make nothing just exactly like what I had seen, but I could fashion from 'em.

CRM. What size pieces were you turning then?

AM. Well, that piece over there with the red flowers on it was about the biggest.

CRM. So you started turning ware about that size, about ten inches high?

AM. I was sixty years old the day I went into the shop and put my hands in the clay to try and get it on the wheel to try to make a piece. I couldn't bring it up. I couldn't get it into my head how to bring it up, but I said if I'd keep turning flat things and turn it up a little bit more and a little bit more 'til I finally got to where I could. I found out what it took and I watched my husband. It was strange how he'd do it. He would bring it up from the bottom this way, and he would shape the top of it, and he'd leave that, and he would go back down there and bring it up then, and he'd bring it out into a bulgy shape like a pitcher. And I watched him, and I just got on to how he was doing it. And it seemed like he couldn't tell me about how to do it. The one thing he told me about how to do it, and that was cutting it off the wheel. I would just stop my wheel and run my wire under it, and just straight across, and I had trouble of it cracking on the bottom. So one day he told me, "I can tell you what's a making your stuff crack." He says, "It's the way you cut it off the wheel." He keeps his wheel a-going, and he sets his wire down here, and he puts his wire down, and it just goes around, the

piece goes around and it just cuts it off. All the same, and don't pull it in the middle. So I got to doing like he did and got shed of my cracks anymore. That's how come I come with a lot of stuff I had here in the house, and that stuff that's up there [the White County Library in Cleveland, Georgia] on exhibit now; it's cracked in the bottom.

CRM. That's the stuff you couldn't get sold.

AM. I just brought it to the house and kept it.

CRM. Now, you used the grapes, and I see you painted on some of the pieces, too.

AM. Well, I painted on some. Now, some of the big vases up there, I painted that—all of that on there—I painted that. . . .

CRM. And then you made roosters and other animals.

AM Yes, and made owls.

CRM. I saw one of your owls up there [at the county library]. What about the duck?

AM. I made the duck, and I made the chickens. And I made three different kinds of chickens. I made one chicken . . . and I brought one of them to the house—it was pretty good size—and I set it out in my flower garden there, and I couldn't keep my old rooster out of that flower yard to save my neck. He'd just stay in it and walk around that old rooster, so I had to take that thing out of the yard.

CRM. That was a pretty good compliment. These were being made about when? About 1950 or so?

AM. Let's see. I think that was made around 1970, because I was gone to the Grand Canyon on a cure with my sister when Lanier fired them pieces. I had about twenty-four of 'em, and he fired 'em while I was gone that year, and I think that was in 1969 or '70. It might have been in 1969.

CRM. But you started making the decorative ware about when?

AM. Well, it was about 1950.

CRM. You've stopped now? How long did you keep on?

AM. I worked in it a couple of years after my husband died.

CRM. That was 1967.

AM. Yes, in '68 and '69 . . . and I never did make anymore. My legs give out on me. So I just had to quit. I just couldn't stand the walkin' from here to the shop and back two or three times a day, you know.

CRM. You were using a kick wheel.

AM. Yeah, we never did have an electric wheel.

CRM. That doesn't help either.

AM. No, it don't help a bit. . . .

CRM. I'm thinking about another woman potter, someone involved in much the same way you were in using decorative things. I'm thinking of the Hiltons, Maude Hilton. Are you familiar with her at all?

AM. No, I wasn't.

CRM. Because about the same time you were doing your work, she was doing—very different—but she was also doing decorative things with her husband. What inspired you on the grapes, which is a great idea?

AM. Well, you see, I had seen a lot of this milk glassware that had grapes on it.

CRM. Pressed glassware?

AM. Pressed or molded, but I just thought that's just a good idea for me. I can put it on with my hands and it would be just as pretty.

GLAZING

**Marie Rogers describes how
they used to do a frogskin glaze.**

CRM. You were saying about how they [Rufus and Horace Rogers] also used salt?

MR. Yes, why, when they would have it real hot temperature, and they'd be throwing that wood in there, and the glaze would already be melted, and they would just take a handful of salt and throw it in and make it, you know, change the color.

CRM. What would it change to?

MR. The fire would look—even the color of the blaze—it would blast up, and it would be kinda greenish looking then.

CRM. And the resulting glaze would turn out greenish?

MR. Yeah, it would make the glaze turn greenish.

CRM. Did they do that a lot?

MR. Not every time they fired, but sometimes when they fired they would go out and he'd say, "I think I'll throw a handful of salt in there this time," and they take so many hand and just throw it through. And that's all they'd do, just so many hand.

CRM. Just sort of as the mood struck them?

MR. Yeah, they'd just do it as the mood struck them.

**D. X. Gordy describes how
he got his glazing materials.**

DXG. Somewhere in Georgia, you can find everything you need for glazes, everything. Practically. I haven't been able to find cobalt and chromium. I

don't have to have it, but I do like to have some, you know, buy a little bit of the cobalt and chromium, but other than that I don't have to go outside the state or anything. I do with certain types of my throwing. I use a little bit of Kentucky ball clay mixed in with the Georgia kaolin to give it more plasticity. I don't always do that, but with certain things it's better to add that to it. But other than those three things, I don't have to go outside of the state. We are living in a crystalline area, too, and this is part of the crystalline area. When I said that, that's where you find your feldspar and other types, and then just south of me is the fall line and is all of your clay, and that goes through Columbus and Macon, but I'm a little bit north of that and into the glazing, and just south of that you get into more glazing, and you find your titanium and your iron, sources of iron, and other things you don't find up here. You find lots of things there you can use too, which would be fine, too, mostly calcium in your glazes. So down there you find all them; up here, you find feldspar and most of the rocks I use in my colors.

CRM. You have to be quite a bit of a geologist, a mineralogist.

DXG. Sometimes I think for glazing you have to be a chemist but I know very little of chemistry. I started reading that one time, but I decided if I had to be chemist to be a potter, I'd have to quit. I decided then a mineralogist would do, so I'd get books—I just bought one the other day on rocks and minerals—and I had other books. I do have books on geology, and usually when they get a geologist in the state capital, I have reason to become acquainted with him, and they tell me about lots of where I can find things. And then I get the book out, and it identifies whether [truck noise], but you can't always do it from the book. The book don't tell nothing 'til I put it in by the kiln and run a test on it. It don't matter chemically what it is, just so it will do what I want it to do, because even if I knew all the chemistry in the world, the way I'm going about it, I'd then have to have it analyzed in the laboratory—so if you analyzed everything I do before I'd know what it is anyway, so it don't matter.

CRM. So you are doing that anyway in the kiln?

DXG. That's right. So it's doing what I want it to do. And this Japanese potter who was touring the country one time, he stopped here. He said my glazes were more oriental than anything he'd seen in the West, anywhere in the West, and I told him I wouldn't try to copy anybody, whether it was Japan or China. I told him I'd always admired oriental pottery. After he left, I was thinking I was going about it pretty much the same way they were. You know, Georgia and South Carolina are pretty much in resources like certain parts of China.

**Eric Miller talks
of glazes, past and present.**

CRM. You kept doing the Albany slip all the way through?

EM. Yeah, well, mostly the Albany slip was used on jugs. They used a white glaze on the churns 'cause it does so much better for pickling and milk, too. The white glaze is a much better glaze for the pickling and kraut or anything. But we're out of it right now; better go get some more.

CRM. What percentage of your ware now is glazed and what percentage is unglazed? Do you have any idea?

EM. Percentage-wise, it's probably a fifth glazed. If we're firing a kiln of two thousand gallons, we might put maybe a hundred gallon of the glazed.

CRM. What sort of glazed ware do you turn now?

EM. Cups, pitchers, cream and sugar, jugs, and churns. That's about it.

**Gerald Stewart talks about
glazes used and remembered.**

CRM. What sort of glazes did you use?

GS. We used to use that white glaze and that Albany slip—brown.

CRM. Which one did you use more of, the white or the Albany?

GS. The Albany. Right smart to that though white glaze.

CRM. Did you use that a lot for churns, crocks?

GS. Yes, churns.

CRM. Did you ever use any salt glaze?

GS. Well, my father did, now. I didn't.

CRM. Why did they switch over from salt?

GS. Well, I just don't know why they switched, but I remember him using salt glaze when I was very small.

CRM. Did you help with the salt?

GS. No, I wasn't big enough then. He would get that kiln so hot and throw that salt in there. It would get so hot to melt that salt.

CRM. That Rebekah pitcher you just showed me, you said it had fly ash on it over Albany slip, and you said your father actually did make ash glazes?

GS. He did make it. He would dip his ashes and do it just like you do this Albany slip glaze and glaze that in. It were real pretty.

CRM. What color would that turn out to be?

GS. About greenish.

CRM. Now, was he using what is called an alkaline glaze, which is lime and ash, or just straight ash mixed with Albany slip?

GS. Just straight ash, and he would mix a little Albany slip with it, and it would make a pretty glaze.

CRM. Why did you stop doing that? Or did you stop?

GS. Yeah, I stopped. I just didn't take time to do it.

CRM. Well, this is certainly handsome; it's a nice piece. It's a nice effect.

**Verna Suggs Duncan discusses
her family's use of glazes.**

CRM. What sort of glazes did you use on the glazed pottery?

VSD. Well, the brown glaze was Albany slip, and it turned out real well, and the other was a number of chemicals mixed with water.

CRM. And that produced what color? White or . . . ?

VSD. Gray or white.

CRM. Sort of a Bristol; sometimes it's called a Bristol. Did you have any decorated pottery, in other words, with designs on it?

VSD. Well, some, not too much. We had some designs. . . .

CRM. Was your husband producing glazed ware up to the end?

VSD. Yeah, he had the brown glaze and the gray glaze. . . . In the early days, they used the hard way of glazing. He [W. D. Suggs] would have the kids to bring the articles to a tub with the glaze in it, and he'd stamp it with a hard slow way, and later they got this little stamp and they'd go down the row, stamp, stamp, stamp, glaze, and put it out.

**Hattie Mae Stewart Brown
talks of glazes.**

CRM. What about the glaze ingredients, the Albany slip?

HSB. I think he brought it in from Albany, New York.

CRM. Did he use any other glazes?

HSB. Well, he used the white slip and the Albany.

CRM. Did he use any Michigan slip?

HSB. Well, the Albany black glaze, mostly Albany he ever used. There was more demand for that, and that white is harder to take to the clay. . . .

CRM. Your husband and your father both did some salt glazing?

HSB. Salt and ashes. Lime ashes and mix it with salt glaze.

CRM. Did they do much of that?

HSB. They did a lot back then when they could get the slip glazes. There was a big demand for that, and sometimes they'd forget to get the glaze and they'd just go ahead and put that on it.

CRM. When did they stop doing that? Or were they doing it all the way through?

HSB. It was in the forties when my husband quit.

CRM. Why did he quit doing salt glaze?

HSB. Well, the other was so much better

CRM. Why do you think it was better?

HSB. It was slick and smoother.

CRM. And the people seemed to like the slickness and the smoothness?

HSB. Guess that's so. It'd make a pretty glaze sometime. Pale green.

CRM. Did he toss it in through the firebox?

HSB. Mmh, it made a pretty glaze.

Bill Gordy discuss
glazes and their ingredients.

BG. When I was at Kennedy's, there was a man finished at Alfred University in New York, the ceramic school, and, as I said, those was bad Depression years, you know, and we never met, and he grew up in Kentucky, up on the Big Sandy River, Ashland, Kentucky. He'd read about me. You see, I was only twenty-two, twenty-three, twenty-four years old. I'd been in [the] American Ceramics Society [magazine] and different magazines. And he wanted to know if he couldn't get on maybe into the pottery there; maybe I could help the pottery. He said, "I am finishing here in ceramic art, glazes and all." He'd been studying under old Dr. Binns,[45] you know. So I got to talking to Mr. Kennedy about it, and he said, "Yes, send him on down, but I can't pay him much." I said, "Well, he's not expecting much." So he came on down, and we worked up a real good friendship. Well, I already knew basically about glazes.

CRM. What was his name?

BG. Edsel Rule. He may be dead now. I haven't heard from him in years and years. Well, anyway, when World War II broke out, he went. . . . He never worked in pottery, just glaze, and he was over at Penland. He studied over there a while, but everybody can't learn to be a potter. Although he'd

45. "Old Dr. Binns" is identified as the English-born Charles Fergus Binns, the founding director of what is now the New York State College of Ceramics at Alfred University, serving in that capacity for more than thirty years until his retirement in 1931. For Binns, see Margaret Carney, *Charles Fergus Binns: The Father of American Studio Ceramics* (New York: Hudson Hills Press, 1998).

been in glazes, he could make a few things. I used to tell him he was too much a perfectionist; he wanted everything to be too perfect, and, of course, I guess that's where his college work came in. He also studied, went to school, in southern California. Well, anyway, I worked with him in glazes for a while, but we're not even using, . . . back then it was mostly pastel shades, you know. We're using an entirely different glaze material now.

CRM. But he taught you a good deal about glazes or, at least, in conversations with him?

BG. Well, you have to start from somewhere, so really—I would help him after work hours. All during the day he had access to the wheel. You see, I would help him with his throwing on the wheel, and he, in turn, we would just go into the theory of glazes, and so we worked with each other. I never directly asked him for any formula, but you know, if you want to get into glazes, actually glazes don't come in, but you got a lead glaze, an alkaline glaze, or you got a lime-based glaze, so you just settle for whatever you— we don't make lead glazes. The biggest part of my glazes are what we refer to as lime-based glaze, and I think my brother does the same thing. I don't know what he uses, and he doesn't know what I use. We don't even work alike on the wheel. He likes his techniques; I like mine. He likes his glazes; I like mine. One thing, he goes to a higher temperature than I do; I only fire to cone eight.

CRM. He's really doing porcelain.

BG. There's no point in that. You know, with the modern things we have —we always had it, but we have access to it now. . . .

Walter Lee Cornelison discusses
Bybee's glazing evolution.

CRM. Now, the shapes you're using, I imagine what you remember from your grandfather's day and from your father's, it was rather different.

WLC. They have actually evolved. In other words, the pottery started with some jars, churns—very essential things. . . . They evolved down through the years to my grandfather, and then he came along, and the pottery was known for a while as Kentucky blue pottery and is still known as Bybee blue. It has evolved just a little bit. It was more of a matte color; it has a gloss to it now. Basically, it is the same. He went from that to a matte green to a matte rose, and then he came up with an uranium tan. It was a beautiful glaze. We never knew exactly what it was going to do, which was great, too. Of course, we lost the uranium during World War II. They came in and took it, and we've never been able to get any back.

CRM. Was that a local source?

WLC. No, it wasn't hard to get back then. You could order it from any company.

CRM. That [glazing] was one of the major uses for it.

WLC. They never did say what they were going to do with it or anything. When they dropped the bomb, we knew what had happened.

**Bill Gordy talks
about some of his glazes.**

CRM. You said you did salt glaze also when you were young?

BG. Yeah, back in my teens. My dad did some salt glazing, you might say, from the time I was born on up to when I was around twenty-one or twenty-two years old. It was just in and out, maybe. He used a lot of Bristol glaze, Albany slip, and then there was some cobalt decorating and salt glaze over it. Now, salt glazing is just to me, in today's world, to me now—I'm referring to myself—it's just something that you want to do. It's not that the sales are altogether that for it, it's just a challenge, you know. It's kind of like making crystal glaze. Crystal glaze is not all that big a seller, 'cause you got to get that big price, but it's just a challenge that the potter says, "I just want to try that, you know, do that." And it's kind of like when I used to do these copper reds; now, that was a challenge. You have trouble, you know, you have to price them higher, and then the customer says, "Why is this one here ten dollars and this one with the same shape five dollars?" You have to go through that whole story all the time, you know. . . .

CRM. You have to do the same thing with the cobalt, don't you?

BG. Right. And we are selling cobalt higher. Not cups—we are selling them the same price—but anything large we are selling higher because we're using so much cobalt. But I think most of the people will read that in the daily papers that cobalt is on the way out and that is why they want to get that last piece. And I think we always will have glazes. I sometimes wonder if someday they will use up all the clay, you know, the good clay. The potters will never use it up, but it is used in other things, water purification.

CRM. Can you tell me something about the glazes you are using? Now, this sort of rose-colored—

BG. Now, that is made with strictly what we refer to as a lime-based glaze. . . . Now, zincs are used in a lot of glazes. You don't use zinc in anything with red, especially if it's made with a chrome. Now, actually, this is made with chromium oxide. Chromium oxide is high in tin. Now, . . . you cannot use zirconium, either. You use tin . . . in making your pinks and

cherry reds, especially. Now, your copper reds is made with copper. . . . Copper reds would be green, but putting it under reduction, you get red and sometimes—you notice this piece—red and green mixed, and some of it will become solid red like the pitcher over there.

CRM. This one has an almost—like a salty, it has almost that kind of orange-skin feeling that you get from salt glaze. How did you get that? Is that an accident?

BG. No, that's overfiring reduction. . . .

CRM. Did you do that intentionally?

BG. Yeah, we reduce it intentionally. I don't do a lot of reduction; it's awful hard on your kiln. Now, this piece here—

CRM. This is your "mountain gold"?

BG. No, that's Albany slip and calcium. It's a blend of calcium and Albany slip.

CRM. It gives the effect of mountain gold.

BG. Now, mountain gold actually is a calcium glaze, but it does contain zinc; that's why—it's got zinc crystals—the small ones pop out. This is mountain gold under reduction.

CRM. Under reduction? The shiny, sort of rainbow effect, that's the reduction?

BG. Right. Now, this is the true mountain gold right over here. But we are overfiring a lot of it now. And this is almost the same here; it was fired under reduction.

CRM. What about this sort of thing?

BG. That's a calcium glaze—copper glaze under oxidation. That's an old piece. We don't make that anymore. And this is, you know, a ginger jar, and that piece is a quite a few years old. I came out with mountain gold in 1951—I believe it was '51. It took a while for it to hit the market good. Gatlinburg named it mountain gold. It just fits the fall leaves. Even on the West Coast they come to hear about it. People wrote me, you know, "If you just tip me about that, I'll never tell anybody."

CRM. So that's a trade secret?

BG. Oh, I tell 'em I'll write a book one of these days and put it all in it. Now, black is lowered with oxides, that's why it's black. Black has as much cobalt in it as blue does, and on top of that you've got to have manganese and iron and chromium. So that's why I think a lot of people don't fool with black; it's too expensive. I got places in the kiln where I like to fire black. Black will stand any kind of heat. Certain places in the kiln mountain gold

will not work. You put black in there. . . . Now, blues don't work good under reduction.

CRM. What about your pink?

BG. No, you don't have any demand for pinks today. Now, pink is the thing that's got to be fired strictly under oxidation.

CRM. So what has that got in it?

BG. That's tin and chromium. . . . The only difference between this and this one [pointing] is you use less tin in this one.

CRM. You use less tin in that, what do you call it, "cherry red"?

BG. Cherry red.

CRM. How about this very sort of variegated . . . ?

BG. That's a rutile glaze, and we have a luster glaze that we put on with a brush over the top. . . . Oh, I do a lot of those things, but the orders are so much for mountain gold and blue 'til it just about eliminates [everything else].

CRM. Do you like that? Or do you like the experimenting?

BG. No, I would rather experiment, but there is less money.

Howard Connor
comments on glazes.

CRM. What sort of pottery was your father making when you started?

HC. Stoneware, jugs, all stonewares.

CRM. Albany slip glazes?

HC. Right, Albany and, let's see, we had two different—New York state, four foot under the ground, they'd dig the glaze out.

CRM. Albany slip. It came down in barrels, right?

HC. Yeah, we used to get barrels.

CRM. Use any Michigan slip?

HC. Michigan, now, your Michigan was red looking while your Albany was dark.

CRM. Chocolate brown. Any Bristol glazes, that white glaze?

HC. Yeah. Oh, yeah. Of course, we'd mix feldspar and Spanish whiting and zinc and white lead and so on. Used to, you could use that.

CRM. Ever use any alkaline glazes? The ash glaze, the lime-ash glaze?

HC. No. Now, I've heard my father speak. They used to make salt glaze, which they were kind of trying to make a solution of to dip it in to make your salt glaze, but your regular salt glaze you take a shovel and throw it into the fire box, and at your high temperature it flashed it.

CRM. Did your father do that too?

HC. I never saw it.

CRM. So when you were growing up, it was all Albany and Michigan?

HC. At Wickliffe, I've forgotten, but that was when brown and white churns come in. They'd glaze half of it brown and half of it white.

Horace V. Brown Jr. describes
glazing in his father's Buckhead shop.

CRM. When they were glazing [the pots], would they fire first, in other words, take the greenware and fire it to bisque? Or would they just, as soon as it was dry, would they then slip it?

HVB. When it was dry. Dad tried to fire some—we called it burning them—first and then glazing them, put glaze and the slip on, and come to find out that when you put a dry jug or churn or anything you want to glaze into that glaze, it absorbs some of it and it's really better. . . . Of course, on a piece that you was gonna stack, most of the time it was the kids' job to wipe that glaze off the top and off the bottom also.

CRM. Did they use salt at all?

HVB. Yeah, Dad used, I believe, he used some salt. I know he used some of that glass and ash. I think he used some in that Albany slip. I think he used some in that white slip, too.

CRM. Was that the salt you threw in vaporizing?

HVB. No, you'd mix it right in with the glaze. He may have had some in his ashes. I've seen him throw ashes in, but I never seen him just throw salt in.

Jack Hewell* remembers
glass glazing and Albany slip.

CRM. What sort of glazes did you use?

JH. We made our own glaze for years and put on a glass glaze.

CRM. What sort of color range did you get?

JH. It ranged from dark to light, sort of brownish, and some of it fired real hard, and we put a cobalt streak right around the middle of it . . . and that was under glaze.

CRM. Did you use Albany slip also?

JH. Oh, yeah, we used Albany slip before, and it got to where you couldn't get it for a period of time during the war, and so we turned to the old glass glaze. We got these broken Coke bottles from the Pepsi-Cola Company in Gainesville and powdered them up—beat 'em up.

CRM. With a glass beater? That sort of thing?

JH. No, my dad designed a four-stump hammer that was going up and down. He designed that. . . .

CRM. Did you grind it up and make it up into a liquid?

JH. Well, we had powdered glass, and we would mix in so much ashes and so much sludge, clay . . . and put it into a liquid form and run it through old mill rocks, and they would wear it smooth, grind it down.

CRM. And you would dip the ware into that?

JH. Well, we didn't dip it; we didn't want any on the bottom on the outside of that. We just took a cup, and we got quite expert at it. We just took a cup and reached around there and started pouring.

CRM. Did you glaze inside with Albany slip?

JH. No, we glazed the inside with glass, too—just slosh it around and pour it out. It made a good vessel, but it was rough on your hands, them ashes in there and sometimes a little lime, and getting down close, it would eat the skin off your hands.

Horace V. Brown Jr.
discusses family glazes.

CRM. When your father was starting out, do you remember what sort of glazes he used?

HVB. Well, what they called Albany slip, and he did get to where they made some white churns, too.

CRM. That's Bristol glaze.

HVB. I don't remember what they called it, but they used some, and they did make some with Albany slip, half white and half brown, and they looked good. And then he mixed some glass and ashes and mixed it with Albany slip, and that made a pretty glaze. And one time, he had a bright idea—of course, we used wood all the time—and just before it was time to cut off, about the time the glaze started to melt, he'd take the shovel and just throw ashes into the fire.

CRM. Fly ash.

HVB. And it made a sort of greenish color that was real pretty.

Ada Adams Hewell and her son, Carl, talk
about the glazes her husband, Bud Hewell, used.

CRM. When did he stop glazing?

CH. I imagine twenty-five years or so ago.

CRM. And before then, most of the glazing was Albany slip?

AAH. Uh huh, and my husband made glass glazing a while after he bought down here and put up. That's what they made in South Carolina, was glass glazing.

CRM. He saw that in South Carolina and picked it up from Mr. Johnson?

AAH. And then he picked it up from all the Coca-Cola places and beat it up, sifted, ground it with clay and ashes.

CRM. Was that a nice ware?

AAH. It was right pretty, wasn't it, Carl?

CH. Yeah, it made a pretty nice appearance.

CRM. But most of the production was Albany slip, though?

AAH. Most of it.

CH. Well, we used that glass for several years, five or ten years, I guess.

CRM. Why did you all give it up?

CH. Well, I don't know. He just decided he'd go back to using Albany slip.

AAH. Yes, but it was hard. It was harder on their hands glazing with it.

CRM. Yes, with the ashes and so forth, because that is really an acid; it's like a lye soap thing.

Wayne Wilson* talks about
collectors and his father's pitcher.

CRM. Now, you haven't ever done any glazed stuff, have you?

WW. My father used to. Matter of fact, there was some man come by here this week that had a one-gallon brown-and-black pitcher. It had my father's name stamped on it: "H. A. Wilson Pottery, Gillsville, Georgia." It must have been fifty years old. The guy was a pitcher collector. He paid fifty bucks for it, and he wouldn't took two hundred dollars for that pitcher, and my dad made it for eight cents, I betcha.

CRM. Well, listen, a lot of them got broken, and there are not that many of them around. Especially if it's got his stamp on it. That really means something.

WW. But I told my brothers, you know, they don't understand the old pottery business quite like I do. You know, we're making stuff and we are selling it now for cash money that twenty years ago, the guy in the pottery you was working for, he wouldn't even accept the merchandise. You'd have to throw it back and recycle it and make it better. But that pitcher, I mean, it was almost perfect, the way they prepared the clay and, I mean, they must have saved up the wood to burn it to have got such a good glaze on it.

**Edwin Meaders remembers
the beauty of the old glazes.**

CRM. Are you using glass glazes?

EM. Well, I don't now, but I did. But I think I'll go back to using it 'cause, I don't know, there's just something about it, well, it's just old, natural stuff. It just looks good to me. It's easy to make.

CRM. As long as there's Nehi cola bottles and things like that.

EM. And you get some ashes and sand.

CRM. Do you use Albany slip?

EM. Yeah, I use Albany slip. Not too often I don't, but that's what I got in this kiln right now.

CRM. What is your favorite type of glaze?

EM. Well, I like that old-fashioned ash glaze that they used here.

CRM. That's like the type Lanier uses with the drip effect? Yeah, that's really nice.

EM. I don't think there is nothing that will ever take the place of it as far as quality is concerned, but a lot of people like this new, pretty—what do they call it—ceramics?

CRM. No, I don't. That's not the stuff I'm looking at. That's not the stuff I'm interested in. I'm interested in the traditional types.

EM. Well, that's what I'm interested in.

THE POTTER'S KILN

**Lamar Franklin* describes
the old J. W. Franklin kiln.**

CRM. When was that big kiln put in?

LF. It was originally built in 1925. It was designed and built by my father.

CRM. Was it based on—how was it built? Did someone come in and build it for him?

LF. No, no, he designed and built it. Some of the people that worked here helped lay the brick, but we did all the work here.

CRM. What was the pattern for it? The type seems more the type that I associate with the factory type or the Pennsylvania type.

LF. It's more like some of the brick kilns. It's bigger in the first place, and its design is bigger. Most of the old kilns in the Southeast were rectangular and had fireboxes down one side. We used to have one along here like that. It had three fireboxes on the south side and two chimneys on the north side.

CRM. Was it used for different type ware?

LF. No, it made the same type ware. I guess another thing that kept people from building this type was the construction of the crown. That's part of a sphere, and you got to have different-shaped brick to get that multiple curve in it . . . so that's got wedge-shaped brick and a lot of different-shaped brick in it.

CRM. You didn't make your own brick for it, did you?

LF. No. But we made a few brick in the late thirties, but never made any money out of the brick business.

CRM. I guess you could now.

LF. We didn't have the proper setup for it. You got to have a lot of mechanization and a big operation to make a brick business.

Carrie Stewart talks about
kilns, glazes, and clay sources.

CRM. Was the pottery always on this location? This is a new shop, a new pot shop, but it's on the site?

CS. Yes, on the site.

CRM. And how about—you have a brick-built groundhog kiln, that's wood-fired, right?

CS. Yes, they still used wood to fire that groundhog kiln, and they would make glazed pottery in the front of the kiln, and the pots which are not glazed are in the back of the kiln because it takes more heat to glaze the glaze on the churns than it does finish the pots.

CRM. What sort of glaze did you use? Anything else other than Albany slip?

CS. No, just Albany slip. Brown.

CRM. Is the kiln out back here the one that—

CS. No, they've had several kilns. This is the last one.

CRM. They have to be rebuilt after a few years. But they have all been the same type?

CS. The same type, yes, wood kiln.

Walter Lee Cornelison
remembers coal-fed kilns.

CRM. Is that a gas kiln?

WLC. Yes, sir. See, we have natural gas within twenty-five or thirty miles of us, so we started. . . . They tell me they started with wood. I don't remember the wood, but I do remember the coal. Just as soon as I was sixteen years old, my father put me on a coal truck. We had those old beehive kilns, and they took a truckload of coal. We didn't haul but about five tons then on those old trucks, and it took about five tons per kiln, and that was one of my jobs. We'd start back through the mountains with stone and such jars, selling them at the stores, and he would have gone ahead of us and sold it.

Gerald Stewart
talks about kilns.

CRM. You always used a wood-fired, groundhog kiln?

GS. Always used a groundhog kiln.

CRM. Brick constructed. But what size were those? About the size you got out here?

GS. About that.

CRM. And what is the measurement on that?

GS. It's about eight by twelve, and it holds about a thousand gallons of pottery. Capacity.

CRM. And you fire with pine, mainly?

GS. Well, we did with wood. Now I fire . . . with gas.

CRM. That's been converted to gas. How long have you had it converted?

GS. Oh, about twelve years. I've been burning with gas about twelve years.

CRM. You've got an electric wheel now, but I expect you started out with a kick wheel.

GS. I started out with a kick wheel.

CRM. When did you switch from foot power to electric power?

GS. Oh, it's been about twenty years.

CRM. How many brick thick is that kiln?

GS. Oh, now it's just one brick, you know, longways. You know, it used to be built just with a single brick.

CRM. That's kind of dangerous.

GS. Dangerous, but that's the way they did, you know. They just couldn't get the brick.

**Bill Gordy remembers
the kilns he used.**

CRM. You said you started out using a wood-fired groundhog-type kiln or railroad type?

BG. Well, not a groundhog. We used saggers, you know.

CRM. What's called a railroad, a walk-in, type.

BG. Yeah, you could walk in. That's what my daddy always used, and the Kennedys. In later years, Kennedy switched into oil burners, round kilns.

CRM. Oh, Kennedy was using the railroad type for Macy's, too? I mean, that's a lot of ware; it must have been huge, though.

BG. As big as this room. Yeah, they made a lot of pottery. It would hold about two thousand gallons stoneware. Yeah, you could just stand up in it. You stack up, you see, in firing. You put them in three and four deep.

CRM. The largest I've seen on my trip has been a thousand gallon.

BG. Well, my daddy had one kiln that would hold about sixteen hundred. My little kiln out here, it could hold four hundred gallon. You see, that's too little for stoneware. You need something at least twelve hundred up—financially, you know.

**Verna Suggs Duncan remembers
groundhogs and beehives.**

CRM. Could you tell me something about the type of kiln you had? At the time, what type of kilns did you have?

VSD. We had a groundhog.

CRM. Wood-fired groundhog?

VSD. Fired with wood? No, natural gas.

CRM. Then you switched to natural gas?

VSD. No, we never did have—Daddy had a wood-fired. We never did have that; we had the natural gas in the groundhog. It didn't get hot enough in the back of the kiln. The last two or three rows would be too soft, so we changed it to a round kiln with the four burners around, and so that was the heat for that.

CRM. When did you change over from the groundhog to the round kiln?

VSD. I don't guess the groundhog lasted over four or five years, I guess.

CRM. So that was about when?

VSD. That gets me when I go back to the dates. I'm no date rememberer.

CRM. Before or after the war, the Second World War?

VSD. Well, it's been since the war. . . .

CRM. So this would have been—you changed sometime in the late forties over to the gas round kiln? . . . How big was the kiln? He had a groundhog kiln, how big was it?

VSD. He had a groundhog.

CRM. How many gallon could he get in it?

VSD. I've been in it all my life, but I don't know. About a couple of truckloads, I guess, to the kiln. And then he made a huge round kiln and fired it with butane. All that money, money, money went into it, and the kiln wasn't successful . . . and that's where his downfall of the pottery was. Had so much money involved in the losses. When you lose it that way, it's gone forever. There's no replace to it.

CRM. Did he sort of stop or slow down after that?

VSD. Well, he went back to another kiln, I believe, after that one didn't, and fired in the other one something.

**Hattie Mae Stewart Brown
describes "Jug" Brown's kiln.**

CRM. What type of kiln did you have?

HSB. A big, old groundhog kiln.

CRM. Was it pine slab fired or gas fired?

HSB. We fired with wood.

CRM. With wood? You fired with wood all the way through?

HSB. All the way.

CRM. Did you ever contemplate going to gas?

HSB. No, he never did. My brother did. He worked part of it with gas.

CRM. How large a kiln was it? How many gallon?

HSB. He had several kilns and he had one would hold around a thousand, eight hundred or thousand gallon.

CRM. It was all stoneware that you used?

HSB. He'd bake about half a kiln of churns, glazed pottery, and half a kiln that wasn't glazed.

**Bill Gordy* remembers
kilns and biscuits.**

BG. One of the things [my daddy] didn't want to trust me with to start with—now this goes back to when I was about seventeen years old—he didn't want to trust me with those big kilns. But I wanted to, I wanted some.

CRM. You said your father really loved firing, right?

BG. Oh, Lord, yes, and he was a perfectionist at it, in wood firing. And he would measure each piece. You know, when you're filling your kiln, it was traditional to have like big jars when you're putting them about three deep—always have the thick part of your hand right in there so you can just touch them with your hand. So he was afraid I'd have it too far apart or too close. Well, anyway, I'd seen him down at the—of course, we had to fire all hours, about forty hours. Well, firing wood kilns used to be sort of a community thing. Communities do that here. I've had neighbors stay up all night.

CRM. I've heard North Carolina people used to bring chickens and so forth and roast them in the kiln.

BG. When we'd open the kiln, you know, my daddy'd throw one of those big doors back when it was about 450 degrees, and my mother would have a big pan of homemade biscuits, and he'd stick them in there right quick, and in just a few minutes they'd brown all over and, boy, were they good. That was old-fashioned, Italian, oven-baked biscuits.

CRM. So, this was sort of, when the word went out that there was a firing going on at the Gordys, a whole crowd of people from the community would come around?

BG. Yeah, and I had 'em here. . . . Sometime I had so many, to tell you the truth, that they'd get a little in the way.

Howard Connor
on kilns

HC. The pottery in the old building was 150 feet long and 50 feet wide.

CRM. That's quite an operation, then?

HC. Oh, yeah. We went as high as thirty-five employees.

CRM. How many times a week were you firing?

HC. It wasn't by the week; it would take still about two weeks to fire one.

CRM. How large is your kiln?

HC. Eighteen and sixteen. Brick kiln.

CRM. You had both of them in operation at that time? One of them your father built in—

HC. In 1940 or '41. I think we fired it the first time. . . .

CRM. And the kiln that is out here now?

HC. That's one I built in 1959.

CRM. Are the old kilns gone now?

HC. Oh, yeah.

CRM. That stood right here, too, sort of next to it?

HC. Yeah, it stood right here in front 'cause the center of the kiln is the only initial place that we have in measuring off land in this area. . . . Before I tore it down, they wanted to draw a plat of this, and [they] asked me to go to the center of the kiln and put this iron pipe down, and I did. . . . Now, these little Mississippi potteries used to, all down here in Mississippi, they fired this old groundhog kiln.

CRM. The Stewarts. Bill Stewart down in Louisville uses a groundhog kiln.

HC. Now [pointing at a churn], that's made at Suggs Pottery. My wife's grandmother used that churn for fifty years.

CRM. I know one of the Suggs is Verna Duncan, Verna Suggs Duncan, down in Amory.

HC. Now, the kiln that's out there at the Davis's at Smithville, my daddy built that kiln during the war. My daddy was a kiln builder, and they never could do building a kiln that would work right, operate right. Now, Duncan used to come up here and buy from us.

Horace V. Brown Jr. talks of
traditional kilns and foreign influences.

CRM. How many people did your father have working? Can you remember any one specific time?

HVB. Well, at one time, I guess, there was probably eight or ten at one time.

CRM. So it was really a big operation?

HVB. Yeah, he was going, really going.

CRM. What sort of kiln was he using?

HVB. What they call a groundhog kiln.

CRM. Wood fired?

HVB. Yeah.

CRM. Do you recall how many gallon capacity it was?

HVB. I don't, I really don't. They make a round kiln, too.

CRM. Did he have that type too?

HVB. No, we had the straight ground-hog. Back in the early part of the twenties, there was some people that had a kaolin and brick company down in south Alabama, out from Gerard [?] there. The man had the brick company, but he . . . his wife—her name was Henrietta—so they started the Henrietta Pottery. Now, they had a German that come from Germany, he did, here, and he built those round kilns. He knew nothing about turning or that type pottery, but he did the molding. You know, they mix up the clay real thin and pour it into the plaster of Paris and let it set 'til the thickness they want and pour it out and then smooth it. That's what he did, and they had the round kilns there.

**Kenneth Outen describes
the kilns of Matthews Pottery.**

CRM. And you were firing here, yourself in a gas-fired kiln?

KO. Right.

CRM. What was the capacity of the kiln?

KO. It would hold about twenty to thirty thousand pieces. We had three furnaces. We had one that would hold fifteen thousand, one that would hold about thirty thousand.

**Kenneth Outen describes his grandfather's
pottery at Catawba Junction, South Carolina.**

CRM. Did you ever hear what sort of kiln they used?

KO. They had a groundhog kiln.

CRM. A wood-fired groundhog kiln?

KO. Right.

CRM. Was the Matthews Pottery on this site the whole time or were you located elsewhere?

KO. It's been on this site for sixty years.

CRM. Is there much to be seen of the kilns?

KO. Everything is in place just about like it was.

CRM. I would like to go around there later and take some photographs, if that would be possible. Hopefully with you in them, if you have a moment to spare.

**Harold Hewell comments on
the kilns his family has used.**

CRM. Now you have got a gas-fired walk-in kiln. Have you always used that type?

HH. No, we used what they call a groundhog fifteen years ago.

CRM. Wood fired?

HH. Yup.

CRM. Was the operation considerably smaller then?

HH. Well, some smaller.

CRM. How many kilns did you have then? Just one?

HH. We just had one, yeah. . . .

CRM. How many gallon does that thing fire?

HH. We burn approximately, just counting it gallon-wise, about a thousand gallons. One firing is a small trailer load.

CRM. How many times do you fire?

HH. Well, right now, we are firing about every five days; we are firing a little oftener than once a week. About every five days is as often as we can fire on account of getting it cool.

CRM. What temperatures are you firing at?

HH. About seventeen hundred degrees.

CRM. And how long is the firing cycle?

HH. It's twenty-seven hours, and cooling, you need about two more days and nights. We can cool it with fans and get in after one day and night. It depends on how much production we got and if we are in a hurry to get in there; if we got another kiln to get in, we will cool it rapidly. If not, we just let it cool down.

**Lanier Meaders discusses
the life expectancy of a kiln.**

CRM. Is this the kiln back here that you built right before your father died?

LM. Well, I started it in '67; his kiln was out there toward the road. There had to be something done to it, and I figured it would be easier to move up here and build one, just start from the ground up . . . and it was too close to the road anyway.

CRM. Did you reuse the brick, that sort of thing?

LM. I used part of them, part of them what could be used.

CRM. How long do you figure this one will hold up?

LM. I'm hoping to get through the summer with it. I don't know whether I will or not.

CRM. So it lasts about a dozen years?

LM. If you use one pretty regular, about three years is all you'll get out of it. That is if you get the thing hot.

CRM. You would be firing how often a year?

LM. Well, I have fired every two weeks. Now I can fire once a month.

CRM. Now are you firing throughout the year.

LM. No, when the weather gets cold, I get out of here. But I have worked all winter, snowing and down to zero weather, but I'm not doing that anymore.

Edwin Meaders
talks about his kiln.

CRM. You started [on a full-time basis] about a year ago. How many times have you fired in this period?

EM. Well, in the past year, I haven't fired it but six firings, but I am trying now to make one every month.

CRM. How many gallon does that hold?

EM. I don't really go by the gallon, just by the piece, you know. I can put sixty common-size pieces in there.

CRM. Did you build this kiln recently?

EM. I built that kiln about fourteen years ago, and I been here off and on since then. I built it good to where it can stand up.

CRM. It's what's called a railroad type kiln.

EM. I think they call it a tunnel kiln.

CRM. Yeah, a railroad tunnel kiln.

EM. Some of 'em calls 'em a groundhog, but I don't think that is.

CRM. This is not quite because that's set into the ground more, but it's the same idea—the chimney's in the back and your draft is going through.

KILN BURNING

D. X. Gordy
listens to his kiln.

CRM. The temperatures are a deciding factor in your shades and colors of your glazes?

DXG. When I make my glazes up, I have to keep in mind the temperature and the kiln atmosphere. I know what the temperature is going to be. I don't need to be too concerned about that. I know I have to get it to the highest point I need to get it to.

CRM. You said about 2,800 degrees.

DXG. But then the environment of the kiln—the thing I have to be watchful for is the kiln atmosphere. You have reduction and oxidation. And with lots of the minerals I am using, if I don't get too much reduction and too much oxidation, it won't be doing anything. We have to sort of get some sort of control, but I don't have any instruments or anything, except what I see and feel and touch and hear. The feel and sound of the kiln has a little to do with it.

CRM. The sound? How do you mean that? Excuse me, how do you mean the sound of the kiln?

DXG. You hear it. The Chinese call it, they say it's a breathing, and they have different fancy names for it. But you can hear the difference in the sound of the draft going through the kiln. If that don't sound right, you've got to change something about your dampers and drafts, but mainly it's what you see. I can feel the kiln, and that gives an idea. I mean, touch the kiln with

my hands, and that gives me an idea. I can almost tell the inside temperature by feeling the outside of the kiln.

CRM. Up the outside of the kiln to find out if it's drawing through?

DXG. That's right, but mainly it's what you see in the kiln. You have to have the right atmosphere, and only if you see that. I don't have any instruments to tell. I don't think on a wood-fired kiln you could have instruments, but you can see when it needs a stoking and when it don't need it, and you've got to reduce it at the right time, and you have got to oxidize it at the right time for your glazes. The kiln is doing as much for your glazes as you are doing yourself, and the kiln will almost tell you what it needs and what it don't need, and you can think of it as sort of a language of its own. You have to understand the kiln even if we build the kiln ourself. And if I build a new kiln, then I have to learn to understand that kiln. I guess you might say it's the mediation between me and the fire.

CRM. How long have you had this one?

DXG. I built this one in 1958, in the winter of 1958–59.

CRM. So each time you would—if you were going to build a kiln or if this one would need repair, it's going to change the whole. It's going to change your relationship, right?

DXG. That's right. I'm going to have to do some experimenting before I know exactly how. To control this one, I have to work it a bit different than I did the one in Westville, because it's a different type even though both of them are alike.

CRM. Does the type of wood you are using also influence—make a difference using hardwoods or pine or what have you?

DXG. The wood, the weather has something to do with it.

CRM. If it's a humid day or a dry day?

DXG A day like today, I don't think had I had it stacked I would fire it up, if I didn't have to. If I had pottery already made, I wouldn't.

CRM. It's too humid?

DXG. That's right. I like it clear, nights especially.

CRM. How long do you fire it when you are doing it? How many hours?

DXG. I guess to fire it, we call it the glossed kiln—that's the second firing. We used to fire between thirty-five and forty hours, but then I decided I was losing too much time and sleep and I decided to do a little experimenting. I never did see my daddy do it or nobody else. I always figured by the time the kiln begins to feel warm on the outside, you've already fired it all day long before it would begin to feel warm. So I decided if that was the case,

I would preheat it the day before I start firing, so I go out and preheat it and build up a good bed of coals, and at night I close all these vents . . . and the next morning the kiln is pretty hot when I touch it. That cuts down about half the hours, so now I can finish it up in about eighteen to twenty hours at that high temperature by preheating it. I don't lose as much sleep.

CRM. Doesn't that make the loading process a little bit . . . ?

DXG. No, I have already got it loaded. I just close it all up, all that heat up with it, and then I go to sleep, and the next morning I get up early and . . . [traffic noise] the kiln about eighteen or twenty hours. . . .

CRM. And that's working as well as the other system?

DXG. I think it works better, because I got the kiln gradually drying out all that first day and it seems to work better if I preheat it and having the kiln all dried out.

CRM. That takes care of the humidity problem, too.

DXG. That's right. I really fire four times. I preheat my bisque firing. I close it. Next morning, I get up and I finish firing that. By the time I've finished that, it takes about fourteen hours. And then I take it all out and glaze it. Then I put it back in, decorated or whatever you want to do with it.

CRM. How long does that process take, on an average? I guess it's hard to say, depending upon what you are doing.

DXG. From that first firing until it gets to the last one?

CRM. Well, the process after you've got it bisqued until you do the glaze firing.

DXG. When I take it from the bisque firing, I take it all out of the kiln and bring it in, depending on what I'm going to have do to the pottery, but I think I can finish it up. I've already put most of my decoration on the greenware. So now I have to take all of that out of the bisque kiln and glaze it, and that takes at least a week or ten days, and when I get it glazed, I put it back in the kiln and then I preheat it one day and fire it. By the time I start my bisque firing and finish all through the finished firing, the glossed firing, it has taken me about three weeks. And the time away, stacking, glazing, stacking the kiln—two times I have got to stack it, taking it out, and then by the time I get the finished pieces, it has taken me about three, maybe four weeks.

Gerald Stewart
and firing a kiln

CRM. How would you stack your kiln? Would you stack the unglazed stuff towards the back?

GS. To the rear, yes. To the back, and the glazed stuff in front.

CRM. Did you use saggers at all?

GS. No, just top on top. See, you sponge the top of your churns and stuff like that.

CRM. So it's not going to stick. What would your firing time be on the kiln?

GS. Thirty-six hours.

CRM. That's the firing? Or does that include the cooling down?

GS. That's the firing itself. It would take about four days to cool down, now.

Johnny Hudson describes how the kiln built by
D. X. Gordy at Historic Westville, Georgia, is fired.

CRM. Boy, those groundhog kilns really belch a lot of smoke when they are fired. Is that a wood-fired one?

JH. It draws well. We built it from experience to getting the temperature up to as high as 3,000 degrees.

CRM. You can do that with wood firing.

JH. That's the only way we have ever used it, but you have got to have good wood to do it, and a lot of it. That's right, and somebody to stay with it. But it's all right, and I enjoy it.

CRM. How many hours do you fire?

JH. About twenty-four hours. That's right. I enjoy doing it.

CRM. Do you do stoneware firing? Or earthenware?

JH. Both of them.

CRM. What sort of glazing do you do?

JH. Albany slip and salt. I think salt is one of the older glazes that goes way back in the years.

CRM. It wasn't used too much in Georgia, strangely enough, because in Georgia pottery, before the Albany slip, there was a lot of lime-ash glazing and not too much salt. How do you use the salt? Do you throw it in?

JH. Throw the salt into the fire after it gets up real hot, to around 1,200 degrees, then we take a shovel and throw it in by the shovel full right through that big door there. We leave that big door after we get up so far, we tear out half of that door so we can put a lot of wood in there, and we throw it, and when it vaporizes itself, it forms a glaze, and that's where that glaze comes about.

CRM. What sort of wood do you use?

JH. Pine. Dry oak or pine, but pine is best.

CRM. Do you use pine for the blasting off at the end?

JH. That's right. Pine is really best. Oak creates a big hard coal and a hot fire, but that pine makes it get on up quicker. That's right.

**Marie Rogers describes how
temperatures used to be gauged.**

CRM. You were talking about not having used cones.

MR. We didn't use cones; we just used trial pieces that he [her father-in-law, Rufus Rogers] cut out of clay. Maybe some pieces he'd already turned and he broke. And he just cut them out, square pieces, and he'd have a hole in the center, and he'd put them in the back of the kiln where he had a peep hole, where he could reach in with an iron rod in the back, and he could always tell by looking at the chimbley [chimney] when it was getting hot how much heat, how much blaze, was going out of the top of the chimbley.

CRM. You fired with wood.

MR. With wood. And he said, "I believe it's getting about ready to cut the thing off" or "Quit throwing the wood in there," and he'd go and take this rod and reach in the back and pull out the trial piece, and if it had got hot enough to melt that glaze in the back on this trial piece, he knew that it was ready to quit firing. And they always put the churns and the pitchers— always the glazed stuff was in front of the kiln, where all the fire was at, 'cause the flowerpot, you didn't use as much heat on your flowerpots as you did on a churn or your pitchers. So they always put them up front so they would be sure they got plenty heat to melt the glaze to get it a temperature, and they would stack the flowerpots in back, and they wouldn't fire them too hard.

**Howard Conner talks
about operating the kiln.**

HC. My daddy bought a couple of cole mines, and what they did, they hauled the right kind of coal in there and let them get it out. And he fired the kiln and it wouldn't fire, and when he got the others started out, I distinctly remember, eleven straight kilns going to the pits from where they'd hauled it. Too much sulphuric acid in it that peeled the glaze off.

CRM. He normally had been wood firing or gas firing?

HC. Now, my daddy was the first ever to fire gas in the kiln at Marshall, Texas. He made his burners from wagon thimbles. . . . Now, the last firing that we did in this kiln out here, we used LP [liquid propane] gas. We would use, used to, nine ton of coal at about eighty-four hours and heat it to about 2,300 degrees.

**Edwin Meaders comments
on wood and heat.**

CRM. Now you are using slab, pine slab for firing?

EM. That's right. I go get me a stack and dry 'em and store 'em up and get ready to fire, and I got me dry wood to fire, and it's got to be dry to get hot enough to melt the glaze.

CRM. Do you have any idea what temperature you're using?

EM. Well, I don't really know. I imagine it's between 1,400 and 1,800. I believe it will range right in there for some loads. Some load it gets hotter; some loads it don't get as hot. 'Cording to the kinda glaze you are using.

MARKETING MATTERS

**Marie Rogers recalls
her husband's stories.**

MGR. I heard my husband say when he was a little bitty boy, a little bitty
thing, he would go with his dad, and they still had a wagon and would carry
it off, and they maybe would be gone a week, and they would go to differ-
ent stores and they would take—they mostly made churns and jugs—and he
would go with him, and they would stay gone a week and come back home
selling jugs and churns.

CRM. Did they sell, or barter, or both? I know some of the potters would
barter their pottery for food stuffs and so forth.

MR. I imagine they did both, 'cause back then I guess things was they
didn't—yes, a lot of times they had to trade stuff.

**Horatio Boggs talks
of supply and demand.**

CRM. How do you market your pottery? You said it's wholesale, basi-
cally.

HB. In the beginning, we hauled it all, sold it by truckload. Thirty years
ago, you had pottery yards; they sold pottery. They wasn't a garden center,
they was a pottery yard, mostly in Florida. You come out the south of Florida
and headed north, you got pottery yards all the way. Now they're all turned
into garden centers, and instead of a few hundred big pottery yards where
you can sell pottery by the truckload, you got half a million of garden cen-
ters which wants two dozen [pots].

CRM. Well, that makes it very difficult, because what you are dealing with has a much smaller volume, and having to go the distance and all the extra bookkeeping and everything else you have to do.

HB. . . . I reckon if we keep on, we're going to have to go back into the stoneware business.

CRM. Why is that?

HB. Flowerpots are not selling. . . . They used to come in. They'd come in from five hundred miles. But when it got to where they'd bring it to them, then nobody's coming, and then your gasoline thing. People that used to come two hundred miles and buy those five-hundred-dollar loads, they didn't mind the cost or nothing. They can't afford it anymore; they're not coming. They're not coming even fifty miles. It's changing times that change your business.

CRM. So you're thinking of seriously going back into more the, say, traditional pottery?

HB. We're going to make stoneware; it would be pitchers and churns.

CRM. When do you plan on going into—are you seriously thinking of going into production that way?

HB. We don't have no problem; all we do is start making it. We're ready.

CRM. What do you think your market will be for that? What sort of people?

HB. They'll come after that. I mean, you can get one distributor and they pay for what you make.

CRM. In terms of what? In terms of utilitarian use? People that, let's say, have the nostalgia interest?

HB. It's going in your gourmet stores in the East and everywhere. A three-gallon churn, $39.95. It sells with a limited production. Nobody is going to take a $39.95 three-gallon churn and make picklin' in it. That's not what it's made for. I sell a five-gallon churn here for $20.00 and everybody faints, falls over backwards; they're not used to it. They always had plenty for nothing, but now that churn will sell for $50.00 in a gourmet store.

**Ralph Miller remembers
mules and barters.**

CRM. How would they market the ware?

RM. Way back in the early days, they did it with mules. . . . I know one man, he had TB, and the doctor told him to get out in the air. He showed up with a bunch of pottery. One time he went off and he stayed sixteen days. He come back and he said, well, he didn't make no money on it . . . and he had a dollar in advance for expenses on it.

CRM. That wasn't bad money then.

RM. No, that wasn't bad money. Buy something with it.

CRM. That was a Stewart? One of the Mississippi Stewarts?

RM. No. . . . He just hauled. He wasn't connected with the pottery.

CRM. He was just a—I guess we would call him a distributor now.

RM. Or a salesman. . . . Back in Depression times, I seen 'em carry a load off. You know what they'd bring back? No money. They traded out— clothes, something to eat.

**Norman Smith recalls
wagons and Model Ts.**

CRM. When you started as a potter, what sort of types of pottery were you making, mainly?

NS. Mostly churns and a few flowerpots. Churns, bowls, and pitchers when I first started. And took it and put it on a truck and go all over the country in a wagon. And maybe sometimes you could get twenty or twenty-five dollars out of a load of pottery goods. The kiln wasn't, shop wasn't, very big then. Right after I started turning the pottery myself, my brother done the peddling and went to an old Model T.

**Gerald Stewart talks of
selling throughout his state.**

CRM. How were you selling your pottery back then? Did people stop by or did you haul it?

GS. We hauled it. Yes.

CRM. Where to?

GS. Almost all the state.

CRM. All over the state? Did you go to Alabama?

GS. No, we didn't get out of Mississippi. We sold it all in Mississippi. They couldn't get enough pottery.

CRM. You were selling up in Columbus?

GS. Columbus, Philadelphia, West Point, Starkville, Jackson. Sold it in the Delta too.

CRM. Were you generally getting orders or were you just loading up in the truck and taking it out?

GS. Regular customers.

CRM. What sort of customers?

GS. Hardware stores or general merchandise stores.

CRM. What about people just dropping in off the road?

GS. Oh, yes, they'd just drop in and buy stuff.

CRM. Now, the last few years? You said you stopped about three years ago because of failing health.

GS. Yes.

CRM. In the last, let's say, twenty years, fifteen years, before you stopped, what sort of ware were you turning then? The same sort of thing all the way through?

GS. All the way through. Just a general line.

CRM. And what sort of customers were you having towards the end of this period? The same type of customers?

GS. The same. Only they would buy more stuff. Just buy a whole kiln, straight out.

Eric Miller talks of supply and demand.

CRM. What sort of ware did your father produce?

EM. Churns and jugs. That's what they used back then. There wasn't much glass back during the war, and they'd put up the ribbon cane in jugs and milk for the churns, you know, they'd use the churns for milk. So that's about all they made, churns and jugs. They had a jug factory back then. They made churns and jugs, and then we gradually got into garden pottery.

CRM. Where did they market the churns and jugs?

EM. It was dealers out of—mostly out of Tennessee and Georgia. They would come down and get truckloads, and then they would deliver it up north at about three times the price what they'd paid us for.

CRM. And after the Second World War, you got into the garden pottery?

EM. The garden pottery.

CRM. The garden pottery you've been doing, that's been marketed through wholesale outfits?

EM. We take orders, you know, and make 'em what they need, and they come and pick it up. That's out of Tennessee and Louisiana, and we used to have all of Florida until Craven started up, but we'll get it back.

CRM. Who is buying the churns now?

EM. Mostly we just don't sell at wholesale, churns. Mostly it's just to individuals here around. The fact is, we make very few, very few. But I need to start it up some wholesale. There is a good demand for it. . . . If I could start making churns now, I could turn that into a big business.

**Carrie Stewart remembers
her customers.**

CRM. What sort of people were buying? Were they buying in large orders? Or were they the local people around here?

CS. Well, no, people would come by, buy just a few pieces sometime. Most of them were people who had come to visit their relatives or friends, and they would be going away and they couldn't carry much with them. We had a pickup, and my husband and I would go to the different towns, and we had regular customers, most of them who were keeping pots and churns.

CRM. These were general stores?

CS. General stores and hardware stores.

**Verna Suggs Duncan* recalls
horse and wagon days with her father.**

VSD. Going back to the horse and buggy days, now, that's when my daddy [W. D. Suggs] delivered all his pottery in a wagon, and of course I had to go with him. . . . He'd warm a brick to keep my feet warm, and had an old tarpaulin—a wagon sheet, they called it then—over the wagon to keep dry in. He'd stop by the side of the road and build him up a fire and scramble eggs and fry meat, and we'd just have a picnic at eating.

CRM. How long would you be gone on some of these trips?

VSD. About two or three days. We'd have to spend the night in some farmer's home, and we might eat breakfast with them or we might do our own cooking out in the yard. From here to Nettleton. You had to spend the night from here to Nettleton, from Smithville to Nettleton.[46]

CRM. What was the farthest distance you covered in hauling the ware? How far did you get? Let's start with your father first.

VSD. There were about five states: Alabama, Tennessee, Florida, and—

CRM. That's not by wagon? That's by truck?

VSD. No, the wagon was just Monroe County and Itawamba, I imagine. The two counties.

CRM. Then once you had a truck—when did your father get his truck first, in the twenties sometime?

VSD. Yeah, in the twenties, I imagine.

46. The present-day driving distance from Smithville to Nettleton is approximately twenty miles.

**Hattie Mae Stewart Brown describes how
ware was hauled and the effects of competition.**

HSB. My daddy [Homer Wade Stewart] hauled it in a wagon with mules. He'd be gone sometimes a week a time to deliver a load of pottery. . . .

CRM. And where would you be doing the hauling then?

HSB. Oh, we'd go anywhere from here to Meridian, Mississippi, Birmingham, just about anywhere you could sell a piece of pottery, that's where we would go.

CRM. Were you doing most of the work on order or were you doing most of it just stopping at stores?

HSB. Now, he [husband Jug Brown] mostly had his orders. There was so much competition.

CRM. That was about when? When did the competition start getting bad?

HSB. It started in the fifties, I guess. There was potters everywhere in the fifties around here.

CRM. Was it more of a problem of too many potters or less demand?

HSB. There was too much pottery.

CRM. There was too much pottery really for the demand at the time. So it's been reduced down to . . .

HSB. To nothing.

CRM. Are there any other potters active in this area of Alabama?

HSB. Not a one.

CRM. All just closed down. When? By the mid-sixties?

HSB. By the middle sixties, they just disappeared. All the little potteries just died out, all died. . . .

CRM. You said there were a lot of potteries in the area at the time. Why particularly here? Or were they all over the Alabama area, at least north Alabama, where the clay deposits are good?

HSB. I don't know why he would want to settle here, as many potteries —I always thought that was silly why he come back here to make pottery, as many as there was around, 'cause there was two around here, two between here and Tupelo.

CRM. Which were those on Tupelo road?

HSB. There was Harris's and Summerford's.[47]

47. Mrs. Brown probably refers here to the same E. S. Harris noted by Verna Suggs Duncan and listed in Smith's *Index of Southern Potters,* 65. This same reference (178) also notes the presence of a D. F. Summerford, who operated a pottery in Bexar.

CRM. Harris's and Summerford's up there, and were there some east of here?

HSB. Course, there was my brother's. And they had two down here from Tuscaloosa, on down that way . . . and they even hauled it from Texas.

CRM. That'd been Marshall Pottery, right?

HSB. With that white glaze. People were a sucker for that. . . . That's what hurt the potters so bad in here.

CRM. You don't feel it was the increasing use of glass, plastic, metal, or containers, but that it was the competition from larger potteries?

HSB. I believe it was.

**Bill Gordy talks about
an evolving clientele.**

CRM. How many years have you been in pottery?

BG. I've been making fifty-four. Right at fifty-four.

CRM. You started out with your father's shop, right? That was at Alverton?

BG. Yeah, that's right. I never did live where my brother lives now. I left there. . . .

CRM. He moved down to Primrose, he moved down there, what, about the time it [Warm Springs] became the summer White House?

BG. He moved there just a little while after I came here [1935]. Oh, I would've stayed on if we could have. . . . You didn't have the market there that could support a big family business. It was bad years, and my daddy [W. T. B. Gordy] didn't have the money.

CRM. But Warm Springs helped, didn't it, though, with Roosevelt being there and so forth?

BG. Well, it helped them then, it did. I don't think it's any good today. Not much, anyway. And the best help you get is where the money's at. Like Clint Bowen over here; that's one of Georgia's largest power plants. Right across from here, there's Atlantic Steel. Right down here in Cartersville, there's Union Carbide, and also all around me there's about thirty great big carpet mills, and forty-three miles down the road is Atlanta, and you once get out there, you know, my pieces make collector's items. According to the antique writing, just anything with Gordy on it, you buy it, so that's the way these people, my neighbors right here, are hoarding it up.

CRM. You're an investment, a hedge against inflation.

BG. So, I guess they figure on making a lot more when, later on, but I don't care.

CRM. What was it like here when you settled here? You didn't have all these plants then?

BG. This was cotton fields when I bought it.

CRM. So why did you pick this particular spot?

BG. Well, I.—just come on back here. Well, I had a good reason. See, this was the main highway. That was the "Main Street" of the South, right out there, which now is Georgia 293, and I picked it. We stayed open seven days of the week. I wasn't here every Sunday but stayed here every Sunday and Atlanta would go to Chattanooga over the weekend and Chattanooga would come to Atlanta. We had a whale of a tourist business, and we catered to the tourist, which very few people will even do today. Today, if I was putting up a pottery, I wouldn't think about catering to the tourists at all. As well known as I am now, if I were a younger man and really wanted to go in to the dollar—now I just enjoy what I'm doing—I would pick out about five hundred of my best people. See, I keep records and addresses and all. I would just send out five hundred letters. I'd say, "Come and get it, we got it." Every time I'd do that, I'd have a fair, you see, and it's the best method. I got the parking place. I can take people right here in my own yard. If they'd want to picnic, I got the tables. . . .

Horace V. Brown Jr.
remembers truckload hauling.

CRM. Where was your father selling? Was it locally to the Atlanta area? Was he hauling it to places?

HVB. All around. Well, I guess he covered most of Georgia.

CRM. So what would they do? Load up a truckload and go out to stores and hardware stores and garden places and so forth?

HVB. He would put one man on a truck and hit the customers and see if they'd need anything, then go on somewhere else and just keep going.

Harold Hewell contrasts past
and present marketing methods.

CRM. What is your market? Do you haul it or ship it?

HH. We do both. We're selling all over the East United States and as far west as Missouri. Probably some of it is re-wholesaled farther west than that.

CRM. So do you have your own trucks?

HH. We do both ways. We ship it by trailer truck and we deliver some ourselves. We don't do any peddling like they did at first.

CRM. I guess your father had, what, a mule and a wagon and then a flatbed truck?

HH. Well, they had wagons. . . . Like to Elberton, I think, is forty miles, and that was probably a week's journey down there and back. About thirty miles to Athens, and that was a pretty good journey itself.

CRM. They sold down in there too? They sold to hardwares and general stores?

HH. It was more or less hardwares back in those day.

Ada Adams Hewell* and her son, Carl,
remember how and where their pottery was delivered.

CRM. How did you do the hauling in the old days?

AAH. Steer wagon way back when his daddy [Eli Hewell] was hauling. Just an old steer hitched it. I heard him talking about it, the steer pulling the wagon. That was before me and him [Bud Hewell] was married. We was just kids then.

CRM. So they would be going to the nearby towns, selling at hardware stores and general stores?

AAH. Yeah, yeah.

CRM. And then in the twenties they started hauling by truck?

AAH. His daddy bought the first truck.

CRM. So that was the first truck in the area?

AAH. To haul jugware on.

CRM. Were they carrying it as far down as Atlanta?

AAH. Oh, yeah.

CH. I don't know that they went as far as Atlanta or not. . . . They went to Athens, I know. I don't guess they went as far as Atlanta with the wagon.

AAH. Not with the wagon, they didn't. With the truck they did.

CRM. How about now? Where are you selling now?

CH. All over. Probably half the United States, I guess. All the southeastern states and some up north out as far as—I guess, some of it goes into Texas, Florida, Ohio. About half the United States.

Billy Joe Craven
describes his delivery system.

CRM. You distribute throughout—what is the reach?

BJC. We have distributors set up in twenty-seven states. We cover an area ourselves on a distributor basis with our pottery in an area of up to a four-hundred-mile radius. We cover a market area that covers from small garden centers up to the large chain, mass-merchant type.

TURNER TALES

**Bill Gordy tells the
sad story of Mr. Reid.**

BG. The fellow Reid, he was a former Texan. Formerly he had worked for my dad. Mr. Reid,[48] he was an educated potter of his time. Now, he didn't go to school to learn to be a potter; he was a schoolteacher. Now, this goes back before the turn of the century, and so he got into pottery later in life, and he worked for my dad. He was a small man, and after [a while] he got tired of working for the other fella. I don't know whether you know it or not, but right out here, about twelve miles from here, there was about a dozen different potteries—the Slighs, the Cantrells, even got a historical marker right by 61 Highway on the right, like from here to Dallas, where it tells about them. Well, I used to know some of them . . . and they made churns, jars, flowerpots. Well, they went through an era there that I had a battle with. You know, I learned on—as I told you—that I learned on churns and jars, but it was not my ambition nor intention to keep it up, 'cause it is just a slow way of working yourself to death and—but I enjoyed making a few of them. I wanted to work at it leisurely, and when I moved here, there was one or two making how they accused me of putting them out of business. I didn't even make a churn. I made art pottery, you know. Look at what I'm doing right now. "No, I'm not going to put you out of business," I said, "you're giving yourself away out there now." Well, what happened

48. James P. Reid (1861–1930) was born in Arkansas. Before setting up his own pottery in Acworth, Reid had worked for a number of Georgia potters, including Bill Gordy's father. See Smith, *Index of Southern Potters,* 148.

was that the young people weren't keeping up pottery, weren't learning, just like you will find with the Bishops—if you will check the Bishops—you've been down in Upson County, Thomaston. You might find four hundred Bishops around there, but you won't find a potter. Every one of them distant kin to me.

Mrs. Gordy. Get back to Mr. Reid.

BG. But, anyway, getting back to him. He committed suicide, and Mr. [Guy] Daugherty and he used to be friends way out in Texas. Mr. Reid's wife was from Virginia. You know, he used to make pottery somewhere up there in a place in Virginia. She come out of a pottery family.

CRM. What was her name?

BG. I don't know. She was Dell Reid, but I don't remember who she was. They had one daughter.

CRM. What was Reid's first name?

BG. Jim. And he was a pretty fair potter, but it is a funny thing, but do you know when he died—it's terrible—they did not have a single piece in the whole house that he had made, or the daughter didn't have a piece? She had a little old, scrawny, tiny sugar bowl that he had made and that was all.

CRM. That's not unusual. I mean, I've found that almost all the way through.

BG. It's almost that way with my daddy, but I have got several pieces that my daddy made, but I've only got two that he gave my wife. One piece before he died way back yonder and I think another piece. Now, these other pieces, people brought them in here and gave them to me—even that jug. A man paid thirty-five dollars for that jug a good many years ago down at Peachtree Gallery and brought here and said, "I want you to have that; it has your daddy's name on it. . . . " Well, really, Mr. Reid committed suicide in January or February—February, I believe—of 1930. What happened was, he went to the doctor; he was feeling bad and went to the doctor. He was sixty-nine years old, and the doctor, old Dr. Birch [?], looked at him; he examined him and he told him, "Jim," he said, "Jim, you go back home and take it easy, you're just wore out anyway. You might as well say you're just worn out and just forget it. You go on back and mess around and do what little you can." You know what he done? He come right to the hardware store and purchased a little old .22 Saturday night special and come back home. And one of them big freights come—the railroads right here, come right behind the pottery. He just slipped that thing up here and pulled the trigger. Right within an hour or two hours after Dr. Birch told him he was a dead man.

Howard Connor
tells a tall kiln tale.

HC. There used to be an old story I've heard my daddy say, fella asked him, said, "Mr. Connor, how many jugs could you burn in that kiln over at Toones?" He said, "Well," he said, "I set a thousand jugs in that kiln once and drew out a thousand and one."

Horatio Boggs* lists
three things about a potter

HB. I met up with a guy from Prattville. He was from Rock Mills. I'd heard of the family. You always hear of the family, your parents talking about them over the years, and you remember the name, but you don't know the people. And I remember the family name from Rock Mills. And he knew all the Boggs; he named every one of them, knew all about them. He said there wasn't but one thing about them. He said they'd all work, they'd all drink, and they'd all fight. Well, I said that's potters for you, but I said I'm the exception—I'm the one that don't drink.

Bill Gordy
drops some names.

BG. You know, he [this visitor] was a writer, too, and he comes on the road in a Ford, had a little traveling camper behind it, and he stopped and had his little pamphlet with him, and he was writing little articles, you know, and he was asking about the people around, me being southern, you know. I asked him, I said, "Just what do you do, what is your business here, 'cause I'd like to know, you keep asking me questions." He handed me his card— still got it—Cornelius Vanderbilt, and so . . . I made a lot of blue at the time. We made a deep blue; it was a good many years ago. And he said, "Would you make me a six-piece set of dishes and ship them to New York?" And I said, "Yes." Cornelius Vanderbilt?

CRM. Worth shipping to?

BG. And so, course we always did ship. . . . But here is what you went through in shipping, all your time for us to ship. Do you know it would take a full day to sit down and crate a twelve-piece set of dishes, and then you got to carry them to the freight office. Well, I shipped 'em. He sent me my money and everything; it just took long. But it didn't ring a bell with me anymore. Then another time, I had another fella I really was tickled to have. I had Sir John Wedgwood pay me a visit, you know, from England. Well,

he had someone drive him up from Atlanta with Mr. Turner . . . and Sir John came up, and I'd been up late firing a kiln, which I don't really like, and my wife came in here and said, "Mr. Turner says he's got a man with him that wants to really see you." I said, "Well, as soon as I finish my breakfast and coffee I'll be right out." So my wife came back, and Sir John handed her one of his business cards—I have it filed too—so I said, "Do you know whose names are on there?" She said, "Who?" I said, "Look, that's Sir John Wedgwood. They've been making pottery for six hundred years in Stoke-on-Trent in England." So I drank that cup right quick, and I came in here and we had about a three-hour chat. He was going over to Saltpeter Cave. See, they use a lot of Georgia kaolin clays. Of course, they have an outlet at Rich's in Atlanta and the Davison's store and a warehouse in New York, and so he, before he left, he said, "Would you ship me some things to England." I said there was no way I could ship to England through Customs. He said, "Just ship it to my office in New York and I'll take it from there." So I did, but anyway, it's some bottles about so high with the tops, and he purchased several of them, and they're marbleized.

CRM. Swirl?

BG. Swirl, real pretty. I'm out of it, but usually I do have it. It took me a long time to fit those clays together, but when I got 'em, I got 'em. And then another time—

CRM. I wonder why he picked that.

BG. It was just different. You know, they make perfection stuff, those Wedgwood people. Well, another time, near that time, I had the royal family of Tunisia come and see me. They were visiting in Atlanta. I made them some special pieces and actually shipped to Tunisia. So I've had some—just to have a little roadside location—I've had some pretty distinguished people. And I've made things for the White House the last two Christmases, not this last Christmas—yeah, this last Christmas—for Jimmy Carter, not Ronald Reagan.

The tale of Casey Meaders' jug as told by Boyd S. Hilton.*

BSH. Anyway, the Casey Meaders' jug tale, which is the classic story of the country potter, and well deserving of being preserved other than by word of mouth, was that Casey liked whiskey, like a lot of potters. That seems to be—I guess they were bored to death with their work and faced with starving to death, the rest of them like they eased their woes with alcohol.

CRM. They also traded a good deal, didn't they?

BSH. Oh, yes, they traded, and they chased women too; in other words, they were men. But Casey liked to drink and he, apparently, was what my mother would call a dram drinker. It's the term for the guy who will sip a few every day but never gets drunk. And I mean every day, too. At that time—it was before the days of prohibition, supposedly, when this happened —I'm not sure about my dates, but there was a lot of small government-licensed distilleries in this country. And they were partly supportive of the jug trade, too. They used local-made jugs. But it is my understanding that this was not a local, licensed distillery; it was a bootleg operation, even though it was before the days of prohibition. It might have been in the twenties, I don't know. Anyhow, the story is that Casey made his own whiskey jug, naturally being a potter he would, and he would take it to the still house, as it was called. And I won't mention the name, although I know it, because we don't want to insult the children of the bootleggers—you understand my position there. I respect him. I think a man's got a right to make whiskey if he wants to make whiskey, and if the government says he can't, well, then, the government's wrong—and I don't drink. He would take his jug, and he would get it filled up, and he would take it back, and he would sip on it until it was empty, and he would go back to get it filled up again out of their barrel. The thing about it was that Casey made his own jug and he put a big fat three on it, to hold three gallons, and everybody accepted it as that. But the jug actually measured four and a half gallons. And he would take his three-gallon jug, so plainly stamped and beautifully made, to the distillery, and they would put four and a half gallons of whiskey in it, naturally just leaving room for the stopper, and he would pay them for three gallons and everybody went home happy. And that has been told more than once, and in different directions, and it is apparently a true story. . . . Now, that's the story of the Casey Meaders' whiskey jug.

**Bill Gordy talks
of the potter's profits.**

BG. When we worked at Smithfield [North Carolina]—that was in bad Depression years, you know—we got real good pay, along about fifty-five dollars a week. And I can remember we would be walking down the street, us potters would, you know, and Smithfield is a little town about four or five thousand, and [people would whisper], "There goes one of those big money makers." I wouldn't even turn around.

**Lanier Meaders marvels at
Smithsonian shopping trips.**

CRM. I understand the Smithsonian has your stuff, too, in their sales shop
and everything.

LM. They were here a while back

CRM. What do they do? Special order a whole series of things from you?

LM. Yeah, takes about six months to make up what they want.

CRM. What sort of quantity do they buy?

LM. Well, the quantities they buy—back the first of the year, early spring,
they come down to the Bybee Pottery in Kentucky and they cleaned out the
showroom, everything in it. Well, they packed it up and moved it on the
truck, and a couple of miles away from the shop and the truck broke down.
They couldn't get it fixed 'til the next day, so while they was fixing the truck,
they come back down looking at the Bybee Pottery again . . . and they looked
in the showroom, and they had it full again, and Ralph Rinzler [folklife
scholar and public affairs director for the Smithsonian] says, "Let's buy this
too."

CRM. So they cleaned it out twice. I'll be going up to Bybee later this sum-
mer. I hope I won't go up just at the time the Smithsonian has just been there.

**Bill Gordy talks of trade
secrets and Gibson of Missouri.**

BG. We had an old potter here—used to be at Acworth, too. His name
was Gibson.[49] He was from Missouri. Now, he was an aggravating old fellow.

CRM. What was his first name?

BG. I always called him Mr. Gibson. He lived way up into his eighties.

CRM. Just "Mr. Gibson from Missouri"?

BG. Yeah, and he had married a girl—he had worked in a pottery at
Matthews, North Carolina, and had married one of the girls up there, and
he moved to Georgia. Well, he never did like me. He thought—I wasn't try-
ing to date his daughter or anything, 'cause we were of dating age both of
us at the time. . . . And he accused me of trying to buy him out, you know.
He didn't own the place; he had it rented. Well, I didn't want his place. See
he come up with right funny ideas. Well, anyway, he was smart in certain
ways. He went to a place over in eastern North Carolina over there, around

49. This probably was Frank Gibson. See Burrison, *Brothers in Clay,* 315.

Jugtown. Now, this is true. Way back—now, this goes back to the turn of the century—when they'd make a churn or a jar they had a fire going. They kept so many brick in it, and they'd put these bricks like this was your churn, they'd put about four brick around it for about five minutes while they'd work up another piece of clay, but then it'd harden up enough that you could pick it up with your hand without using a lifter. . . . Alright, Mr. Gibson carried his own lifters when he was going to work at a different pottery, and he went in there, you know, and he started making churns, and one fellow from another pottery come in and said, "How you get 'em off the wheel?" "Oh, I just pick 'em up." "I'll just hang around and see how you take 'em off the wheel." You know, Mr. Gibson quit; he just went up and got his pay and walked on off.

CRM. Secrets of the trade, eh?

BG. Oh, there were lots of little, old petty things, you know. I tell people in glazes, I don't mind. You might—say you're having trouble with your glaze—I might tell you what to do. I don't know it all. Now, giving out the formulas, I just don't do it, but the little technical things. You know what I tell 'em. Yeah, it's in these books here if you just open 'em up and look through it. Yeah, it's in there.

**The story of Casey Meaders's
shrine, as told by Boyd S. Hilton.***

CRM. We are talking about Casey Meaders and his pottery in North Carolina. Where was that located?

BSH. About fifteen miles airline from here, down in the Balls Creek area. You've heard Balls Creek mentioned? Well, it's about fifteen miles east of here, fifteen or twenty.

CRM. They say the story is fable?

BSH. Well, yeah, part of it. Casey Meaders came up here from Georgia.[50] That is generally accepted. And, apparently, there was some family friction

50. Casey Meaders (1881–1945) was the brother of Lanier Meaders's father, Cheever. He married in 1917 and opened a pot shop near those of other family members in the Mossy Creek District of White County, Georgia. In 1920, he left his first wife and departed for North Carolina. See Ralph Rinzler and Robert Sayers, *The Meaders Family: North Georgia Pottery,* Smithsonian Folklife Studies 1 (Washington, D.C.: Smithsonian Institution Press, 1980), 34, and Burrison, *Brothers in Clay,* 261.

when he came, 'cause he never went back, according to legend. And they didn't come to visit him, whence came your observation that he disappeared. He didn't disappear. He came up to North Carolina and started making pots, by himself. I have a friend who has helped Casey Meaders dig clay, who has helped Casey Meaders fire his kiln—when he was a kid, twelve years old —and who has helped him haul it around in a T model pickup and sell it. But I have never got the full story, but there is that much in existence which is available. What is not available is the inside of Casey's shop, which is still in existence, completely surrounded with cement blocks and a roof and a locked door and on the property where his daughter now lives.

CRM. The shop is encased in another building?

BSH. She took that shop and she built another building around it and locked the key and said, "Nobody goes in there. My daddy was the best potter that ever lived and nobody's going to handle his stuff or break his stuff or steal his stuff." I'm quoting legend now, not facts. But you get enough of these legends together and they all lock in and intermesh, and you begin to see that they make a complete story. You understand?

CRM. So it's right like the day he died?

BSH. Not the day he died but after he died. It's apparently, according to one person who claims to have been in it, is that the inside of his shop is exactly like he left it, tools and all. But you can't go in it. Terry Zug [University of North Carolina–Chapel Hill professor of folklore and English and North Carolina pottery authority] wasn't permitted to go in it, and Terry can be right persuasive to little old ladies 'cause he has that easy going manner, you see, and you tend to accept Terry as not a smart aleck or a fast-buck artist. Because he's not. But that is the story of Casey Meaders's shop, and it's there and if you want to try it, you go ahead. It's your head and their stone wall.

A story of whiskey jugs and watermelons, as told by Horace V. Brown Jr.*

HVB. Of course, all of the Browns drink a whole lot, including me. I quit.

CRM. Does that come from selling jugs to bootleggers?

HVB. That's right. You always have to sample. It's right funny. There was one time, we had—it was hard times then—we'd been up around Dalton and with a load of jugs, and there weren't nobody with any money, and a store owner there told daddy where a bootlegger was and he might buy it, some from him, and we went over there and he swapped a load of jugs for

five gallons of corn whiskey and a load of watermelons. And he started hitting that—there weren't a lot of paved roads back then, and he started hitting that whiskey 'cause it was pretty good, I guess, and every once in while we would hit a hole, and when we got home, we didn't have any watermelons—bursted, every one of them. They went to the hogs.

WHAT THE
FUTURE HOLDS

**Marie Rogers talks
about the next generations.**

MR. [My daughter] Norma got to where she would try it and she could throw, turn, pretty good. She had taken some in college. The only thing she learned in college was this coiling. They didn't—she didn't get around to the wheel.

CRM. Where did she go?

MR. Oh, she went over in Columbus, that's where she'd take that.

CRM. Columbus College?

MR. Yes, mostly coil. Most she learned was when she was here.

CRM. Does she do any turning now?

MR. Yes, she can turn. Not in Texas, but she can now when she comes home, she can do some.

CRM. She is living in Texas now?

MR. Oh, yeah, but she doesn't want me to get rid of the wheel or anything; she wants it, which I am not intending to do. I hope I can teach my little grandson to do it.

CRM. Is he Norma's child?

MR. He's Brenda's, but Brenda can't do it.

CRM. They live here?

MR. She lives up on the—about a half mile from here.

CRM. What's your grandson's name?

MR. Heath Coker. Norma got him a little electric, a little battery one, and sent it to him for Christmas. She wanted him to try and teach him how to do it, and I thought it was money throwed away, but he can turn a little, small piece on it so he might.

CRM. It's a good start.

MR. If you ever come back around through here—

CRM. I may see him.

MR. He might be the potter. [Laughs.]

Horatio Boggs talks of
the past and the future.

HB. It takes a lot of "just stay with it and it'll come to you. . . ." You can take ten children and put them on the wheel and help them. You can pick one out of that ten that will learn right away, and the rest of them, they might as well cut cord wood or they don't have the hands nor the talent. You can sense the talent right off. They'll do it. It's all in the hands—they don't need the head—and the feel, and they just go right at it.

CRM. How many generations of Boggs been involved with it?

HB. Well, we know of six.

CRM. Six. Does that count your grandson?

HB. Yes, now I have great-grandchildren, but no potters.

CRM. Not yet.

HB. I don't think they'll be any there. But I have two grandsons that both will probably be potters. If they don't do it, I would like for them to learn. Both my sons, they can turn, but they don't. They are potters.

CRM. Is there someone to take over this operation for you, what do you think?

HB. I have one son with me [Wayne Boggs, 1941–].

Oscar Smith* speculates
on a successor.

CRM. Did you manage to train your son at all? Did he have any interest in it?

OS. Well, he—my son—he worked at it off and on, but I kept him in school.

CRM. What is his name?

OS. Pettus Smith. He's the manager of the Goodyear Store over here in Clanton. He made rabbit figures when he was a little boy; he wasn't over ten years old. I gave him all that he made out of it. He got through college. I

didn't want him to work at it because the work was so hard if you've got other work to do. He says when he gets his time worked out—I think he lacks a year or two more time of having his pension worked out with Goodyear—he says when he has it worked out, he'll put up a shop and start.

Gerald Stewart discusses the demise of the Mississippi potter.

CRM. Mr. Stewart, you are one of the two last potters in Mississippi. Do you have any feelings about that?

GS. Yes, I sure do. I hate to see it, you know, nobody learned. Of course, now, we got some of these, I call it ceramic. They can make a little stuff.

CRM. Studio art pottery. That's quite different.

GS. I know it is, altogether different.

CRM. Did you train anybody yourself?

GS. Well, I trained Bill [Stewart, his nephew].

CRM. How do you account for the lack of continuing traditional pottery making [in Mississippi]? What reasons do you see for why it has stopped or almost stopped?

GS. Well, I tell you, this younger generation ain't got the patience to learn. It takes patience to learn to be a potter. You got to stand still long enough to learn to be a potter.

CRM. Did the change in how we live and things we have in our homes, in terms of glass and plastics and metal and this sort of thing, have an influence on the shutting down of a lot of potteries, do you think?

GS. No. I don't think so

CRM. It's just a matter of patience . . . people wanting to do that?

GS. That's right.

CRM. You think there would still be a demand for pottery if there was pottery out there?

GS. Yes sir, plenty of it.

CRM. Good, I'm glad you feel that way.

Verna Suggs Duncan talks about the end of pottery production.

CRM. Now, after your husband died—do you have children?

VSD. One son.

CRM. Did he go into it?

VSD. No, his daddy always talked against it. Said, "Get something to make some money." This is hard, hard labor and no money to it. You barely

exist unless you can really have money to put out. It is a struggle, you know, if you have to live off what you make, and at that time, the plastic was coming in and that hurt the flowerpot sale.

CRM. You think that is what . . . ?

VSD. That actually hurt the flowerpot sale, and now, recently, Wal-Mart and all these florists and things surrounding Amory has come in. Well, they sell pots and they sell flowers. And if I had had a good variety of things, I'd have had a better business, but I don't stay home. I go fishing and tend to my grandchildren.

CRM. And [your younger brother] Rex had a pottery?

VSD. No, he was in that same pottery. After my daddy's health failed, he carried it on 'til it went so bad so he went up north and stayed several years, and then he come back and they tried it again to make it go, but it was just too much expense, and he quit and went into this die and tool outfit. . . .

CRM. So the potters in your family were your father, your brother Rex, and . . .

VSD. And me.

CRM. And you, and your husband, who married into it. So it's really stopped then; there is no one else to—

VSD. No one. We've kept the place. People have wanted to rent it, but I said it's mine; it's paid for if I don't ever use it. I didn't want nobody living here, working right in my nose with me not being involved in it. They didn't want to have no say-so in a sale of my own. Now, I wouldn't have that. . . .

Howard Connor
looks to a finite future.

CRM. After the fire you just decided to—

HC. Well, I couldn't go with like possibly $100,000 to build back. That was almost just out for me. You see, the family is cut down to one, me. There was other companies that offered me distributorships if I didn't go back into manufacturing, so that is what I did.

CRM. Do you have children?

HC. No. My brother [Alfred] had two little girls; I've got two nieces. And my sister and her husband has no children.

CRM. So there is nobody else in the family that's in the pottery business?

HC. That's the end. That's it, the end of it.

**Harold Hewell contemplates
a return to old forms and types.**

CRM. Have you thought at all about going back into the stoneware stuff? There seems to be a market now.

HH. Well, we would like to, but we don't think it would be profitable, and it's expensive to make it.

CRM. And your market is good for the earthenware?

HH. It's good for this.

**Hattie Mae Stewart Brown
deals with sorrow and hope.**

HSB. Now I've got two boys. I have a son, my oldest [Jack Owen Brown, 1941–1965]—he got killed in a car wreck in '65, and he could go in a pottery, set up three or four hundred gallon, and walk out three or four 'clock in the evening. He wasn't but eighteen years old.

CRM. He was following along in the pottery . . . ?

HSB. Now, I have another son. He was like my little brother. He didn't take no interest in making the pottery, but he would wait on you and do other parts of it, but he could make pottery too. . . .

CRM. How old is he?

HSB. He's thirty-eight.

CRM. What is his name?

HSB. Jerry Brown. He lives here in Hamilton.

CRM. Does he have a pottery?

HSB. No, but he's planning to pick up one of those little things. . . .

CRM. Those electric kilns.

HSB. Now, he could do good with it, too. . . .

CRM. So why is he thinking of going to making pottery?

HSB. Just to have something to set on the side just for a hobby.

CRM. He enjoys it? Does he plan to sell anything or actually open up a pottery?

HSB. Oh, he could sell it if he could make it, as fast as he could make it and this little boy of his—they just have one child. . . . And he is working with his daddy making as much business he can.

CRM. And your grandson, then, is he making pottery at all?

HSB. He could make most of it hisself, and he's just been into my brother's [Gerald Stewart] a few times and is just crazy over it. That's the reason my son wants to put it up for him.

CRM. What's his name?

HSB. Jeff Brown. He is sixteen and will be seventeen in November.

CRM. Another Brown.

Grace Hewell discusses her grandchildren as potters.

GWH. I've learnt Matthew to turn, my grandson. Now I'm learning Nathaniel. Of course, Nathaniel is hardly as interested in it as Matthew. Of course, he's still small. Matthew has been making pots ever since he was three years old. You see, he'd sit in my lap, and he'd come every day, and he'd want to make some pots sitting up here in my lap making pots. . . . You see, we have a Georgia Mountain Day in Gainesville, so they invited Matthew to come with his wheel, and they invited Bill Gordy to come with his wheel. So you know how good Bill Gordy is—so he's standing over there and he's showing them how he could run a pot up . . . and Matthew was just taking that in. So in a minute Matthew just went and got on his wheel, and everybody piled on over there to watch Matthew make pots. You see, he didn't know how to do any of them tricks, so he said, "Do y'all believe that I can make a pot with my eyes closed?" I thought I'd die laughing, you know, 'cause Bill Gordy had been talking about how he could, so that was the only thing Matthew could think of—he could make a pot with his eyes closed. And so Bill's wheel wouldn't work good the way it was plugged in, so he wanted to borrow Matthew's cord, so Matthew let him have his cord a little while, and then he looked at him and Matthew told him, says, "I want my cord back. I want to show them how to make a pot."

CRM. Bill told me about it. He said he is a really good potter.

GWH. That was real funny. See, he was just seven years old then.

Wayne Wilson talks about his son's determination.

CRM. Do you have children?

WW. Yes.

CRM. Are any of them following along with this do you think?

WW. My little boy is. He is usually right under my feet, you know, doing every step I made.

CRM. How old is he?

WW. Ten.

CRM. What's his name?

WW. Jerry. Everybody in school, you know how kids are, they don't know what they are going to do, but ever since he was five years old, you know, anybody can ask him what he is going to do and he says, "I'm going to be a pottery man like my daddy." He told my mother the other day, her nephew—he graduated from school, and he don't know what he's going to do or wants to do—and he says, "You know he's got a problem, he don't know what he is going to do. I don't have that problem. I know what I'm going to do."

CRM. Are you pleased about that?

WW. Kinda. But I certainly want it to be different between me and him than how it was between me and my dad. . . .

CRM. Potters are very much individualists, and it's their shop, and sons don't get very much of a say until the father's retired or died or something. Is that about it?

WW. Yeah.

CRM. I know that was the case with Lanier [Meaders] and Cheever Meaders. It was very much that way.

WW. Weird things.

**Henry Hewell comments on
family pride and future predictions.**

CRM. Do you have any particular feeling about the fact that you are part of a family that in this area has been making pottery for generations?

HH. About the same, I guess, that a farmer would have that's been farming for generations. I'm sure he'd have a certain amount of pride, too.

**Quillian Lanier Meaders* on
cashing in and making a living.**

CRM. The Meaders are the only family in this [White] county now turning out pottery at all. I mean, the Dorseys and that whole crowd, they are all gone?

LM. All gone. This is the only place left of the whole area.

CRM. Of what used to be a major pottery producing area. Do you have any feelings about that yourself as being at sort of being one of the last people who is preserving what used to be a very thriving industry?

LM. Well, the only feeling that I have about it is cashing in on it.

CRM. How do you feel about people that come around asking questions like I'm asking?

LM. I figure you're trying to make a living.

CRM. Good for you, yeah. I also have fun at it, too.

LM. Well, everybody has got his own calling. And if he don't have it, he's lost.

CRM. Sure enough, sure enough.

EPILOGUE

A Generation Later

Almost a quarter century has elapsed since I made my taping expedition through the South. After such a long interval, I found it a poignant experience to listen to these recordings once again as I selected and transcribed the excerpts for this volume. Sadly, most of the voices preserved on these tapes are now stilled; in fact, many of the participants died not long after the recordings were made. These interviews, both the transcribed excerpts presented here and the complete tape recordings preserved at the McKissick Museum, have acquired a special historical significance, not only in documenting a continuing tradition but also in commemorating the passing of a generation that had done much to keep the southern potter's craft alive.

Looking back from the perspective of more than two decades, it would seem that some of my predictions and projections have come to pass, while circumstances have intervened to alter others in either positive or negative ways.

South Carolina

In my home state of South Carolina, the pottery story has been uneven. Shortly after I had completed my survey, Billy Henson of Inman (just to the northwest of Spartanburg) decided to forsake his occupation as a mechanic and return to his family's old pottery turning traditions. Billy sought the advice of such established potters as Lanier Meaders and Burlon Craig and constructed a pottery shop and groundhog kiln following the old procedures. A quick student at the wheel, Billy soon was producing jugs and churns of increasingly acceptable form and then covering them with the alkaline glazes traditional to the upstate region of South Carolina. Sadly, what might have led to a reestablished tradition in this part of the state ended with his death in 2002. On the other hand, the moribund potting activities centered around Bethune and once in the hands of the peripatetic Brown family have

been reactivated by Otis Norris, who had grown up around the several potteries in the area. After several false starts, Norris opened his Sandhills Pottery east of nearby McBee in 1998, and it now shows every indication of prospering in the years to come.

Frequent exhibits devoted to southern and, in particular, South Carolina–produced ware, are featured at the South Carolina State Museum in Columbia and at the University of South Carolina's McKissick Museum, which, as has been noted, also sponsors an energetic research and collection mission dedicated to the southern ceramic tradition. Published evidence of this initiative can be found in the museum's exhibitions and catalogs devoted to the story of alkaline-glazed ware and to the more recent pottery practitioners. This book is, of course, further proof of the McKissick Museum's commitment to such research projects. Meanwhile, the little-known history of the Kershaw County potteries (including those in Bethune) has been extensively studied and published in book and exhibition form by two devotees, Harvey Teal and the late Arthur Porter McLauren. Their scholarly efforts have joined those of a variety of investigators across the South who have benefited from the labors of the first generation of "by-the-state" researchers and who currently are delving deeply into the traditions of specific local potting centers. Clearly, the befogged knowledge of southern pottery current in John Ramsay's day is being replaced by soundly researched and well-documented studies that are laying the foundations for a future regionwide reappraisal. Such efforts have raised the level of general public awareness and have sparked a general interest in traditional ceramics as a point of regional pride.

North Carolina

Just as North Carolina led the way in the first round of pottery preservation during the 1920s, it has taken a leadership role in this second stage of the effort. Typically, success has been accompanied by some disappointment. The splendid collection of historic pottery assembled and opened to the public in 1969 by Dot Cole and her husband Walter Auman no longer invites the visitor into the little red clapboard building they had relocated next to their pottery in Seagrove. The Aumans, who had done so much to preserve and document the Carolina pottery tradition and who were leaders in the craft themselves, died tragically in an automobile accident in 1991. Years earlier, however, in 1983, the Aumans had transferred ownership of their collection to the Mint Museum in Charlotte, and over the next six years it was moved to that location. There, much of it can be seen in a gallery dedicated to the

Aumans' memory, complemented by the handsome collection put together by ceramic expert Daisy Wade Bridges.[51]

Back in the Piedmont, the role once played by the Aumans' collection as a historic reference point within the vibrant community of Seagrove area potteries has been assumed by the North Carolina Pottery Center, which opened its doors in 1998. Its handsome exhibition building offers the visitor not only a growing collection of historic North Carolina pottery but also a variety of changing thematic exhibits. The center's role is augmented by the private shop / museum of the Southern Folk Pottery Collectors Society in nearby Bennett, organized by Billy Ray Hussey, who is a prominent force in area pottery making. Hussey organizes periodic auctions of southern ceramics and publishes a most informative and well-illustrated newsletter for his Collectors Society that presents relevant materials not only from his own state but also from throughout the region. Another display of the work of southern potters is being formed at Creedmoor, north of Durham, at the Cedar Creek Gallery's Museum of American Pottery. In Raleigh, the Visual Arts Center of North Carolina State University, under the guidance of its director, Charlotte Vestal Brown, and ceramic historian Leonidas Betts, frequently features exhibitions of North Carolina wares, both historic and contemporary, and the permanent collections of the North Carolina State Museum presents some fine examples of traditional North Carolina pottery. In Chapel Hill, the survey of world art housed in the University of North Carolina's Ackland Art Museum has been enhanced through a stellar collection of primarily North Carolina pottery assembled by one of the leading authorities on North Carolina pottery, Terry Zug. In order to document particular family contributions to the history of pottery making, several of the potteries have begun establish their own private collections. Such displays can be enjoyed by visitors to the Jugtown, M. L. Owens, and Ben Owen Potteries in the Seagrove district. In the Catawba Valley district of the state, the Hickory Museum of Art now serves as a visual custodian of that region's rich pottery tradition. Other collections of pottery from this area of the state are in the possession of the historical societies of both Lincoln and Catawba Counties. Public consciousness of the potting past, present, and future is high in North Carolina.

51. See Daisy Wade Bridges, *In Prayse of Potts: A Tribute to Dorothy and Walter Auman*, exhibition brochure (Charlotte, N.C.: Mint Museum of Art, n.d.).

And what of the North Carolina potters and potteries themselves? Although a good outcome for the potteries of the Piedmont seemed assured in 1981, no one could have foretold the extraordinary success they enjoy today. Unfortunately, most of the old potters have passed on (and one of the most significant of the shops, that of J. B. Cole, has closed), but their places have been taken by a new generation of tradition-conscious turners. The handful of pot shops strung out along or near the little county road (N.C. Highway 705) leading south out of Seagrove some twenty years ago has given birth to more than a hundred potteries (at last count and still growing) that attract crowds of eager buyers. The public spotlight is particularly bright in November of each year, when the annual Seagrove Pottery Festival takes place. Initiated in 1980, this gathering focuses attention on the local heritage and promotes the diverse work of the area's many potteries. Of course, not all of these establishments fit a strict definition of a "traditional pottery," but lineage and style often support many of their connections to the past. Elsewhere in the Piedmont, the Seagrove festival's success has been emulated in the Sanford Pottery Festival.

Other pottery celebrations have been organized to highlight the accomplished turners in the westerly portion of the North State: the Catawba Valley Festival, initiated in 1997; the Carolina Pottery Festival, held in Shelby; and the Appalachian Pottery Market, which has been held annually in Marion since 1986. Unfortunately missing from such pottery showcases is Boyd S. Hilton, whose raconteurship matched his turning skills; he passed on only four years after I had recorded him. His son, Boyd R. Hilton, turned little until his retirement from Duke Power Company but reopened his father's shop in 2003 and now works full time at the wheel, turning out practical items often edged with blue in the typical Hilton family style. He also produces dogwood-embellished pieces and has continued his father's intricate swirl experiments. The Hilton family's celebrated neighbor, Burlon Craig, continued to maintain his state's alkaline-glaze tradition until his death in 2002. The Catawba Valley style remains vital, however, through the efforts of Burlon's son Don and his grandson Dwayne; Joe Reinhardt, whose family is one of the most respected potting dynasties in the region; and Charles Lisk, who set up his pottery adjoining that of Burlon Craig in 1982. Others in the area have taken advantage of the Craig fame as well. Even farther west, the two potteries founded by Brown family members, Brown's Pottery in Arden and Evan's Pottery in nearby Skyland, continue to thrive, and the venerable Pisgah Forest Pottery, established by W. B. Stephen more than

eighty years ago, operates under a new management determined to revive the spectacular crystalline glazes of its founder.

Kentucky

In Kentucky, things are much as they were. Walter Lee Cornelison continues to turn at his wheel in the historic Bybee Pottery, while family members and assistants, who do the molding and casting of other ceramic items, help assure the production of some 125,000 pieces of pottery per annum. The shelves are stocked each Monday, Wednesday, and Friday in preparation for the rush of buyers when the doors open at 8:00 A.M.; within the hour, they are empty once more. The history of traditional pottery in the state also has been receiving attention, as was evidenced by the symposium "Kentucky Clay," held at the J. B. Speed Museum in Louisville, Kentucky, in 1996 in cooperation with the Museum of Early Southern Decorative Arts. The continuing popularity of folk and craft pottery among collectors in Kentucky is demonstrated at the annual Great American Pottery Festival held in Richmond, only a few miles from the Bybee Pottery.

Georgia

In Georgia, Arie Meaders's prediction concerning her family's continued connection with turning seems to have been accurate. Although her son Lanier died in 1998, Edwin maintains his activity and is enjoying the financial benefits of popularity; Cleater Meaders relocated to Hoschton, not far from the family's home base in North Georgia, and, until his death in 2003, he maintained his own web site featuring delightful alkaline-glazed razorback hogs and grape-decorated vases. Other members of the Meaders clan have recognized the potential that the success of Lanier (and, later, of Edwin and Cleater) created and have turned to their wheels and the smoke from their groundhog kilns fills the air around Cleveland. Their talents have received special recognition each year since 1991 in the Mossy Creek Campground Pottery Show. Encouraged by the commercial success of the Meaders family, Hewell's Pottery, after four decades of exclusively producing unglazed horticultural ware, has resumed the turning of traditionally glazed ware. In this, the Hewells were led by Chester and his mother Grace Hewell, and now Hewell's Pottery is celebrated not only for its popular unglazed garden pottery but also for its collector-oriented churns, jugs, and pitchers. Chester's sons, Matthew and Nathaniel, already were insisting on their turn at the wheel when the Hewells were visited in 1981; now their face jugs are

regarded as among the most recognizable products of the Hewell family. This "retro-transition" has assured the continued success of Hewell's Pottery, which now hosts a general folklife event known as the Turning and Burning Festival, held annually in October. The Oconee Cultural Arts Pottery Extravaganza held just south of Athens in Watkinsville recently has become another focal point for collectors of Georgia's traditional pottery.

Happily, Marie Rogers embarked upon her adventure in turning at just the right moment and enjoys a continuing success and special recognition as one of the leading female potters of the folk tradition. The current state of Georgia ceramics is the poorer, however, due to the passing of both Gordy brothers, D. X. and Bill, whose approaches to the potter's craft were so different but complemented each other so well. Those interested in the history of Georgia's ceramic past now may enjoy the resources of the Atlanta History Center, which houses the collection formed by folk-art historian John Burrison.

Alabama

In Alabama, Boggs Pottery continues to operate as a producer of horticultural pottery at its Prattville location. Sadly, Norman Smith is gone, but his pot shop was listed in 1999 on the Alabama Register of Landmarks and Heritage. Oscar Smith's prediction that his son, once retired, would reclaim the family wheel has come to pass. For the past decade, Pettus Smith, working out of his shop just off Interstate 65 in Clanton, has been turning out brown-glazed pitchers stylistically aligned with his family tradition but now marketed, along with his face jugs, through folk-art centers. The same is true for the Miller dynasty, which has given Eric a successor in his son Steve, who further hopes that, as a fifth-generation Miller potter, he can "get my children one day interested in it and carry on for another hundred years maybe."[52] Eric himself, recognizing the awakened interest in the southern folk pottery tradition, accelerated the production of glazed ware. By the late 1980s, he also had began to turn out a line of brightly colored face jugs, which, by the start of the new millennium, were fetching respectable auction bids from collectors. At one time reconciled to the production of garden pottery, the Miller Pottery now emphasizes its position as a producer of folk art, a role celebrated in a television segment "Miller's Pottery: Turning for Generations," produced by the University of Alabama's public broadcasting station

52. As quoted at http://www.theoutsidersart.com/news/2091033079106.

as part of its *Alabama Experience* series. Also, happily for the Alabama tradition, Hattie Mae Stewart Brown's son Jerry (b. 1942), who inherited his turning instincts from both his father, Horace V. Brown Sr., and from his mother's Stewart lineage, returned to the family tradition in the late 1980s and now operates a most successful pottery geared to the tastes of the modern folk-art buyer. He even has his own web site. Jerry Brown's abilities as a traditional turner have been encouraged by an NEA National Heritage Fellowship and have been addressed in an article on the ninth-generation Brown potter in the May 2001 issue of *Southern Living*.

Mississippi

In Mississippi, Gerald Stewart has died, and his nephew, Bill, has left the pottery business. Fortunately, the family connection with the craft has been preserved in the person of Frank Stewart, who has taken his turn at the wheel in Louisville. His son, Keith, who operates a pottery in Taylor in Lafayette County, not far from Oxford, has assured the continuation of the Stewart line of potters at least for one more generation. Sadly, however, Howard Connor was right in his prediction that for his family's potting tradition his passing was, indeed, "the end of it."

Once upon a time, the southern potter carried his wares to town in a mule-drawn wagon; then came the Model T truck and, later, wholesale distributors or, in the case of the Georgia Cravens, a fleet of "eighteen wheelers" to transport the pottery to garden centers and outlet stores. Increasingly, nowadays, the pottery of the southern turner is being marketed across the Internet "super highway" through electronic folk-art galleries or even via the individual web sites of the potters, willing, as ever, to not only turn to tradition but also make the transitions necessary to keep a great American art form flourishing.

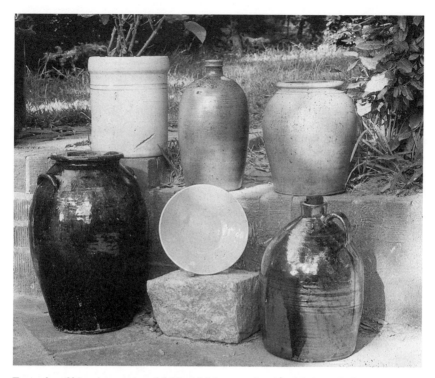

Examples of historic pottery at McKissick Museum showing fabrics and glazes used by potters in the South (front row from left: stoneware storage jar with alkaline glass glaze by Nelson Bass, ca. 1880–1900, Catawba Valley, N.C.; earthenware dinner plate with turquoise lead glaze, ca. 1932–33, Rainbow Pottery of Arthur Ray Cole, Sanford, N.C.; stoneware jug with Albany slip, probably North Georgia, ca. 1920–30. Rear row from left: stoneware horticultural pot with Bristol glaze and cobalt banding made ca. 1960 for the Botany Department of Mississippi State University by Joseph Duncan Pottery, Amory, Miss.; Stoneware jug with salt glaze and Albany slip interior attributed to the Wrenn Brothers Pottery, ca. 1880–90, Piedmont area, N.C.; Stoneware storage jar with salt glaze and Albany slip interior, ca. 1860–80, probably northern Kentucky.

APPENDIX
Terms and Techniques

The Turner's Wheel

Southern potters traditionally have turned their clay on a treadle wheel (often mistakenly called a kick wheel), which utilizes the pushing action of the potter's foot on the treadle bar to turn the wheel head's crankshaft and balancing flywheel.[53] The southern turner, almost without exception, finds it more efficient and comfortable to stand while turning. By the time these interviews were conducted, many of the potters in the region had converted their old foot-powered treadle wheels to gasoline or electric power. A good potter, turning ware and not art, could produce between three and four hundred gallons of pottery a day using up about a ton of clay. Although most traditional southern pottery is hand turned on the wheel, a few of the potteries (e.g., Brown's Pottery in Arden, North Carolina, and Bybee Pottery in Waco, Kentucky) produce some of their stock in a more production-line fashion by using jigger or slip mold casting procedures. Jiggered ware (usually plates or bowls) is produced by placing a slab of clay over a revolving mold and lowering a template to define the exterior contours of the piece; even more mechanical is the slip-casting process in which slip is poured into a mold of standardized shape and thickness.

Clay Bodies
Earthenware

Often called redware, earthenware clays contain considerable iron oxide and are burned (fired) at kiln temperatures varying from 1,800 to 2,200 degrees Fahrenheit (about 945 to 1,200 degrees Celsius or cones 08 / 1 to 1–6). At the

53. For a more thorough discussion of the technical aspects of the turning procedure, see the chapter "Process and Equipment" on pages 33–79 of Nancy Sweezy's *Raised in Clay*.

higher temperature ranges, the fabric is identified as either high-fired earthenware or low-fired stoneware. Earthenware remains somewhat soft and porous and easily chips, but because it can still expand and contract, it is suitable for oven use. Because it has not been burnt to vitrification temperatures, the pottery must be given a coating of glaze if it is to hold liquids.

Prior to 1800, earthenware was the most common type of American pottery, but when the raw lead oxides with which it was being glazed were proven to be unsafe, it became less popular for storage use and was largely replaced by stoneware. Potters continued to produce earthenware for cooking and table use, but relatively little of this has survived due to frequent handling and consequent breakage. In the 1920s, with the discovery of safer, nontoxic glazing compounds and the rising demand for smaller, brighter, and more decorative items, many southern potters returned to the production of earthenware. In the region, today, the turning of earthenware is most closely associated with North Carolina (with the Piedmont in the central part of the state and with Buncombe County in the west) and with the Bybee Pottery in Kentucky. Unglazed horticultural earthenware also is produced throughout the South.

Stoneware

Stoneware clays have less iron content than those used for earthenware but are heavy in silica; they generally are lighter in color and must be burned at higher temperatures in order to harden. At these temperatures, ranging from 2,300 to 2,400 degrees Fahrenheit (about 1,200 to 1,300 degrees Celsius, or cones 7–11), the clay body will become dense, vitrify, and be impermeable to liquids. It is most suitable for large storage vessels but can crack when used for cooking. Although a glaze is unnecessary, stoneware pottery is generally given a decorative coating of salt, slip, alkaline, or Bristol glaze.

Produced in this country since the eighteenth century, stoneware reached its greatest popularity with the decline of lead-glazed earthenware in the early nineteenth century. With the spread of glass, metal, and then carton and plastic containers, stoneware production was curtailed in most of the United States. The stoneware tradition was kept alive in the rural South and has been revived to satisfy the taste of collectors of authentic Americana.

Porcelain

Porcelain fabrics have a fine, white body paste due to the presence of kaolin clays and are fired at very high temperatures, well above those used in the production of stoneware, although the addition of certain fluxes permit vitrification at lower ranges. In porcelain production, the clay is completely vitrified and is often translucent. Certainly not part of the history of true

traditional pottery in the South, variations of this sophisticated ceramic fabric have been used by a few of the region's potters: W. B. Stephen of the Pisgah Forest Pottery in western North Carolina and D. X. Gordy in western Georgia.

Glazes
Alkaline Glaze
The use of alkaline glaze is thought to be unique to China and the American South. A Chinese connection is, as yet, unproven, and the technique may well have been developed independently by cost-conscious southern potters eager to utilize available materials and to avoid the use of precious salt for glazing purposes. An alkaline glaze is prepared from various combinations of sand and wood ashes, slaked lime, ground glass, flint rock, feldspar, whiting, and iron cinders. Like the salt, slip, and Bristol glazes, alkaline glaze is used with high-fired stoneware. In color, depending upon the ingredients and firing practices, an alkaline glaze may vary from greenish yellow, through light and dark green, to a deep brown or black. It often has a drippy texture and is typified by a glossy, glassy feel and a transparent, even translucent, appearance.

Specific regions and potters are identified with particular varieties of this glaze. Alkaline glazing, apparently, was first developed in this country during the second decade of the nineteenth century in the Edgefield district of western South Carolina and spread from there into western North Carolina, southwestern Virginia, Tennessee, Georgia, Alabama, Florida, Mississippi, and Texas. Once, perhaps, the dominant glaze of the South, its use declined in the post–Civil War era when Albany and Michigan slip and then Bristol glaze was introduced. These glazes were easier to work with and produced more uniform results. By the last quarter of the twentieth century, the alkaline tradition had all but disappeared, its use being confined to various members of the Meaders family in Georgia and Burlon Craig in North Carolina. Happily, alkaline glazes have experienced a resurgence in popularity in recent years throughout much of the area in which they had been in use. The lack of consistency in the glaze's appearance now attracts a new, collector clientele.

Salt Glaze
Invented in Germany in the fifteenth century, salt glazing was carried to England and transmitted to America by both English and German colonists, becoming the glaze of choice for stoneware throughout most of the United States by the early nineteenth century. In salt glazing, table salt is thrown into the kiln during the firing process and becomes vaporized. Fusing to the

surface of the pottery, it produces an orange-peel-like protective coating. Although transparent, the salt glaze provides a range of color possibilities, depending upon the mineral content of the clay body and the chemical reaction it has with the salt. In other cases, the vaporized salt would accumulate on the brick ceilings of the kilns and drip down upon the pottery during subsequent firings, producing random and decorative glassy drops. In the larger and more urban potteries of the Northeast and Midwest, much salt-glazed ware was decorated with cobalt blue bands or flower and animal motifs in a fashion reminiscent of the Westerwald region of Germany. This practice was rarely followed in the South due to the prohibitive cost of cobalt and its lack of availability. Once found throughout the South as a rival to the alkaline glazing method, the production of salt-glazed traditional pottery is now limited to several potteries in the Piedmont of North Carolina.

Albany (and Michigan) Slip

The use of a slip on southern stoneware really began in the years following the Civil War. Barrels of a fine, glacial clay from the area around Albany, New York, were shipped into the Reconstruction-era South, where potters would mix it with water. The resulting soup of liquid clay, called a slip, was kept in tubs into which the unfired (greenware) pottery was dipped. When fired, slip-coated pottery generally turned a rich, chocolate brown color but, depending upon conditions and the minerals present in the clay body, could range from mustard yellow to black. The surface of an Albany slip-coated vessel was free of crazing, quite smooth, and lent itself to easy cleaning. In preparation and use, it also was gentler on the hands than alkaline glaze, and many southern potters adopted Albany slip and the similar Michigan slip (which burned to a black finish) for use in their stoneware production. Potters working in the salt-glazing tradition also used Albany slip to coat the interior of their jugs and crocks, which could not be glazed by the vaporizing salt due to stacking. Sometimes, particularly in the Piedmont of North Carolina, the entire vessel would be dipped in slip and then salted in the kiln, producing a smooth, green surface called "frogskin." Today, Albany slip stoneware is being produced in Georgia, Alabama, and Mississippi and also provides a base for certain earthenware glazes.

Bristol Glaze

Bristol was the fourth and most recent of the traditional southern stoneware glazes. Introduced from the northern potteries in the late nineteenth century, the Bristol glaze is really a slip and, like Albany slip, produces a smooth and easily cleaned surface. An obvious product of the industrial age, it was composed of a variety of ceramic chemicals (calcined zinc oxide, feldspar,

whiting, and kaolin clay). Aesthetically, the least variable and exciting of the glaze choices, Bristol fires to a hygienic white and, often, is enlivened by the application of cobalt blue banding. More recent potters also have mixed cobalt and other color additives into the glaze itself. At the beginning of the twentieth century it became popular to glaze jugs with both Albany slip and Bristol to produce a two-toned effect. Dabbing a glaze of color oxides on top of a Bristol-coated pot prior to firing can produce a mottled effect known as spongeware, a technique particularly associated with Kentucky's Bybee Pottery.

Earthenware Glazes

Before it fell into disfavor at the end of the eighteenth century, American earthenware was glazed with clear, raw lead oxides that could leach out in storage contact with acidic contents. In the early twentieth century, new and fully stable lead glazes were developed and were applied by the potters, especially in North Carolina, who had yielded to popular demand for smaller and more decorative items. A variety of other glazes were subsequently developed utilizing frits and feldspar as fluxing media to promote fusion. Various combinations of Albany slip and Bristol glaze also are sometimes used on earthenware. Earthenware glazes can produce a rainbow of colors and are well suited to the changing tastes of the modern era.

Specialty Items

Face Jugs

The origins of this typically southern novelty item (sometimes called a voodoo jug) is obscure and much debated. Some would see the face jug as belonging to the African American tradition and see connections with effigy pots in Ghana and the Congo. Others find closer links with the bellarmine jugs of Germany or the Toby pitchers of England. And a connection with American Indian ceramics is not to be completely excluded. It is more likely, however, that the type was developed independently due to the anthropomorphic shape of the jug and to potters who "fooled around" at the end of a day devoted to repetitive turning. These jugs may even have been intended as caricatures and possibly were commissioned by individual buyers. Lanier Meaders's face jugs often have much of the self-portrait in them. In any case, the type is most prevalent in the South. Having made their first appearances back in the nineteenth century, face jugs have emerged as a popular (even ubiquitous) item for many of the contemporary potters and are avidly sought by collectors.[54]

54. For more on face jugs, see note 7, p. xxii.

Rebekah Pitchers

The form of the Rebekah pitcher is characteristic of the more decorative ware produced by the southern traditional potter during the twentieth century. The shape descends ultimately from the classical Greek oinochoe wine pitcher. The name is also Mediterranean in origin and refers to the biblical story of Rebecca at the well found in Genesis 24:11–21. Potters agree on the scriptural source, and initial inspiration may well have been found in a Bible illustration. Who first produced the form (it also appears with the same name in pottery made by the Catawba Indians of South Carolina) is uncertain, but it is found all over the Southeast in unglazed garden ware as well as in Albany slip stoneware and glazed earthenware. That the peripatetic Brown family was instrumental in the Rebekah's popularity and diffusion is likely.

Swirlware

The spiraling bands of true swirlware, as produced by Burlon Craig and Boyd S. Hilton in North Carolina's Catawba Valley, depend not on glaze (in their work the surface is protected by a clear alkaline glaze) but upon two different clay bodies whose mineral constituents allow for contrasting colors when fired. The trick (so vividly described by Boyd Hilton) in making this ware is to turn the clay in such a way that the two clays combine yet remain distinct. Swirlware was highly developed by Catawba Valley potters during the first half of the twentieth century as a way of appealing to the "fancy ware" tastes of a new motorist clientele and also as a demonstration of the individual potter's control and expertise. Historically, in the Catawba Valley, swirlware is particularly associated with the Propst and Reinhardt families. Burlon Craig learned from the latter and, in turn, passed on the technique to Boyd S. Hilton, who carried the technique to perfection. Others, elsewhere in the South, also have experimented with swirlware: the North State Pottery of the Coopers; A. R. Cole and his son, G. F., all working in Sanford, North Carolina; Charles B. Maston (from about 1930 to 1935) at the Charlie R. Auman Pottery in Seagrove, North Carolina; W. B. Stephen, who was making a variant of English agateware as early as about 1915 at his pottery in western North Carolina; and the Cornelisons at the Bybee Pottery in Kentucky.

Kilns

American turners have "burned" their wares in a variety of differently constructed and functioning furnaces. In shape, the potter's kiln may be either rectangular ("groundhog" or "tunnel") or round ("beehive"). The rectangular

pottery kiln is of German origin but, curiously, seems to have been one of the earliest types built in America—at Jamestown, Virginia, between 1625 and 1640. The Jamestown colony's first potter, apparently, had been trained in England under emigrant German potters, and he brought the kiln type with which he personally was familiar to the New World. From its Jamestown roots, the type spread throughout the South. Commonly called a "groundhog" kiln, this variety was often dug into a hillside and used surrounding earth as a buttress. In this type of cross-draft kiln, flame and heat are pulled directly from a firebox in the front to a chimney in the rear, thus "burning" the pottery along the way. The groundhog kiln, along with the alkaline glazes with which it often is associated, is unique to the southern tradition of American pottery. The "railroad tunnel" kiln is closely related to the primitive groundhog but is taller and built above ground. A later and even larger rectangular kiln has side fireboxes and in which the hot air circulates in a downdraft fashion to a chimney opening beneath the level of the floor. All of these kilns originally were wood burning. Although the simple groundhog kiln continues to be exclusively wood burning, the other types were adapted for the use of coal initially and then converted to either oil or gas.

The beehive kiln, of English origin, was preferred throughout most of the United States but was not introduced into the South until after the Civil War. These round kilns may be designed to work in either an updraft or downdraft mode, depending upon how the hot air is circulated from perimeter fireboxes through the stacked greenware in the center. In the updraft variety, the air is pulled directly through the pottery to openings in the domicile ceiling. In the downdraft kiln, the hot air passes through the pottery twice, once as it rises to an exitless ceiling and then again as it finally is drawn downward toward a flue and chimney opening located below the level of the floor. The downdraft kiln was developed in the nineteenth century and proved more economical in its consumption of fuel and more consistent in the production of evenly fired pottery.

Some of the large potteries in the region, those producing horticultural wares in particular, utilize more modern, commercial kilns, including envelope or shuttle kilns, catenary arch kilns, or muffle kilns. A number of southern potters, especially those at the early stage of their career, although producing traditional pottery, burn it in small, studio-type electric kilns. The results may be uniform, but they lack the "character" associated with earlier kiln types. The potters are practically unanimous in their desire to return to the wood-burning groundhog or tunnel kilns favored by the old-time turner.

Greenware was loaded into the kiln, often placed within clay boxes, called saggers, that both protected the ware from direct contact with the flame and permitted it being stacked to ceiling height. An average "burning" might take from nine to twenty or more hours, depending upon kiln type, fuel, weather, and pottery fabric and complexity. The burning cycle typically consists of an initial "tempering" at low temperature to draw moisture from the ware, followed by a long "slow firing" to evenly raise the heat of the kiln. A final phase of a wood firing consists of "blasting off" the kiln, a process in which the fire is quickly fed with fuel to elevate the kiln temperature to a maximum intensity. Much of the burning procedure depends upon the intuition, experience, and traditions of the turner. Much of what takes place within the kiln might be best described as a controlled accident, conditioned by such factors as the nature of the pottery fabric and glaze, the draw of the chimney, the type of fuel used (particularly so, if wood), the intensity of the flame, how the pottery has been loaded and stacked, the age of the kiln, the accumulation of salts and glazes on the ceiling, weather conditions, and the interaction of all these elements.

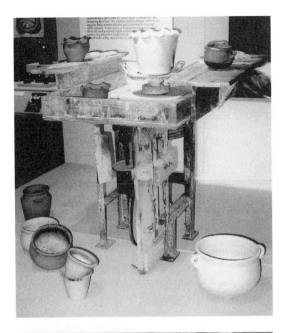

Jimmy Brown's wheel from the Otto Brown Pottery, Bethune, S.C., as exhibited in 1988 in "Turned to Tradition: The Folk Pottery of Today's South," Columbia Museum of Art (donated by Frances Brown Thompson and her children to the McKissick Museum in 2001).

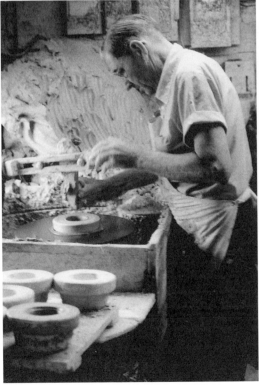

Jigger turning at Bybee Pottery, Waco, Ky.

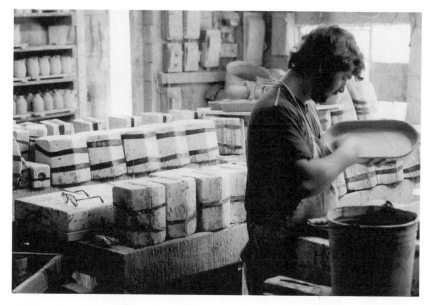

Mold casting at Bybee Pottery, Waco, Ky.

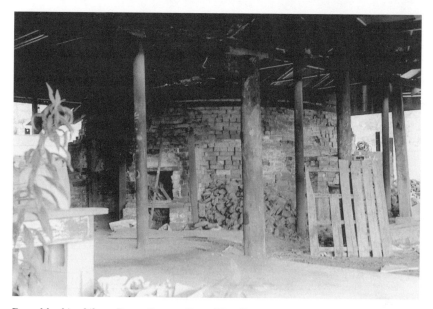

Round beehive kiln at Boggs Pottery, Prattville, Ala.

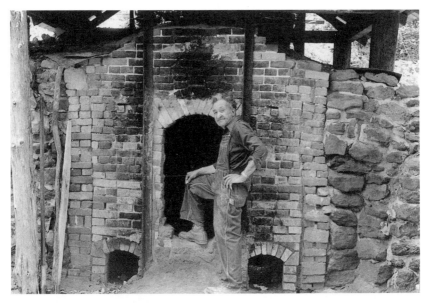

Johnny Hudson standing in front of groundhog kiln built ca. 1970 by D. X. Gordy at Historic Westville, Lumpkin, Ga. Note the draft openings flanking the firing door.

Ruins of the Otto Brown railroad tunnel kiln in 1980, Bethune, S.C.

Gas-fired, crossdraft envelope kiln at Craven Pottery, Gillsville, Ga.

BIBLIOGRAPHY

Auman, Dorothy Cole, and Walter Auman. *Seagrove Area*. Asheboro, N.C.: Village Printing, 1976.

Auman, Dorothy Cole, and Charles G. Zug III. "Nine Generations of Potters: The Cole Family." *Southern Exposure* 5 (1977): 166–74.

Baldwin, Cinda K. *Great and Noble Jar: Traditional Stoneware of South Carolina*. Athens: University of Georgia Press, 1993.

Barber, Edwin Atlee. *The Pottery and Porcelain of the United States: A Historical Account of American Ceramic Art from the Earliest Times to the Present Day*. 1893. Reprint, Glen, N.Y.: Century House Americana, 1971.

Betts, Leonidas, and Charles G. Zug III. *Burlon Craig: An Open Window into the Past*. Exhibition catalog. Raleigh: Visual Arts Center, North Carolina State University, 1994.

Bivins, John F. *The Moravian Potters in North Carolina*. Chapel Hill: University of North Carolina Press, 1972.

Bridges, Daisy Wade. "Ash Glaze Traditions in Ancient China and the American South." *Journal of Studies of the Ceramic Circle of Charlotte and the Southern Folk Pottery Collectors Society* 6 (1997).

———. *In Prayse of Potts: A Tribute to Dorothy and Walter Auman*. Exhibition brochure. Charlotte, N.C.: Mint Museum of Art, n.d.

———, ed. *Potters of the Catawba Valley, North Carolina*. Exhibition catalog. *Journal of Studies of the Ceramic Circle of Charlotte* 4. Charlotte, N.C.: Mint Museum of History, 1980.

Bridges, Daisy Wade, and Kathryn Preyer, eds. *The Pottery of Walter Stephen*. Exhibition catalog. *Journal of Studies of the Ceramic Circle of Charlotte* 3. Charlotte, N.C.: Mint Museum of History, 1978.

Brown, Charlotte Vestal, and Leonidas J. Betts. *Vernacular Pottery of North Carolina, 1982–1986, from the Collection of Leonidas J. Betts*. Exhibition catalog. Raleigh: University Center Gallery, North Carolina State University, 1987.

Burrison, John. "Alkaline-Glazed Stoneware: A Deep South Pottery Tradition." *Southern Folklore Quarterly* 39 (1975): 377–403.

———. *Brothers in Clay: The Story of Georgia Folk Pottery.* Athens: University of Georgia Press, 1983.

———. "Folk Pottery of Georgia." In *Missing Pieces: Georgia Folk Art, 1770–1976,* edited by Anna Wadsworth, 24–29, 86–103. Atlanta: Georgia Council for the Arts and Humanities, 1976.

———. "Georgia Jug Makers: A History of Southern Folk Pottery." Ph.D. diss., University of Pennsylvania, 1973.

———. *The Meaders Family of Mossy Creek: Eighty Years of North Georgia Folk Pottery.* Atlanta: Georgia State University, 1976.

Burrison, John, et al. "Southern Folk Pottery." In *Foxfire 8,* edited by Eliot Wigginton and Margie Bennett, 71–384. Garden City, N.J.: Anchor Press / Doubleday, 1984.

Busbee, Julianna. "Jugtown Pottery: New Ways for Old Jugs." *Bulletin of the American Ceramic Society* 16, no. 10 (1937): 415–18.

Byrd, Joan Falconer. "Lanier Meaders: Georgia Folk Potter." *Ceramics Monthly* 24, no. 8 (1976): 24–29.

Carnes-McNaughton, Linda F. *The Mountain Potters of Buncombe County, North Carolina: An Archaeological and Historical Study.* Raleigh: North Carolina Archaeological Council, 1995.

Carney, Margaret. *Charles Fergus Binns: The Father of American Studio Ceramics.* New York: Hudson Hills Press, 1998.

Carson, Courtney. "Seven Generations of Pottery." *Sandlapper* 1, no. 8 (1968): 18–20.

Clark, Ivan Stowe. "An Isolated Industry: Pottery of North Carolina." *Journal of Geography* 25 (1926): 222–28.

Counts, Charles. *Common Clay.* 1971. Rev. ed., Indiana, Pa.: A. G. Halldin, 1977.

Coyne, John. "A Dynasty of Folk Potters: The Meaderses of Mossy Creek." *Americana* 8, no. 1 (1980): 40–45.

Crawford, Jean. *Jugtown Pottery: History and Design.* Winston-Salem, N.C.: John F. Blair, 1964.

Crocker, Michael A., and Newton Crouch Jr. *The Folk Pottery of Cheever, Arie, and Lanier Meaders: A Pictorial Legacy.* Griffin, Ga.: C & C Productions, 1994.

Davidson, Jan. *Coverlets: New Threads in Old Patterns.* Exhibition brochure. Smithsonian Institution Traveling Exhibition Service and the Mountain Heritage Center, Western Carolina University. Washington, D.C.: Smithsonian Institution, 1988.

DeNatale, Douglas, Jane Przybysz, and Jill R. Severn, eds. *New Ways for Old Jugs: Tradition and Innovation at the Jugtown Pottery.* Exhibition catalog. Columbia: McKissick Museum, University of South Carolina, 1994.

DePratter, Chester, and Stanley South. "Return to the Kiln: Excavations of Santa Elena in the Fall of 1997." *Legacy* 3, no. 1 (1997): 6–7.

Ferrell, Stephen T., and T. M. Ferrell. *Early Decorated Stoneware of the Edgefield District, South Carolina.* Exhibition catalog. Greenville, S.C.: Greenville County Museum of Art, 1976.

Gilreath, Ed, and Bob Conway. *Traditional Pottery in North Carolina: A Pictorial Publication.* Waynesville, N.C.: Mountaineer, 1974.

Greer, Georgeanna H. "Alkaline Glazes and Groundhog Kilns: Southern Pottery Traditions." *Magazine Antiques* 149, no. 4 (1975): 768–73.

———. *American Stonewares: The Art and Craft of Utilitarian Potters.* Exton, Pa.: Schiffer, 1981.

———. "Basic Forms of Historic Pottery Kilns Which May Be Encountered in the United States." *Conference on Historic Site Archaeology Papers* 13 (1978): 142.

———. "The Folk Pottery of Mississippi." In *Made by Hand: Mississippi Folk Art,* edited by Patti Carr Black and Charlotte Capers, 45–54. Exhibition catalog. Jackson: Mississippi Department of Archives and History, 1980.

———. "Groundhog Kilns: Rectangular American Kilns of the Nineteenth and Early Twentieth Centuries." *Northeast Historical Archaeology* 4 (1977): 42–54.

———. "Preliminary Information on the Use of Alkaline Glaze for Stoneware in the South, 1800–1970." *Conference on Historic Site Archaeology Papers* 5, no. 2 (1971): 154–70.

Guilland, Harold F. *Early American Folk Pottery.* Philadelphia: Chilton Books, 1971.

Harwell, Converse. "Construction and Operation of the Harwell 'Ground-Hog' Kiln." *Bulletin of the American Ceramic Society* 20, no. 1 (1941): 10–11.

Hertzman, Gay Mahaffy. *Jugtown Pottery: The Busbee Vision.* Exhibition catalog. Raleigh: North Carolina Museum of Art, 1984.

Holcombe, Joe, and Fred Holcombe. "South Carolina Potters and Their Wares: The Landrums of Pottersville." *South Carolina Antiquities* 18, nos. 1 and 2 (1986): 47–62.

Horne, Catherine Wilson, ed. *Crossroads of Clay: The Southern Alkaline-Glazed Stoneware Tradition.* Exhibition catalog. Columbia: McKissick Museum, University of South Carolina, 1990.

Horowitz, Elinor Landor. *Mountain People, Mountain Crafts.* Philadelphia: J. B. Lippincott, 1974.

Hudson, J. Paul, and C. Malcolm Watkins. "The Earliest Known English Colonial Pottery in America." *Magazine Antiques* 71 (January 1957): 51–54.

Huffman, Allen, and Barry Huffman. *Innovations in Clay: Catawba Valley Potters.* Hickory, N.C.: Hickory Museum of Art, 1987.

Huffman, Barry. *Catawba Clay: Contemporary Southern Face Jug Makers.* Hickory, N.C.: Hickory Museum of Art, 1997.

Hussey, Billy Ray, ed. *Women Folk Potters: The Southern Pottery Heritage.* Robbins, N.C.: Southern Folk Pottery Society, 1998.

Ketchum, William C., Jr. *The Pottery and Porcelain Collector's Handbook: A Guide to Early American Ceramics from Maine to California.* New York: Funk & Wagnalls, 1971.

Ketchum, William C., Jr., and Joseph J. South. *Regional Aspects of American Folk Pottery.* York, Pa.: Historical Society of York County, 1974.

Koverman, Jill Beute. *Making Faces: Southern Face Vessels from 1840–1990.* Exhibition catalog. Columbia: McKissick Museum, University of South Carolina, 2000.

———, ed. *"I Made This Jar": The Life and Works of the Enslaved African-American Potter, Dave.* Exhibition catalog. Columbia: McKissick Museum, University of South Carolina, 1998.

Laub, Lindsey King. *Evolution of a Potter: Conversations with Bill Gordy.* Cartersville, Ga.: Bartow History Center, 1992.

Leftwich, Rodney, Tom Patterson, and John Perreault. *From Mountain Clay: The Folk Pottery Traditions of Buncombe County, NC.* Exhibition catalog. Cullowhee: Belk Art Gallery, Western Carolina University, 1989.

Lincoln County Historical Association and Lincoln County Museum of History, ed. *Two Centuries of Potters: A Catawba Valley Tradition.* Exhibition catalog. Lincoln, N.C.: Lincoln County Historical Association and Lincoln County Museum of History, 1999.

Lock, Robert, Archie Teague, Yvonne Teague, and Kit Vanderwal. *The Traditional Potters of the Seagrove, N.C. Area.* Greensboro, N.C.: Antiques and Collectibles Press, 1994.

Mack, Charles R. *Gallery Guide to "Turned to Tradition: The Folk Pottery of Today's South."* Exhibition gallery guide. Columbia, S.C.: Columbia Museum of Art, 1988.

———. "Traditional Pottery: A Southern Survival." *Southeastern College Art Conference Review* 10 (Spring 1984): 176–83.

———. "Turned to Tradition: The Folk Pottery of Today's South." *Collections: The Magazine of the Columbia Museum of Art* 1 (Fall 1988): 9–15.

———. "Two Traditions in Tradition." In *1998 Fall Folklife Festival.* Brochure. Columbia: McKissick Museum, University of South Carolina, 1998, 7–8.

Mack, Charles R., and Ilona S. Mack. "Bunzlauer Geschirr: A German Pottery Tradition." *Southeastern College Art Conference Review* 13, no. 2 (1997): 121–31.

Matheny, Paul. "Face Vessels and Contemporary South Carolina Folk Pottery." *North Carolina Folklore Journal* 48, nos. 1–2 (2001): 22–27.

McLauren, Arthur Porter, and Harvey Stuart Teal. *"Just Mud": Kershaw County, South Carolina, Pottery to 1980.* Camden, S.C.: Kershaw County Historical Society, 2002.

Owens, Vernon. "Building and Burning a Groundhog Kiln." In *Studio Potter Book,* edited by Gerry Williams, Peter Sabca, and Sarah Bodine, 146–49. Florence, Ky.: Van Nostrand Reinhold, 1978.

Perry, Regina A. *Spirit or Satire: African-American Face Vessels of the 19th Century.* Exhibition catalog. Charleston, S.C.: Gibbes Art Gallery, 1985.

Ramsay, John. *American Potters and Pottery.* 1939. Reprint, New York: Ars Ceramica. 1976.

Raycroft, Don, and Carol Raycroft. *American Country Pottery.* Des Moines: Wallace-Homestead, 1975.

Rinzler, Ralph. "Cheever Meaders, North Georgia Potter (1887–1967)." In *Forms Upon the Frontier: Folklife and Folk Arts in the U.S.,* edited by Austin Fife, Alta Fife, and Henry Glassie, 76–78. Logan: Utah State University Press, 1969.

Rinzler, Ralph, and Robert Sayers. *The Meaders Family: North Georgia Potters.* Smithsonian Folklife Studies 1. Washington, D.C.: Smithsonian Institution Press, 1980.

Ritchie, Johnna M., and T. Dale Ritchie. *Guide to North Carolina Potters.* Concord, N.C.: Watermark Publications, 1996.

Sayers, Robert. "Potters in a Changing South." In *The Not So Solid South: Anthropological Studies in a Regional Subculture,* edited by J. Kenneth Morland. *Proceedings of the Southern Anthropological Society* 4 (1971): 93–107.

Schwartz, Marvin D. *Collector's Guide to Antique American Ceramics.* Garden City, N.J.: Doubleday, 1969.

Schwartz, Stuart C. *North Carolina Pottery: A Bibliography.* Charlotte, N.C.: Mint Museum of History, 1978.

———. *The North State Pottery, Sanford, North Carolina.* Charlotte, N.C.: Mint Museum of History, 1977.

———. "Traditional Pottery Making in the Piedmont." *Tarheel Junior Historian* 17, no. 2 (1978).

Scotchie, Virginia. *Setting Up Your Ceramic Studio: Ideas and Plans from Working Artists.* New York: Lark Books, 2003.

Seagrove Pottery Festival. Brochures. Seagrove: Museum of North Carolina Traditional Pottery, 1982–.

Smith, Elmer, and Brad Rauschenberg. *Pottery, a Utilitarian Folk Craft.* Lebanon, Pa.: Applied Arts Publishers, 1972.

Smith, Howard A. *Index of Southern Potters.* Vol. 1. Mayodan, N.C.: Old America, 1986.

Smith, Samuel D., and Stephen T. Rogers. *A Survey of Historic Pottery Making in Tennessee.* Nashville: Division of Archaeology, Tennessee Department of Conservation, 1979.

Spangler, Meredith Riggs. "In Prayse of Potts." *Journal of Studies of the Ceramic Circle of Charlotte* 2 (1973): 5–23.

Spargo, John. *Early American Pottery and China.* Rutland, Vt.: Charles E. Tuttle, 1974.

Staub, Shalom. "Folklore and Authenticity: A Myopic Marriage in Public Sector Programs." In *The Conservation of Culture: Folklorists and the Public Sector,* edited by Burt Feintuch, 166–79. Lexington: University Press of Kentucky, 1988.

Stradling, Diana, and J. Garrison, eds. *The Art of the Potter: Redware and Stoneware.* New York: Main Street / Universe Books, 1977.

Strong, Susan R. *History of American Ceramics: An Annotated Bibliography.* Metuchen, N.J.: Scarecrow Press, 1983.

Sweezy, Nancy. *Raised in Clay: The Southern Pottery Tradition.* Washington, D.C.: Smithsonian Institution Press, 1984.

―――. "Tradition in Clay: Piedmont Pottery." *Historic Preservation,* October / November 1975, 20–23.

Terry, George D. "Pottery." In *Southern Make: The Southern Folk Heritage,* edited by George D. Terry and Lynn Robertson Myers, 11–14. Columbia: McKissick Museum, University of South Carolina, 1981.

Vlach, John M. *The Afro-American Tradition in Decorative Arts.* Exhibition catalog. Cleveland: Cleveland Museum of Art, 1978.

Webster, Donald. *Decorated Stoneware Pottery of North America.* Rutland, Vt.: Charles E. Tuttle, 1971.

Weinhold, Rudolf. *Töpferwerk in der Oberlausitz: Beiträge zur Geschichte des Oberlausitzer Töpferhandwerks.* Berlin: Academie-Verlag, 1958.

Wigginton, Eliot, and Margie Bennett, eds. *Foxfire 8.* Garden City, N.J.: Anchor Press / Doubleday, 1984.

Willett, E. Henry, and Joey Brackner. *The Traditional Pottery of Alabama.* Exhibition catalog. Montgomery, Ala.: Montgomery Museum of Fine Arts, 1983.

Wiltshire, William, and H. E. Comstock. *Folk Pottery of the Shenandoah Valley.* New York: E. P. Dutton, 1975.

Zug, Charles G. III. "Jugtown Reborn: The North Carolina Folkpotter in Transition." *Pioneer America Society Transactions* 3 (1980): 1–24.

―――. *The Traditional Pottery of North Carolina.* Exhibition catalog. Chapel Hill: Ackland Art Museum, University of North Carolina, 1981.

―――. *Turners and Burners: The Folk Potters of North Carolina.* Chapel Hill: University of North Carolina Press, 1986.

INDEX

Page references in italics refer
to illustrations.

Greenware drying under the summer's sun at the Bybee Pottery, Waco, Ky.

TRACK LIST FOR AUDIO CD

1. Charles Mack introduces the potters. 0:25

2 & 3. Howard Connor remembers his earliest days at the wheel. 1:09, 1:29

4. A pitcher takes shape with Cleater Meaders at the wheel. 2:52

5. Hattie Mae Stewart Brown talks about pottery involvement. 1:00

6. Walter Lee Cornelison recounts family origins and potshop beginnings. 2:44

7. Quillian Lanier Meaders comments on being hassled. 1:42

8. Kenneth Outen gives background on the Matthew's Pottery. 1:00

9. Ralph P. Miller tells of potting heritage and Yankee origins. 2:43

10. Marie Rogers talks about how she became a potter. 2:47

11. Harold Hewell chats about his family and their potting connections. 1:02

12. Norman Smith talks about the early days. 1:43

13. Wayne Wilson remembers learning from a master. 1:50

14. Annette Brown Stevens talks about what her family turned. 1:25

15. Horatio Boggs describes three things about a potter. 0:45

16. Horace V. Brown Jr. tells a story of whiskey jugs and watermelons. 1:20

17. Boyd Shuford Hilton tells the tale of the Casey Meaders' jug. 2:58

18. Gerald Stewart describes the variety of wares he and his family made. 1:47

19. Edwin Truitt Meaders discusses the variety of ware he is producing. 2:31